Viṣṇu's Flaming Wheel
The Iconography of the *Sudarśana-Cakra*

The publication of this monograph
has been aided by a grant from the
Samuel H. Kress Foundation

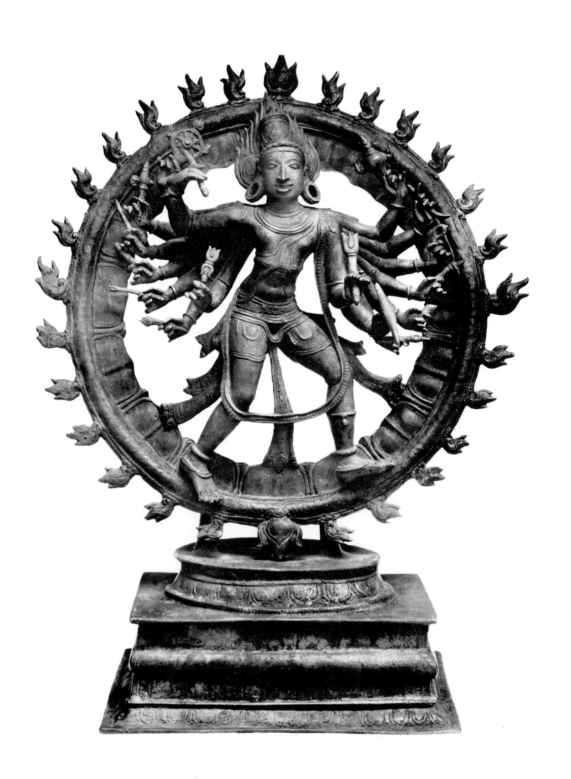

W. E. BEGLEY

Viṣṇu's Flaming Wheel:
The Iconography of the
Sudarśana-Cakra

PUBLISHED BY

NEW YORK UNIVERSITY PRESS

for the College Art Association of America

NEW YORK 1973

Monographs on Archaeology and Fine Arts
sponsored by
THE ARCHAEOLOGICAL INSTITUTE OF AMERICA
and
THE COLLEGE ART ASSOCIATION OF AMERICA
XXVII
Editor: Lucy Sandler

to Vimala

Acknowledgments

THIS MONOGRAPH on the *sudarśana-cakra* attribute of Viṣṇu is an outgrowth of my sporadic researches in topics of Hindu iconography over the past ten years, during which time I have benefited greatly from the scholarly advice and encouragement of teachers, colleagues, and friends in this country, Europe, and especially India. Heading the list of all those who have rendered direct and indirect service is my former teacher, Professor W. Norman Brown of the University of Pennsylvania, for whom I would like to express my deep admiration, especially for his exemplary and inspiring ability to deal profoundly with ideas and kindly with his students. Other former teachers who advised me at various stages in the assembling and developing of the material contained here include Professor Stella Kramrisch, previously of the University of Pennsylvania, and the late Professor Benjamin Rowland of Harvard University. The list of learned scholars, colleagues, and friends with whom I have discussed numerous aspects of my research in Hindu iconography in general and *cakra* symbolism in particular includes: Mr. P. R. Srinivasan, Department of Epigraphy, Archaeological Survey of India, Mysore; the late Dr. M. Seshadri, Director of Archaeology, Mysore; Dr. V. Raghavan, Madras University; Mr. C. Sivaramamurti, Director, National Museum, New Delhi; Dr. Herbert Härtel, Director, Museum für Indische Kunst, Berlin; the late Dr. V. S. Agrawala, Benares Hindu University; Dr. U. P. Shah, Baroda University; Mr. M. A. Dhaky, American Academy of Benares; Dr. R. C. Agrawala, Director of Archaeology, Rajasthan; Dr. P. P. Apte, Poona University; Dr. John Rosenfield, Harvard University; and Dr. C. R. Jones, University of Pennsylvania.

Portions of the material of the monograph were first presented at professional conferences; to the chairmen of the sessions involved I once again express thanks for their timely encouragement: Dr. Harold Stern of the Freer Gallery of Art, chairman of the session at the Annual Meeting of the College Art Association in Los Angeles (January 1965), where I presented a paper with the same title as the present monograph; and Dr. J. A. B. van Buitenen of the University of Chicago, chairman of the session at the 27th International Congress of Orientalists in Ann Arbor (August 1967), at which I presented a paper entitled "The Earliest *Sudarśana-cakra* Bronze and the Date of the *Ahirbudhnya-Saṃhitā*."

The manuscript was put into almost final form during 1970–71, while I was engaged in research in India as a Faculty Research Fellow of the American Institute of Indian Studies. I am

very grateful to the administration and staff of the Deccan College Research Institute—especially Dr. H. D. Sankalia, Joint-Director—and to the administration and staff of the Bhandarkar Oriental Research Institute for the opportunity to make use of their facilities during my stay in Poona. To Dr. B. B. Lal, formerly Director-General, and Mr. M. N. Deshpande, the new Director-General of the Archaeological Survey of India, New Delhi, my appreciation for their help in facilitating my research. I am especially grateful to my friend Mr. R. P. Goswami of the library staff of the Deccan College for much bibliographical assistance and especially for his advice and help in preparing the translations of certain Sanskrit passages included in the monograph. Assistance with translations was also provided by Mr. V. B. Deo.

Two other acknowledgments: my gratitude to Professor Lucy Freeman Sandler, editor of the College Art Association Mongraph Series, for her advice and criticism, and for accepting my somewhat exotic manuscript for inclusion in this distinguished series; and to Mr. Robert L. Bull and Ms. Alice Rosenthal of the New York University Press for careful editing and helpful suggestions.

The illustrations reproduced in this study derive from various photographic sources, all of which are here gratefully acknowledged: *Archaeological Survey of India*: Frontispiece and Figures 3, 4, 12, 18, 35, 44, 51, 60, 61, 62, 63, 64, 65; *Madras Government Museum*: 45, 47, 48, 66, 67, 68, 69, 71, 72, 76, 78, 79, 80; *Institut Français d'Indologie du Pondichéry*: 52, 54, 55, 56, 57, 58, 70, 74, 75, 77; *American Academy of Bernares*: 15, 19, 21, 23, 28, 33; *Cleveland Museum of Art*: 30, 34; *Indian Museum, Calcutta*: 32, 37; *Museum für Indische Kunst, Berlin*: 24, 25; *National Museum, New Delhi*: 41, 42; *Department of Archaeology, Deccan College*: 16; *Los Angeles County Museum*: 27; *Museum of Fine Arts, Boston*: 29; *Prince of Wales Museum, Bombay*: 20; *Royal Ontario Museum, Toronto*: 26. The following colleagues and friends have also generously supplied photographs for certain illustrations: Mr. A. Atwell: Figure 49; Dr. P. Chandra: 38; Mr. R. V. Leyden: 46; Dr. A. Lippe: 22; Dr. M. Seshadri: 53; Mr. T. Schrunk: 14, 17; and Mr. W. H. Wolff: 50. A few illustrations have been prepared from the following books and articles, complete references to which will be found in the Bibliography: A. S. Altekar, *Catalogue of the Gupta Gold Coins in the Bayana Hoard*: Figure 8; J. N. Banerjea, *The Development of Hindu Iconography*: 43; N. K. Bhattasali, *Iconography of Buddhist and Brahmanical Images in the Dacca Museum*: 36; A. Ghose, "An Image of Ārya-Avalokiteśvara of the Time of Vainyagupta": 10; Stella Kramrisch, "Pāla and Sena Sculpture": 31; J. Mittal, "The Temple of Basheshar Mahadev in Kulu": 11; U. P. Shah, *Studies in Jaina Art*: 9; C. Sivaramamurti, "The Weapons of Viṣṇu": 6, 39, 40. Except for certain text figures which are documented in the footnotes, the remaining illustrations have been prepared from my own photographs and drawings. My dating of some of the objects reproduced should be regarded as provisional.

W. E. Begley
University of Iowa

Contents

List of Illustrations

नमः सुदर्शनायैव सहस्रादित्यवर्चसे
ज्वालमालाप्रदीप्ताय सहस्राराय चक्षुषे
सर्वदुष्टविनाशाय सर्वपातकमर्दिने
—*Garuḍa Purāṇa* 33.8,9

Introduction

I T HAS BEEN REMARKED that "an insight into the significance of a god's emblems and attributes is useful, nay indispensable for an understanding of his character." [1] This is especially true in the case of the great Hindu deity Viṣṇu, whose complex assimilative heritage has been traced all the way back to his namesake in the *Ṛg Veda*. The Vedic Viṣṇu was a deity of relatively minor significance whose mythical associations seem to have been partly solar. [2] Because of this ancient heritage, many of the later deity's attributes—and especially his flaming wheel—have long been held to be imbued with solar symbolism.

But a more important constituent than the Vedic deity in the composite Viṣṇu of the historical period was the Epic hero Vāsudeva-Kṛṣṇa, a central character in the *Mahābhārata*, who eventually came to be identified as an incarnation of the Supreme Being. [3] Before the assimilation of Kṛṣṇa with Viṣṇu took place, however, there seems to have existed—at least as early as the second century B.C.—an independent cult of Kṛṣṇa worship known as Bhāgavatism, or the veneration of Vāsudeva-Kṛṣṇa, called *bhagavat,* or the "Blessed One." [4] Kṛṣṇa's literal role in the *Mahābhārata* is that of warrior-knight of the *kṣatriya,* or noble class. As a symbolic attribute of his potency as both hero and deity, Kṛṣṇa wields on the battlefield the fiery and formidable

1. J. Gonda, *Aspects of Early Viṣṇuism* (Utrecht, 1954), p. 96.

2. See A. A. Macdonell, *Vedic Mythology,* 2nd ed. (Varanasi, 1963), pp. 37ff. Macdonell remarks that according to a statistical standard of reckoning, Viṣṇu "would be a deity only of the fourth rank, for he is celebrated in not more than five whole hymns and in part of another, while his name occurs only about 100 times altogether in the RV." Although Macdonell infers that Viṣṇu "was originally conceived as the sun," it should be noted that evidence for Viṣṇu's solar character is ambiguous, and many scholars have questioned this interpretation.

3. See Hemachandra Raychaudhuri, *Materials for the Study of the Early History of the Vaishnava Sect* (Calcutta, 1920; 2nd ed. 1936); cf. also the recent study by Suvira Jaiswal, *The Origin and Development of Vaiṣṇavism* (Delhi, 1967).

4. See Ramaprasad Chanda, *Archaeology and Vaishnava Tradition,* Memoirs of the Archaeological Survey of India, No. 5 (Calcutta, 1920).

1

sudarśana-cakra, or "wheel-beauteous-to-behold." Because the flaming wheel of the deity was clearly regarded from the outset as an actual weapon, the view of some scholars that "the basic idea underlying the wheel in its association with Vāsudeva is solar" [5] and that "the wheel as a symbol par excellence of the god is undoubtedly one of the tangible connections with the Vedic Viṣṇu, an aspect of the sun," [6] is untenable. Furthermore, the militaristic connotations of the *cakra,* or discus, emblem continued for centuries, underlying even the recondite symbolism which it acquired during the medieval period. The complex character of Viṣṇu himself needs to be reassessed, not only against the broad background of Hindu mythology and religious history, but also within the specific crucible of the changing significance of the deity's attributes.

The present monograph attempts to clarify important aspects of the symbolism of Viṣṇu's chief attribute through a detailed investigation of the iconography of the *sudarśana-cakra* in its personified form. Part One contains a brief historical survey of references to the *cakra* as fabled weapon and esoteric symbol in Vedic, Epic, Purāṇic, and Tāntric literary sources, while Part Two outlines the iconographic development proper.

Personifications of Viṣṇu's discus first appear in Indian art around the beginning of the fifth century A.D., continuing into the eighteenth century and beyond. This long iconographic evolution has been divided into two sections, each covering a span of 700 or more years. The first section (fifth to twelfth century) deals with the two-armed *cakra-puruṣa* in attendance upon Viṣṇu; the second (thirteenth to eighteenth century) with the multi-armed cult images of the deified *sudarśana-puruṣa.* While two short articles have appeared dealing with the significance of the *cakra-puruṣa,* adequate attention has not yet been devoted to the medieval icons of the *sudarśana-puruṣa.*[7] Hence the present study is the first comprehensive exposition of the iconography of Viṣṇu's personified discus.

I would like to point out, however, that the monograph does not aim at being a definitive account of *cakra* symbolism—an impossible goal in any event, considering the great mass of literary and artistic material available for study. Rather, an attempt has been made to define broad patterns of meaning in the observable variations in both artistic form and symbolic content of a single iconographic motif traced through the course of almost three millenia. Not daring to attack the ponderous realm of Hindu iconography head-on, I have instead seized upon a small part of it, hoping that—through magnification—the part might reveal something of the scope and character of the whole. A few of my own highly tentative conclusions about the iconological implications of the historical development of Hindu mythology and religion are reflected in the broad period

5. Jitendra Nath Banerjea, *The Development of Hindu Iconography,* 2nd ed. (Calcutta, 1956), p. 145.

6. *Ibid.*

7. See C. Sivaramamurti, "The Weapons of Vishnu," *Artibus Asiae,* 18 (1955), 128–137; and R. C. Agrawala, "Cakra Purusa in Early Indian Art," *Bhāratīya Vidyā,* 24 (1964), 41–45. Publica-

tions containing brief references to the *sudarśana-puruṣa* will be cited below in Part Two. Although the terms *cakra-puruṣa* and *sudarśana-puruṣa* are actually synonymous, for the sake of convenience they have been applied in this study to the two-armed and multi-armed personifications respectively.

categories (Vedic, Epic, Purāṇic, and Tāntric) which I have devised as a framework for the discussion of literary references to the *sudarśana-cakra*. I trust that my colleagues in the field of Indology will be tolerant of the oversimplified periodization and partly intuited chronology. From my colleagues in the field of art history I also ask indulgence for my occasional use of somewhat controversial stylistic terminology in referring to major artistic periods; in a future study I hope to work out more extensively and defend properly my view on the problem of periodization in Indian art.

The Literary Tradition: The *Cakra* In Mythology And Tāntrism

I The *Cakra* as Fabled Weapon

Vedic Period (*ca.* 1200–600 B.C.)

A WEALTH OF CONCEPTS and connotations has accrued to the *cakra* from the earliest period of Indian civilization. The word apparently meant both discus and wheel to the Vedic Āryans, an ambiguity still current today.[8] The solar disk was referred to as a *cakra,* or a wheel like that of a chariot moving across the path of the sky.[9] In other connections, the wheel represented the majestic turning of the heavens themselves around the universal axis.[10] In later times, the *cakra* became associated with morality—being appropriated by the Buddhists as a symbol of *dharma*—and with Time and Death, which were likened to wheels that cannot be turned back.[11] Probably based on the analogy of the turning wheels of the chariots of heroic conquerors, the powerful ruler in the earthly sphere was aptly termed a *cakravartin,* or "turner of the wheel"—literally and figuratively a controller of destiny, of life and death.[12]

The *cakra* is now perhaps best known as the chief attribute of the Supreme Deity Viṣṇu, who is regarded as the Preserver of the Universe.[13] Partly because Viṣṇu in the *Ṛg Veda* is usually

8. See A. A. Macdonell and A. B. Keith, *Vedic Index,* 2 vols. (London, 1912), I, p. 252, entry under "Cakra." The Vedic wheel was provided with a rim (*pavi*), spokes (*ara*), and a nave (*nābhi*), the central opening of which is called *kha*; the wheel was fixed on to the chariot by means of an axle (*akṣa*), and fastened with an axle pin (*āṇi*). The Vedic *cakra* as weapon is discussed below.

9. Macdonell, *Vedic Mythology,* p. 31 and *passim.*

10. *Ibid.,* p. 62, where reference is made to *RV* 10.89.4, in which Indra is said to hold "asunder heaven and earth as two wheels are kept apart by the axle." For an imaginative study of the symbolism of the cosmic axis, see John O'Neill, *The Night of the Gods: An Enquiry into Cosmic and Cosmogonic Mythology and Symbolism,* 2 vols. (London, 1893–1897). See also Henri Gaidoz, *Le dieu gaulois du soleil et le symbolisme de la roue,* Étude de mythologie gauloise, Vol. 1 (Paris, 1886); and William Simpson, *The Buddhist Praying Wheel: A Collection of Material Bearing on the Symbolism of the Wheel and Circular Movements in Custom and Religious Ritual* (London, 1886).

11. For an exposition of the meaning of the Buddhist *dharma-cakra,* see V. S. Agrawala, *The Wheel Flag of India,*

Chakra-Dhvaja (Varanasi, 1964); for references to the *cakra* as the Wheel of Time, see below, Note 120.

12. See O. H. de A. Wijesekera, "The Symbolism of the Wheel in the Cakravartin Concept," in *Felicitation Volume Presented to Professor Sripad Krishna Belvalkar,* ed. A. S. Altekar (Benares, 1957), pp. 262–267. Wijesekera denies that the wheel of the *cakravartin* carries any solar connotation; he traces the origin of the concept back to the *Ṛg Veda,* where Indra is "the wielder or turner of a wheel of power and might, probably of *sovereignty.* . . . The solar aspect of the wheel seems to be a secondary development, a projection, so to say, of a figure of speech from the earthly to the celestial sphere" (p. 267). Instead of "turner of the wheel," the term *cakravartin* may mean "one who possesses or rules over a large circular territory."

13. This is the traditional medieval interpretation of Viṣṇu as the second member of the Hindu triad of Brahmā, Viṣṇu, and Śiva, the representative agents of the creation, preservation, and destruction of the universe. Actually, however, in the theistic cults of the two Supreme Deities Viṣṇu and Śiva, each is regarded as performing all three of these cosmic functions.

characterized as a solar deity, scholars have frequently transferred the traits of the Vedic deity to the Viṣṇu of the historical period:

The sun which sustains the universe was his [Viṣṇu's] chief emblem, and perhaps the original idea of the many-armed images which represented Vishnu was to suggest the all-pervading rays of the midday sun. His *chakra*, the Wheel of Life, which, like the Buddhist Wheel of the Law, seems to have been evolved from the swastika, symbolized not the sun itself but its apparent revolution around the earth.[14]

However, it seems more probable that the Preserver aspect of the historic Viṣṇu derives not from his presumed solar ramifications, but rather from his Epic and Purāṇic role as a divine warrior.[15] Furthermore, the interpretation of Vedic Viṣṇu as purely a solar deity seems open to question.[16] Viṣṇu is celebrated in the *Ṛg Veda* chiefly for his wide-ranging three strides, with which he paces off the universe—clearly demarcating the lowest and middle spheres from the highest realm to which he alone can attain.[17] While it is true that in a well-known passage Viṣṇu is associated with the solar year, with its cycle of four seasons of 90 days each—conceived as steeds which the deity sets in motion "like a revolving wheel" [18]—he is nowhere unequivocally equated with the sun.

Elsewhere in the *Ṛg Veda*, there are references to Viṣṇu in his association with the great deity Indra which suggest that his nature was also partly that of a warrior god.[19] For "although the Ṛgvedic Viṣṇu is not credited with warlike activities, he assists Indra in his encounters with demons, particularly with Vṛtra." [20] In these exploits Viṣṇu acts as the helper of Indra and is therefore subordinate to him.[21] Furthermore, it is Indra, and not Viṣṇu, who wields a *cakra* as one of the weapons which he uses to destroy Vṛtra and other demons.[22] Indra's chief weapon, of course, is the *vajra,* which is usually translated as "thunderbolt." [23] The *vajra* is specifically described as being made of metal (*ayasa*),[24] although it also is said to have been fashioned by

14. E. B. Havell, *The Ideals of Indian Art* (London, 1911), p. 73.

15. The iconographic function of Viṣṇu as divine preserver is analogous in the fourfold divisions of the Hindu caste structure to the *kṣatriya's* traditional role as upholder of the social order.

16. Gonda, for example, prefers to see Viṣṇu as an essentially non-Aryan fertility deity (*Aspects of Early Viṣṇuism*, pp. 11ff).

17. Macdonell, *Vedic Mythology*, pp. 37–39; cf. Gonda, *Aspects of Early Viṣṇuism*, pp. 55–72. Macdonell interprets "the three steps as the course of the solar deity through the three divisions of the universe" (p. 38). It is possible that the symbolism of the three strides has little to do with the sun; the myth instead appears to be cosmogonic in character, with Viṣṇu in the role of celestial architect of the triple structure of creation.

18. *RV* 1.155.6; cf. 1.164.11, 48 (cited in Macdonell, pp. 38–39).

19. For the relationship of Viṣṇu to Indra, see Gonda, *Aspects of Early Viṣṇuism*, pp. 28–32ff. Macdonell points out that "the most prominent secondary characteristic of Viṣṇu is his friendship with Indra, with whom he is frequently allied in the fight with Vṛtra" (*Vedic Mythology*, p. 39).

20. Sukumari Bhattacharji, *The Hindu Theogony* (Cambridge, 1970), p. 292. Indra in the *Ṛg Veda* is the chief warrior deity of the Āryans. Statistically, he appears to be the most important of all the Vedic deities; Macdonell remarks that Indra's "importance is indicated by the fact that about 250 hymns celebrate his greatness, more than those devoted to any other god and very nearly one-fourth of the total number of hymns in the RV" (*Vedic Mythology*, p. 54).

21. This relative hierarchy is partly retained in the *Mahābhārata*, although ultimately Indra relinquished pride of place to the Epic Viṣṇu.

22. See the important article by O. H. de A. Wijesekera, "Discoid Weapons in Ancient India, A Study of Vedic *Cakra, Pavi* and *Kṣurapavi*," *Adyar Library Bulletin*, 25 (1961), 250–261. The following discussion of the Vedic *cakra* as weapon is based upon the points made in Wijesekera's article.

23. See the discussion of Indra's *vajra* in Gonda, *Aspects of Early Viṣṇuism*, pp. 32ff. Gonda regards the *vajra* as a fertility symbol as well as "an offensive or destructive weapon of war" (p. 37).

24. *RV* 1.52.8, etc. (cited in Macdonell, *Vedic Mythology*, p. 55). The precise meaning of the term *ayasa* is uncertain; it can refer to iron and steel as well as bronze and copper. For a survey of the evidence for iron-working in the Vedic period, see M. N.

Tvaṣṭr from the bones of the mythical sage Dadhīca.[25] It is further described as being sharp, with either 100 or 1000 points.[26] As a weapon, the pronged *vajra* possesses certain characteristics in common with the wheel-like *cakra,* not the least of which is the Vedic and Epic stress on their military efficacy. It is significant that the term *cakra* occasionally appears to be used as a synonym for *vajra.*[27]

Even though references to the *cakra* as a weapon are infrequent in the *Ṛg Veda,* we may infer that it was in all probability a small metal disk with razor-sharp edges and a hole in the center to facilitate hurling it through the air.[28] An actual discoid weapon certainly seems to be implied in *Ṛg Veda* 8.96.9:

A sharpened weapon is the host of Maruts. Who, Indra, dares withstand thy bolt of thunder? Weaponless are the Asuras, the godless: scatter them with thy wheel [*cakra*], Impetuous Hero.[29]

(*tigmam āyudhaṃ marutām anīkaṃ kas ta indra prati vajraṃ dadharṣa anāyudhāso asurā adevāś cakreṇa tām apa vapa ṛjīṣin*)

In his commentary on this passage, the medieval Vedic exegete Sāyaṇa explains *cakra* as *cakrarūpeṇa vajreṇa* ("a *vajra* having the form of a *cakra*"), which "shows that he regarded it as a weapon of discoid shape but was doubtful as to its specific function as a club or projectile."[30] In *Ṛg Veda* 2.11.20, it is stated that Indra "hurled forth his *cakra* as the sun [sends his disk rolling], and, aided by the Aṅgirases, rent Vala" (*avartayat sūryo na cakraṃ bhinad valam indro aṅgirasvān*).[31] Here again, Sāyaṇa's commentary shows that he understands *cakra* in the sense of weapon.[32]

In contrast to the passages where the *cakra* is clearly a weapon, however, we should note that the word is frequently used as a metaphor for the sun, and that occasionally it is uncertain

Bannerjee, "Iron and Steel in the Ṛgvedic Age," *Indian Historical Quarterly,* 5 (1929), 432–440. The superior military power of the Aryans who invaded India is usually attributed to their use of weapons made of iron.

25. See John Dowson, *A Classical Dictionary of Hindu Mythology,* 7th ed. (London, 1950), s.v. "Vajra;" also Macdonell, *Vedic Mythology,* p. 55.

26. Macdonell, *op. cit.,* p. 55: "It is four-angled, hundred-angled, hundred-jointed, and thousand-pointed." Although the *vajra* sometimes appears in early Buddhist sculpture in the form of a club, it usually is depicted as a six-pointed prong; it should be noted that the epithet *ṣaṭ-kona,* "hexagram," or "six-angled device" is sometimes applied to the *vajra* (Dowson, *loc. cit.*).

27. *RV* 10.73.9 (cited in Wijesekera, "Discoid Weapons," p. 225).

28. Wijesekera suggests that the prototype of the metallic *cakra* may be "the stone discus as a primitive implement, surviving from the neolithic hunting cultures of the primitive Indo-European period" ("Discoid Weapons," p. 258). There is, however, no archaeological evidence in India to substantiate this hypothesis. As a parallel to Indian *cakra,* Wijesekera cites the

Greek *dískos,* which may originally have been used as a projectile weapon (p. 259).

29. Translated in R. T. H. Griffith, *Hymns of the Ṛgveda,* Chowkhamba Sanskrit Studies, Vol. 35 (Varanasi, 1963), II, 245. Griffith comments that *cakra* here refers to "a sharp-edged quoit used as a weapon of war."

30. Wijesekera, "Discoid Weapons," p. 254.

31. *Ibid.*

32. *Ibid.,* p. 255: "Sāyaṇa's explanation is as before: 'whirled his *vajra* for the slaughter of the Asuras' (*asurahananārtham vajram abhrāmayat*)." In addition to the *cakra,* Wijesekera (pp. 260–264) cites the terms *pavi* ("rim") and *kṣurapavi* ("sharp rim") as probably referring to discoid weapons, although the usual meaning is "metallic rim or band" around the outer perimeter of a wheel. Thus in *RV* 6.8.5, Agni is requested to "cut down the wicked (foe) as it were, with the *pavi,* like a tree with the sharp edge (of an axe)" (p. 261). The term *pavi* in this passage has been translated as "sharpened bolt" (Griffith) and "iron weapon" (Geldner). According to Wijesekera, in the passages where the term *kṣurapavi* occurs, it most probably implies a "weapon of the shape of a flattish metal ring with its outer edge as sharp as a razor blade" (p. 264).

whether Indra is to be understood as hurling a weapon like the sun or the actual sun itself. Certain passages describe him as having "hurled at his enemies the solar disk, tearing off or plundering it from the sun."[33] In *Ṛg Veda* 1.174.5, for example, we read: "Let [Indra] tear the sun's disk off in the onslaught, let the thunderbolt-armed one go forth to meet his rivals" (*pra suraś cakraṃ bṛhatād abhīke abhi spṛdho yāsiṣad vajrabāhuḥ*).[34] When we consider that Indra's role in the *Ṛg Veda*—in addition to his exalted position as the Āryan lord of battle—is primarily that of an atmospheric and thunder deity, it is not surprising to find a close correlation between natural phenomena and the deity's mythical exploits. The Vedic poet's fascination with allusions to the sun in the form of similes and metaphors also continues into later periods of religious literature;[35] but despite a certain amount of semantic ambiguity, it seems reasonably certain that the *cakra* was actually used as a discoid weapon by the Vedic Āryans, even though it was apparently a far less important part of their military arsenal than the *vajra* and certain other weapons which are glorified in the *Ṛg Veda*.[36] In one hymn, for example, "the arrow is adored as divine and is besought to grant protection and to attack the foe"—thus providing a precedent for the near deification of the weapons of the *kṣatriya* hero which we later find in the *Mahābhārata*.[37]

Although the Vedic Viṣṇu is associated with Indra in the performance of several of the latter's adventures, he himself has no connection in the text with the *cakra* as weapon. This seems strange in view of the fact that in the Epic period the *cakra* is Viṣṇu's most distinctive attribute, and the hallmark of his new role as the paramount warrior deity, a position which he gradually usurped from Indra. The literary works intervening between the *Ṛg Veda* and the *Mahābhārata*— the *Brāhmaṇas*, *Upaniṣads*, and *Sūtras*—shed little light on how this transformation was effected. For the most part, these texts thrust mythology into the background, except where it specifically pertained to the orthodox sacrificial religion or the new cults of yogic introspection.[38] The *Brāhmaṇas* ignore Viṣṇu's associations with the warrior deity Indra and connect him instead with the ritual sacrifice, which had by that time superseded in importance the very deities it had originally been designed to celebrate.[39] As a result of his symbolic connection with the Sacrifice, Viṣṇu came to be regarded in the *Brāhmaṇas* as the "highest god"—although this designation may have been meant literally, as a reference to the third and highest step of the deity.[40] The

33. Wijesekera, p. 256.

34. *Ibid.,* p. 257.

35. Wijesekera believes that the *cakra* and other implements of war may have been heated, since in *RV* 2.34.9, it is described as "glowing" (p. 254). If the *cakra* was actually used in the Vedic period as a fiery weapon, this would help to explain its metaphorical association with the sun (see below, Note 52 for a Purāṇic reference to the *cakra* being smeared with oil—presumably to be ignited).

36. Macdonell mentions that "the whole of RV. 6, 75 is devoted to the praise of various implements of war, armour, bow, quiver, and arrows" (*Vedic Mythology*, p. 155).

37. *Ibid.*

38. Since these texts document only the religious thinking of the intelligentsia, it is possible that the warrior aspect of Viṣṇu's nature continued to develop in the popular religion.

39. Bhattacharji, *The Indian Theogony*, p. 292.

40. In *Aitareya Brāhmaṇa* 1.1, "Viṣṇu as the locally highest of the gods is contrasted with Agni the lowest, all the other deities being placed between them" (Macdonell, *Vedic Mythology*, pp. 41–42). See also Julius Eggeling, trans., *Śatapatha Brāhmaṇa*, Sacred Books of the East, Vols. 12, 26, 41, 43, 44 (London, 1879-1910). In *ŚB* 3.7.1 (18) it is said that "The wise ever behold that highest step of Vishnu, fixed like an eye in the heaven." The doorway leading to Viṣṇu's abode is sometimes said to be the sun, through which the souls of the departed pass.

Śatapatha Brāhmaṇa, one of the oldest works in this category, "tells a myth of how Viṣṇu, the sacrifice, by first comprehending the issue of the sacrifice, became the most eminent of the gods." [41] Elsewhere the same text states that "then the gods by sacrificing with Viṣṇu, who was equal in size to the sacrifice, gained the whole earth." [42] In the *Śatapatha Brāhmaṇa* we also find the earliest reference to the cosmic being Nārāyaṇa, another of the divine constituents of the composite Viṣṇu of the historical period.[43] Like Viṣṇu in the *Brāhmaṇas,* Nārāyaṇa is primarily associated with the Sacrifice. According to the text, Nārāyaṇa "thrice offered sacrifice at the instance of Prajāpati," and on one occasion "is said to have performed a *pañcarātra-sattra* (sacrifice continued for five days) and thereby obtained superiority over all beings and 'became all beings.' " [44]

In the *Brāhmaṇas* both Viṣṇu and Nārāyaṇa are far from being personalized divinities; they are rather embodiments of sacerdotal concepts of the metaphysical significance and religious supremacy of the Sacrifice. Although these speculative notions undoubtedly contributed to Viṣṇu's rise to the position of Supreme Deity, the emergence, in the Epic period, of the monotheistic cult of the deified tribal hero Vāsudeva-Kṛṣṇa was probably far more crucial.[45] In the *Mahābhārata,* as will be pointed out below, both Kṛṣṇa and his divine counterpart Viṣṇu were elevated to exalted rank largely as a result of their gradual appropriation of the legendary powers of Indra. In this transformation, Viṣṇu's association with the Sacrifice in the period of the *Brāhmaṇas* was less important than his newly acquired military prowess—symbolized by his distinctive weapons and heroic exploits.[46]

Epic Period (*ca.* 400 B.C.-400 A.D.)

The *sudarśana-cakra* is praised in the *Mahābhārata* (5.53.12) as "the foremost of all discoid weapons" (*varam . . . cakrāṇāṁ ca sudarśanam*) and, by implication, of all other weapons as

According to the *Jaiminīya-Upaniṣad-Brāhmaṇa* (1.3.5), "one escapes through the midst of the sun, which is a fissure in the sky; as is the (axle-) hole of a cart or of a chariot, even so is this fissure in the sky" (translated in Gonda, *Aspects of Early Viṣṇuism,* p. 94). It is interesting to note that both sun and wheel metaphors are here employed in conjunction.

41. Macdonell, *Vedic Mythology,* p. 41; see *SB* 14.1.1, translated in Eggeling, *Śatapatha Brāhmaṇa,* Vol. 5, p. 442. However, after Viṣṇu had attained to the position of supremacy, "his head, by his bow starting asunder, was cut off and became the sun (*āditya*). To this story [*Taittirīya Āraṇyaka* 5.1.1-7] adds the trait that the Aśvins as physicians replaced the head of the sacrifice and that the gods now able to offer it in its complete form conquered heaven" (Macdonell, *ibid.*).

42. Macdonell, p. 41. This is an early version of the *Vāmana* myth, which here has obvious cosmogonic connotations; later versions stress the notion of universal conquest.

43. Raychaudhuri, *Early History of the Vaishnava Sect,* p. 65. Originally Viṣṇu and Nārāyaṇa were completely distinct deities;

by the time of the *Mahābhārata,* however, they had virtually merged into each other, sharing each other's traits and personality.

44. D. C. Sircar, in *The Age of Imperial Unity,* ed. R. C. Majumdar, The History and Culture of the Indian People, Vol. 2 (Bombay, 1951), p. 435. The adjective *pañcarātra* ("five-night") qualifying *sattra* (sacrificial "session") may be the origin of the designation Pāñcarātra applied to the early Vaiṣṇava faith; see below, note 85. However, Sircar also notes that in the *Śatapatha Brāhmaṇa,* "Nārāyaṇa is not identified with Vishnu or any of the *ādityas*" (*ibid.*).

45. See Sircar, pp. 431-440; and especially Raychaudhuri, *Early History of the Vaishnava Sect,* pp. 55-70 and *passim.*

46. Although in the *Śatapatha Brāhmaṇa* passage cited above (Note 41) Nārāyaṇa is said to have a bow, there is otherwise no indication that either he or the Viṣṇu of the *Brāhmaṇas* possesses military traits in common with the Epic deity; as has already been suggested above, the traits of Viṣṇu in the *Mahābhārata,* including his fabulous weapons, seem to be a direct inheritance from his rival Indra.

well.[47] The *cakra* probably formed part of the arsenal of weapons carried into battle by most Epic warriors, but the *sudarśana-cakra* is specifically identified as the chief weapon-attribute of Vāsudeva-Kṛṣṇa and of the divine being Viṣṇu. Although the *cakra* is characterized with typical Epic hyperbole as a "fiery wheel with a thousand spokes,"[48] it seems clear that at the core of the poetical exaggerations is an actual discoid weapon. In one passage (1.29.2), the *cakra* is described less figuratively as a "sharp-rimmed metal [*ayasmaya*] disk" which is cast through the air by "whirling it rapidly" (*cakraṃ . . . paribhramantamaniśaṃ tīkṣṇadhārayasmayam*).[49] And in another passage (6.55.86), Kṛṣṇa is described as "whirling with his [right] arm his discus of beautiful nave and edge sharp as a razor, effulgent as the sun" (*sunābhaṃ vasudevaputraḥ sūryaprabhaṃ . . . kṣurantamudyamya bhujena cakraṃ*).[50]

The phrase "effulgent as the sun" (*sūryaprabham*) calls to mind the earlier metaphorical association of the *cakra* with the sun occurring in the *Ṛg Veda*, an association which obviously appealed to the poetical imagination of the Epic authors. In another *Mahābhārata* passage, the metaphor is made more explicit (3.23.32):

And rising into the sky, it seemed like a second sun of exceeding effulgence at the end of the *Yuga*.[51]

(*rūpaṃ sudarśanasyāsīdākāśe patatastadā dvitīyasyeva sūryasya yugānte pariviṣyataḥ*)

However, the *carka* is described merely as being like the sun; there is no suggestion that it actually represents the sun. The poetic image of the dazzling radiance of the metal discus was probably suggested by the practice of hurling it through the air, where it could reflect the brilliant rays of the sun. Since the *cakra* is referred to in the mythological compendium the *Matsya Purāṇa* as "a wheel with eight spokes and besmeared with oil," it appears that the discus could also have served as an incendiary weapon—assuming of course that the oil was to be set on fire and not merely used to facilitate hurling.[52] The assumption that the *cakra* was a much-used weapon in ancient India is further substantiated by a reference to the Indian *cakra* in the annals of the Sui Dynasty (589–617 A.D.), where it is described as a "disk of the size of a Chinese mirror, with a

47. References to the *Mahābhārata* will be cited from the critical text published by the Bhandarkar Oriental Research Institute, and edited by V. S. Sukthankar *et al.* (Poona, 1927–1966); the translations for the most part are taken from P. C. Roy, trans., *The Mahābhārata of Krishna-Dwaipāyana Vyāsa* (Calcutta, 1884–1896). See also S. Sørenson, *An Index to the Names in the Mahābhārata*, 2 vols. (London, 1904), s.v. "Sudarśana" (it should be noted that the numbering of chapters and verses in the critical edition differs from Roy's translation and Sørenson's *Index*). Roy's translation of the passage 5.53.13 (*Udyogaparvan*, LIII, p. 194) gives "foremost of all weapons"—reading *āyudhānāṃ* instead of *cakrāṇāṃ ca*. The former reading, however, is found in only about one-fourth of the manuscripts collated for the critical edition.

48. E. Washburn Hopkins, *Epic Mythology*, 2nd ed. (Varanasi, 1968), p. 206.

49. Reference cited in Wijesekera, "Discoid Weapons," p. 252. For further information about technical aspects of metalworking in ancient India, see Note 24 above.

50. Roy's rendition of *udyamya* as "whirling" is a free translation, since the word literally means "lifted up" (*Bhīṣma-parvan*, LIX, p. 222).

51. Roy, *Vanaparvan*, III, p. 66. That the *cakra* seemed like a "second" sun obviously implies that it is not the sun itself, although its fiery properties are metaphorically allied to those of the solar disk.

52. Quoted in P. C. Chakravarti, *The Art of War in Ancient India*, Dacca University Bulletin, 21 (1941), 172.

central perforation and the outer rim jagged like a saw; when thrown at a man from afar, he will surely be hit."[53]

In the *Mahābhārata* passage which relates how Kṛṣṇa received the *sudarśana-cakra* as a gift from Agni, the Vedic deity of fire, the *cakra* is explicitly described as an actual weapon (1.216.21):

And Pāvaka [Agni] then gave unto Krishna a discus with an iron stick attached to a hole in the centre [*vajranābha*]. And it was a fiery weapon and became his favorite.[54]

(*vajranābham tataścakram dadau kṛṣṇaya pāvakaḥ āgneyam astram dayitam sa ca kalyo 'bhavattadā*)

There is much speculation about whether the term *vajranābha* is to be translated literally or figuratively.[55] The literal translation would be "with a hard, or adamantine nave," while the figurative meaning of the compound may be something like "in the navel (centre) of which is the 'lightning-bolt' "[56] or—even more poetically—"with a nave like thunder."[57] The *cakra* may in fact have been hurled through the air by means of a stick or metal rod inserted into a central aperture. However, representations of the discus in Indian sculpture most frequently show it being held vertically by the rim, although occasionally it is depicted in a horizontal position with the index finger inserted through a hole in the center.[58] Even more rarely, the discus resembles a lotus which is held by a stalk—a mode of representation which was perhaps inspired by *Mahābhārata* imagery (6.55.89):

And that lotus of a discus called *Sudarśana*, having for its stalk the beautiful arm of Caurin [Kṛṣṇa], looked as beautiful as the primeval lotus, bright as the morning sun, which sprang from the navel of Nārāyaṇa.[59]

(*sudarśanam cāsya rarāja śaurestaccakrapadmam subhujorunālam yathādipadmam tarunārkavarṇam rarāja nārāyananabhijātam*)

Despite some poetical ambiguity with respect to the appearance of the *sudarśana-cakra*, all textual references uniformly place great emphasis upon its fabled destructive power. As a weapon, it was capable of immolating vast hordes of demons and laying waste even entire cities with its sharp cutting edge and tremendous blazing heat.[60] A further remarkable characteristic of the Epic

53. Berthold Laufer, *Archaic Chinese Jades* (New York, 1927), p. 27. Wijesekera mentions that the *Śiśupālavadha* of Māgha (18.45) describes the *cakra* "as a weapon which is hurled from a distance and cuts off the limbs of the enemy" ("Discoid Weapons," p. 252).

54. Roy, *Adiparvan*, CCXXV, p. 625.

55. See Gonda, *Aspects of Early Viṣṇuism*, p. 98.

56. *Ibid.* This is Gonda's own translation, which reflects his attempts to connect Viṣṇu with fertility cults. Thus he says, "In view of the importance of the *vajra-* and *nābhi-*concepts in ancient Indian thought this term, then, would be highly significant: the navel (place of origin, birthplace) or place of contact with life and higher powers contains the *vajra-*, the bolt instrument in fertilizing and in promoting life."

57. From M. N. Dutt's translation of the *Mahābhārata*, *Karṇaparvan*, LXXVI, 32 (quoted in Gonda, p. 98).

58. The steel *cakras* which were used by Sikh warriors until fairly recent times seem to have been hurled in this manner. Gaidoz remarks that "aujourd'hui encore les montagnards afghans se servent de cette arme qui, maniee par une main habile, peut porter des coups mortel" (*Le dieu gaulois du soleil*, p. 11). Cf. also Jeannine Auboyer, "Quelques réflexions à propos du cakra, arme offensive," *Arts Asiatiques*, 11 (1965), 119–130.

59. Roy, *Bhīṣmaparvan*, LIX, p. 222. In some later Pāla- and Sena-period sculptures, the *cakra* and other weapon-attributes are actually carried on the tops of lotus stalks held in the hands of Viṣṇu.

60. Despite the hyperbole, the numerous exploits performed by both Viṣṇu and Kṛṣṇa clearly imply that the *cakra* burns as well as cuts the enemy, reinforcing the suggestion made above that it may have been used as an incendiary weapon.

cakra is its ability, as Agni informs Kṛṣṇa (1.216.24), to "irresistibly slay the enemy and again come back into thy hands" (*śatruṣu/ hatvāpratihataṃ saṃkhye pāṇimeṣyati te punaḥ//*).[61] The fact that the *cakra* returns to the hand of the user should be taken only as a magical quality ascribed to it and not as a point of similarity to some sort of boomerang.[62] In the following passage, the *cakra* materializes in response to a mere thought of Viṣṇu, and then proceeds to destroy demons with such ferocious glee as to suggest that the poet has conceived of the discus as having anthropomorphic characteristics, thereby paving the way toward actual personification (1.17.18–22):

And Nārāyaṇa seeing the celestial bow in the hand of Nara, called to mind his own weapon, the Dānava-destroying discus. And lo! the discus, *Sudarśana*, destroyer of enemies, like to Agni in effulgence, and dreadful in battle, came from the sky as soon as thought of. And when it came, Achyuta [Viṣṇu] of fierce energy, of arms like the trunk of an elephant, hurled with great force that. weapon, effulgent as blazing fire, dreadful, and of extraordinary lustre, and capable of destroying hostile towns. And that discus that consumeth all things at the end of time, hurled with force from the hands of Nārāyaṇa, and falling constantly everywhere, destroyed the Daityas and Dānavas by thousands. Sometimes it blazed like fire and consumed them all; sometimes it struck them down as it coursed through the sky; and sometimes, falling on the Earth, it drank their life-blood like a goblin.[63]

The tendency to personify objects, natural phenomena, and even abstract concepts is as widespread in the Epics as it is in the *Ṛg Veda*.[64] Since the weapons of even the ordinary Epic warrior were among his most highly prized possessions, it is hardly surprising that those of the legendary hero were regarded with reverential awe. The chief weapons of Kṛṣṇa were all given special names, thus assigning a separate identity to them and setting them apart from the similar weapons of all other warriors.[65] That even ordinary weapons were regarded as having an inherent magical power is demonstrated by the injunction in the *Mahābhārata* (12.160.85) that "wise warriors should always worship their swords" (*aseśca pūjā kartavya sadā yuddhaviśāradaiḥ*).[66] According to the *Rāmāyaṇa* (3.46.16), all weapons theoretically have an actual personified form (*tathā'yudhāni te sarve yayuḥ puruṣavigrāḥ*)—a logical outgrowth of the poetical device of metaphorically ascribing human characteristics to them.[67]

61. Roy, *Ādiparvan*, CCXXV, p. 625.

62. That the *cakra* actually possessed the properties of a boomerang is a theory put forward by D. R. Patil, *Cultural History from the Vāyu Purāna* (Poona, 1946), p. 227.

63. Roy, *Ādiparvan*, XIX, pp. 82, 83.

64. Cf. Macdonell, *Vedic Mythology*, pp. 2, 115ff, 147ff; Hopkins, *Epic Mythology*, p. 53 and *passim*. However, with regard to abstract deities like Desire, etc., the Epic is far more prolific. As Hopkins states, "there is no limit to a pantheon where hope, hell, and hunger, cows and corn, the west and wisdom, etc. are all called gods."

65. In addition to Sudarśana, the names of the other weapons of Kṛṣṇa are: Śārṅga, the bow (*dhanus*); Kaumodakī, the mace (*gadā*); Nandaka, the sword (*khadga*); and Pāñcajanya, the conch (*śaṅkha*)—the latter used for signaling on the battlefield. A European parallel which comes immediately to mind is King Arthur's legendary sword Excalibur.

66. Hopkins remarks that in this verse "the Sikh's pūjā of the sword is anticipated" (*Epic Mythology*, p. 54).

67. Quoted by Hopkins (*loc. cit.*), who states that the passage shows that "neuter words are thus made masculine by implication, as when the personified weapons (neuter) appear to sight as masculines." As will be pointed out in Part Two, the sex of the personification of each particular weapon depends upon the gender of the Sanskrit word for that weapon. In actuality, however, the personifications of *cakra* (which is neuter) appear as youthful or dwarfish male figures.

The attitude in the *Mahābhārata* toward weapons in general and toward the weapons of Kṛṣṇa in particular reinforces the theory that Vāsudeva was originally an actual person who came to be euhemeristically raised to the level of divinity as a result of his legendary exploits.[68] The deification of Vāsudeva-Kṛṣṇa is seen at several stages of development in the Epic.[69] Kṛṣṇa himself at one point denies having any supernatural power, and maintains that he "was unable at any time to perform a divine act." [70] It is significant that the majority of his legendary feats are attributed to the magical power of his weapons, the *cakra* and *gadā,* both of which were presented to him by deities of the Vedic pantheon.[71] As Agni says to Kṛṣṇa, when presenting him with the *sudarśana-cakra* (1.216.22): "With this, O slayer of [the demon] Madhu, thou shalt be able without doubt to vanquish in battle even foes that are not human" (*abravītpāvakaścainametena madhusūdana/ amānuṣānapi raṇe vijeṣyasi na saṃśayaḥ//*).[72] The essential point is that a divine origin appears to have been ascribed to Kṛṣṇa's weapons before Kṛṣṇa himself came to be deified.

On the basis of the fragmentary and controversial accounts of Indian religions provided by Megasthenes, who was a Greek ambassador at the court of Candragupta Maurya, it has been suggested that a cult of Kṛṣṇa was well established in the region of Mathura by about 300 B.C.[73] The epithet *bhagavat,* or "blessed one," came to be applied to Kṛṣṇa; hence the origin of the term Bhāgavatism which characterizes the form of the Vaiṣṇava sect that evolved in the early historical period. Beginning as a local tribal religion, Kṛṣṇa worship became syncretistically blended with the cult of Vedic Viṣṇu and the cosmic being Nārāyaṇa, who, as mentioned above, are speculatively associated in the *Brāhmaṇas* with the personified Sacrifice.[74] At what point in the

68. For persuasive arguments in favor of the euhemeristic interpretation of Kṛṣṇa, see Raychaudhuri, *Early History of the Vaishnava Sect,* p. 35 and *passim;* also D. C. Sircar, in *The Age of Imperial Unity,* p. 432, where he states that "the historical character of Vāsudeva . . . need not be doubted." Thus the weapons of Kṛṣṇa were originally the actual weapons of an actual hero before the hero and his weapons came to be deified.

69. Hopkins points out that different stages in the process of Kṛṣṇa's deification occasionally exist side by side in the same passage; as when Mārkaṇḍeya, after explaining the cosmic slumber of Viṣṇu, adds, "Now I remember, this supreme god is your relative here, called Govinda and Janārdana" (*Epic Mythology,* p. 213). Hopkins also observes that while the Epic clearly equates Kṛṣṇa with the god Viṣṇu, Kṛṣṇa's divinity does not go unchallenged. Some sort of theological dispute seems to be implied by the statement in the *Mahābhārata:* "Foolish is he who says that Vāsudeva is only a man" (quoted in Hopkins, p. 215).

70. *Ibid.* Kṛṣṇa adds however, "that he would do what he could as a man . . . that is, he could not interfere with the will of the gods."

71. The *sudarśana-cakra* was presented by Agni; the *gadā* by Varuṇa (*Mbh.*1.216.21–25). Hopkins remarks (p. 215) that Kṛṣṇa's acts "suggest, as do his gifts from the gods, that he was a man."

72. Roy, *Ādiparvan,* CCXXV, p. 625. Elsewhere in the text, however, Kṛṣṇa bemoans that even with his discus, he himself, leave aside Arjuna, would have been unable to slay Karṇa "if Karṇa had not thrown away Indra's spear" (Hopkins, p. 215).

73. Sircar (in *Age of Imperial Unity,* p. 432) asserts: "But that Vāsudeva was the object of such devotion, at least as early as the fourth century B.C. is proved by the statement of Megasthenes that the Souraseni, i.e., the people of the Mathurā region, held Herakles in special honour; for there is no doubt that Herakles was the Greek analogue of Vāsudeva-Kṛṣṇa." For an opposing view, see Allan Dahlquist, *Megasthenes and Indian Religion* (Uppsala, 1962). Dahlquist identifies Herakles not with Kṛṣṇa, but with his archrival Indra, thereby suggesting that Indra still held the upper hand as late as about 300 B.C. However, few scholars accept this ingenious hypothesis.

74. Mythologically Nārāyaṇa is described as a divine sage who, along with his less-exalted counterpart Nara, attained supreme power through the performance of ritual austerities. The Pāṇḍava hero Arjuna came to be identified with Nara, while Kṛṣṇa himself was considered to be an emanation of Nārāyaṇa. In the *Mahābhārata,* Viṣṇu—the transformed "highest god" of the *Brāhmaṇas*—is equated with the cosmic being Nārāyaṇa; in fact, as Hopkins points out (p. 204), "the epic in general is an apologia for Viṣṇu as Nārāyaṇa . . . either incorporate in Kṛṣṇa or as an independent superior god." Later in the *Purāṇas* the assimilative process is reversed, and the composite Nara-Nārāyaṇa is said to be one of the *avatāras* of Viṣṇu.

historical development of the Vaiṣṇava sect this assimilation occurred is uncertain, but the identification of Kṛṣṇa as the Supreme Deity seems to have been first formulated as a religious dogma in the *Bhagavad Gītā*.[75] The *Gītā* is, however, regarded as an interpolation in the original narrative stratum of the Epic. The rudimentary basis of the later concept of the *avatāras,* or periodic "descents" of the deity into the terrestrial sphere, is found in the *Gītā*,[76] although it is uncertain whether we may infer from the text that Kṛṣṇa has already been actually identified as an incarnation of Viṣṇu.[77] That the cult of Kṛṣṇa as the All-God was not widespread at the time of the composition of the *Gītā* is indicated by the lines (*BhG* 7.18): "Who thinks 'Vāsudeva (Kṛṣṇa) is all,'/ That noble soul is hard to find" (*vāsudevaḥ sarvam iti sa mahātmā sudurlabhaḥ*).[78] However, the text implies the existence of a fully developed cult, with *pūjā* being performed to the deity, who is regarded as being pantheistically present in the essence of all modes of existence.[79]

In Chapter 10, Kṛṣṇa maintains that he epitomizes the quality of excellence in everything, saying (*BhG* 10.21): "Of the Ādityas I am Viṣṇu, of lights the radiant sun" (*ādityānāmaham viṣṇurjyotiṣāṃ raviraṃśumān*).[80] Surprisingly, Kṛṣṇa further states (*BhG* 10.28): "Of weapons I am (Indra's) *vajra*" (*āyudhānāmaham vajram*).[81] That the most excellent of all weapons is the *vajra* of Indra and not Kṛṣṇa's own *sudarśana-cakra* suggests that the Vedic deity may have still enjoyed a certain measure of prestige at the time the *Gītā* was composed.[82] In Chapter 11, Kṛṣṇa reveals himself to Arjuna in his All-form, an awesome theophany which seems to anticipate the later iconographic conception of the multi-armed images of the *sudarśana-puruṣa*. Arjuna is dazzled by this wondrous and terrible vision of the theriomorphic, thousand-armed deity, whom he describes (*BhG* 11.17) as "burning this whole universe with Thy radiance" (*svatejasā viśvam idam tapantam*).[83] After viewing the deity's All-form, Arjuna apologizes for having forgotten that

75. See Franklin Edgerton, *The Bhagavad Gītā*, Harvard Oriental Series, Vols. 38, 39 (Cambridge, 1944). Although the *Gītā* forms part of the *Bhīṣmaparvan* of the Epic, it is usually printed as a separate work; the eighteen chapters of the text correspond to *Mahābhārata* 6.23–40.

76. See especially Chapter 4, vv. 7, 8 (Edgerton, *Bhagavad Gītā*, Vol. 1, p. 43):

For whenever of the right
 A languishing appears, son of Bharata,
A rising up of unright,
 Then I send myself forth.

For protection of the good
 And for destruction of evil-doers
To make a firm footing for the right,
 I come into being in age after age.

77. See Edgerton, *op. cit.,* Vol. 2, pp. 30–33. Edgerton believes that the text does identify Kṛṣṇa with Viṣṇu (in *BhG* 10.24,30).

78. *Ibid.,* Vol. 1, p. 77.

79. Ritual offerings are implied in the phrase "A leaf, a flower, a fruit, or water/ Who presents to me with devotion. . . ." (*BhG* 9.26; Edgerton, vol. 1, p. 93).

80. Edgerton, Vol. 1, p. 101. In 10.37, Kṛṣṇa says: "Of the Vṛṣṇi-clansmen I am Vāsudeva/ Of the sons of Pāṇḍu, Dhanaṃjaya (Arjuna)" (*ibid.,* p. 105).

81. *Ibid.,* p. 103.

82. Reference has already been made to Kṛṣṇa's tacit admission that the weapons of Indra are superior to his own (Note 72 above). It is possible, however, that Indra's *vajra* continued to be regarded as the foremost weapon, long after the prestige of the deity himself had waned.

83. Edgerton, Vol. 1, p. 111. Kṛṣṇa explains that the fiery radiance of the All-form is a manifestation of the destructiveness of Time itself. As we shall see in Part Two of this study, the iconography of the multi-armed images of Sudarśana is also partly based on the metaphorical concept of Time the destroyer.

Kṛṣṇa is no ordinary mortal; although Kṛṣṇa, in fact, appears in human guise throughout the greater part of the Epic.[84]

The early Bhāgavata faith developed—perhaps at about the beginning of the Christian era—a doctrine of the quadripartite nature of Kṛṣṇa called *catur-vyūha,* which literally means four "formations" or "emanations" of the deity.[85] It is perhaps significant that an original or primary meaning of the word *vyūha* may have been "battle formation," or a grouping of warriors into a particular arrangement for strategic purposes.[86] The four emanations of the deity include:[87]

VĀSUDEVA-KṚṢṆA: son of Vasudeva of the *kṣatriya* clan of the Yādavas, cousin of the Pāṇḍavas, and scion of the Vṛṣṇi tribe situated in the region of Mathura

SAṄKARṢAṆA (or Balarāma): elder half-brother of Kṛṣṇa

PRADYUMNA: son of Kṛṣṇa by Rukmiṇī

ANIRUDDHA: son of Pradyumna

Originally Śāmba, the son of Kṛṣṇa by Jāmbavatī, seems to have been a fifth member of this composite group of deified heroes.[88] These five are undoubtedly referred to in the Mora

84. *BhG* 11.41. Arjuna then requests Kṛṣṇa to appear again in his normal form (*BhG* 11.46; Edgerton, Vol. 1, p. 119):

> Wearing the diadem, carrying the club, with disc in hand,
> Just (as before) I desire to see Thee;
> In that same four-armed shape
> Present Thyself, O Thousand-armed One, of universal form!
>
> (*kirītinam gadinam cakrahastam
> icchāmi tvam drustumaham tathaiva
> tenaiva rūpena caturbhujena
> sahasrabāho bhava viśvamūrte*)

That Kṛṣṇa's "normal" form is here described as four-armed substantiates the view that the *Gītā* is a later interpolation in the text; in any event, it is probably not earlier than the first century B.C. The earliest known image with four arms which seems to have Vaiṣṇava affiliations dates to the late first century B.C. (see below, Note 186).

85. The tenets of the Bhāgavata faith, or Bhāgavatism (also referred to by the terms Sātvata, Ekāntika, and Pāñcarātra), appear to have been first expounded in the so-called Nārāyaṇīya section of the *Śāntiparvan* (*Mbh.* 12.321ff). This section, however, is regarded by many scholars as being apocryphal; in any case, it probably belongs to a very late period of the Epic. The doctrines of the Bhāgavata faith are in part an extension of the *Bhagavad Gītā.* See R. G. Bhandarkar, *Vaiṣṇavism, Śaivism and Minor Religious Systems,* 2nd ed. (Varanasi, 1965), pp. 4ff; also see Raychaudhuri, *Early History of the Vaishnava Sect,* pp. 12, 13, and *passim.* For the later esoteric theology of the Bhāgavata or Pāñcarātra sect, see F. Otto Schrader, *Introduction to the Pāñcarātra and the Ahirbudhnya-Saṃhitā* (Madras, 1916).

86. The use of the word *vyūha* as a theological term would

seem to reinforce the euhemeristic interpretation of Kṛṣṇa's rise to divinity since it literally denotes deployment of forces or men—in this case the four Epic heroes themselves.

87. According to the pseudophilosophical interpretation of the *catur-vyūha* doctrine in the Nārāyaṇīya section of the Epic, "Vāsudeva was the highest Being, and was the inner soul of all beings, Saṃkarṣaṇa was the *jīva,* Pradyumna the *manas,* and Aniruddha the *ahamkāra*" (*Mahābhārata,* Vol. 16, "Introduction" to the *Śāntiparvan,* pp. ccxxviii, ccxxix). Cf. Schrader, *Introduction to the Pāñcarātra,* p. 39, where he points out that although this interpretation of the *vyūhas* gradually disappears from the later Pāñcarātra literature, the *vyūhas* continue to be related to the process of secondary creation. Primary creation stems entirely from Vāsudeva, who came to be regarded as the Supreme Deity and the noumenal support of the entire universe. The fully developed Pāñcarātra theology attributed to the deity six *guṇas,* or essential characteristics (Schrader, pp. 32, 33):

1. *jñāna,* or "knowledge"
2. *aiśvarya,* or "lordship"
3. *śakti,* or "potency"
4. *bala,* or "strength"
5. *vīrya,* or "virility"
6. *tejas,* or "splendor"

Schrader points out that "in their totality, the Guṇas make up the body of Vāsudeva" (p. 34); while the three other *vyūhas* partake of only two *guṇas* each. Thus the divine nature of Saṅkarṣaṇa is composed of *jñāna* and *bala;* Pradyumna of *aiśvarya* and *vīrya;* and Aniruddha of *śakti* and *tejas.*

88. See J. N. Banerjea, "Images of Śāmba," *Journal of the Indian Society of Oriental Art,* 12 (1944), 129–134; also see his *Development of Hindu Iconography,* 2nd ed. (Calcutta, 1956), pp.

inscription of the time of Mahākṣatrapa Rājuvula in the early first century A.D.[89] The inscription records the dedication of images of the *pañcavīra,* or five heroes, who may originally have been accorded separate as well as collective veneration.[90] When Kṛṣṇa alone came to be apotheosized as the Supreme Deity, the other heroes were assimilated into the godhead. Kṛṣṇa's *cakra, gadā,* and other weapons, with which he had wreaked such havoc on enemies and demons, took on increased importance as intrinsic and necessary attributes of his supernatural military might and his divine omnipotence. Although originally subordinate to Indra, the Epic Viṣṇu abrogated Indra's former position of supremacy and assumed the role of the *kṣatriya* deity par excellence.[91] Through the syncretism of Kṛṣṇa and Viṣṇu, their roles as divine embodiments of heroic military power—and by extension, of universal sovereignty—were reciprocally reinforced. On the analogy of the *kṣatriya* hero who preserved order in the phenomenal world, the composite deity Viṣṇu came to be regarded as the noumenal support of all existence, the creator and upholder of the universe.

Purāṇic Period-I (*ca.* 200–600 A.D.)

The Vaiṣṇavism of the *Purāṇas* characterizes with greater profundity the supernal nature of the Supreme Deity. The thesis of Kṛṣṇa's divinity, for which the Epic offers an apologia, is an accepted fact even in the *Harivaṃśa,* which is traditionally regarded as a continuation of the *Mahābhārata.*[92] The date of the *Harivaṃśa* is uncertain, but that the apotheosis of Viṣṇu found in

386, 430–431. It is significant that Śāmba was dropped from the composite group apparently because of his association with the cult of sun worship. However, the fact that his ancestry on his mother's side was non-Āryan may also have contributed to his eventual exclusion.

89. See Chanda, *Archaeology and Vaishnava Tradition,* pp. 166, 167; Banerjea, *Development of Hindu Iconography,* pp. 93, 94; also P. R. Srinivasan, "Inscriptional Evidence on Early Hindu Temples," *The Adyar Library Bulletin,* 25 (1961), 511–523. Chanda believed that the *pañcavīra* images represented the five Pāṇḍava heroes, but Banerjea has demonstrated conclusively that the five Vṛṣṇi heroes are implied. Although intact representations of the *pañcavīras* do not survive in North India, they are depicted on a relief slab recently discovered in Andhra Pradesh (see Figure 2 and Part Two, Note 189).

90. The archaeological evidence for the existence of cults of the deified Vṛṣṇi heroes is discussed most thoroughly by Chanda, *Archaeology and the Vaishnava Tradition*; and Raychaudhuri, *Early History of the Vaishnava Sect.* See also Banerjea, *Development of Hindu Iconography,* pp. 386, 387. Banerjea implies that the *catur-vyūha* concept was developed after the elimination of Śāmba from the list of deified heroes, even though the cult of Śāmba continued until at least the seventh or eighth century A.D. Concerning the development of the deified *pañcavīras,* Banerjea remarks that "the systematizers of the cult-tenets did not take much time in transforming the Vīra concept about the central deity and some of his relations into the Vyūha or 'emanation' concept; to this was added the Vibhava or 'incarnation' concept

of the principal cult-god Vāsudeva [who was] identified with Viṣṇu and Nārāyaṇa sometime before the beginning of the Christian era. According to the re-oriented ideology of the cult, the one god Vāsudeva-Viṣṇu-Nārāyaṇa could be conceived in his fivefold aspects or forms":

1. *para*—the highest form
2. *vyūha*—emanation
3. *vibhava* (or *avatāra*)—incarnation
4. *antaryāmin*—the "inner controller"
5. *arcā*—image

91. Hopkins observes that in the Epic "Indra passes over to Viṣṇu many of his titles and also his heroic deeds. Viṣṇu becomes the typical fighter for the gods. . . . He is Vāsavānuja, Indra's junior by birth, as traces remain of his inferiority, as when he is Upendra, and Indra is Mahendra. But the later epic, while it cannot omit the derogatory title Upendra (under Indra), yet defiantly calls him Atīndra (over Indra) . . . Viṣṇu in the [*Rāmāyaṇa*] is called quite rightly Indrakarman, 'having Indra's deeds,' not only as Kṛṣṇa but as independent slayer of demons, to whom the gods appeal for help" (*Epic Mythology,* p. 204).

92. The critical edition of the text is being published by the Bhandarkar Oriental Research Institute; see P. L. Vaidya, ed., *The Harivaṃśa* (Poona, 1969). Vaidya does not believe that the constituted text is earlier than the fourth century A.D.; on the contrary, some portions are probably much later. For translations, see M. A. Langlois, trans., *Harivaṃśa* (Paris, 1834); M. N. Dutt, trans., *Harivamsha* (Calcutta, 1897).

the *Purāṇas* must have been achieved long before the fifth century A.D. is indicated by the exalted veneration of him by the early Gupta emperors, who describe themselves as the "most devout worshippers of the Divine One" (*paramabhāgavata*).[93] The invocation to Viṣṇu at the beginning of the Eran pillar inscription of the time of the emperor Budhagupta, dated 484 to 485 A.D., states:

Victorious is the lord, the four-armed (god Viṣṇu)—whose couch is the broad waters of the four oceans; who is the cause of the continuance, the production, and the destruction . . . of the universe; (and) whose ensign is Garuḍa![94]

(*jayati vibhuścaturbhujaścaturarṇṇavavipulasalilapary-aṅkaḥ*

jagataḥ sthityutpattinya[yādi] heturggaruḍaketuḥ)

With respect to the mythological treatment of Kṛṣṇa-Viṣṇu's weapons, the *Purāṇas* greatly expand upon the fabulous exploits already detailed in the Epic. The *Vāmana Purāṇa* (12.44) makes explicit what had only been implied in the *Mahābhārata*—that the *sudarśana-cakra* is superior to all other weapons:

As Viṣṇu is the most exalted of gods, the Himālayas of the mountains, [so is] the Sudarśana of weapons. . . .[95]

(*yathā surāṇāṃ pravaro janārdano yathā girīṇām api śauśirādriḥ*

yathāyudhānāṃ pravaraṃ sudarśanam. . . .)

In accordance with the Purāṇic tendency to speculate about origins—both cosmic and mundane—several of the *Purāṇas* furnish information not contained in the Epic about the creation of Viṣṇu's flaming discus. Most of the accounts involve the direct participation of the celestial architect and demiurge Viśvakarma, and most also claim that the *sudarśana-cakra* and other divine weapons were made from the sun.[96] But here again the association of the *cakra* with the sun seems largely metaphorical. The *Purāṇas* do not suggest that the *cakra* is the symbolical equivalent of the solar disk; instead they stress that the various divine weapons are forged from only a fraction of the sun's radiance: thus the *Viṣṇu Purāṇa* (3.2.8–12) relates:

To diminish [the sun's] intensity, Viśvakarman placed the luminary on his lathe, to grind off some of his effulgence, and, in this manner, reduced it to an eighth: for more than that was inseparable. The parts of the divine Vaishnava splendor, residing in the sun, that were filed off by Viśvakarman, fell, blazing down upon the earth; and the artist constructed of them the discus of Vishnu, the trident of Śiva, the weapon of the god of wealth, the lance of Kārttikeya, and the weapons of the other gods: all these Viśvakarman fabricated from the superfluous rays of the sun.[97]

93. Candragupta II (*ca.* 376–415 A.D.) was apparently the first emperor to use this epithet; see J. F. Fleet, *Inscriptions of the Early Gupta Kings and Their Successors,* Corpus Inscriptionum Indicarum, Vol. 3 (Calcutta, 1888), pp. 28ff.

94. Fleet, *Inscriptions of the Early Gupta Kings,* pp. 88ff.

95. *The Vāmana Purāṇa,* ed. Anand Swarup Gupta, trans. S. M. Mukhopadhyay *et al.* (Varanasi, 1968), p. 67.

96. Viśvakarma is briefly mentioned in the latest portion of the *Ṛg Veda* as an abstract creator god who borrows many of the traits of Tvaṣṭṛ, the divine artificer of Indra's *vajra.* For a summary of the character of the Purāṇic figure, see Dowson, *A*

Classical Dictionary of Hindu Mythology, pp. 363, 364; for Viśvakarma and other topics in the *Purāṇas,* see V. R. Ramachandra Dikshitar, *The Purāṇa Index,* 3 vols. (Madras, 1951–1955).

97. H. H. Wilson, trans., *The Vishnu Purāṇa,* 3rd ed. (Calcutta, 1961), p. 215; for the Sanskrit edition of this text, see J. V. Bhattacaryya, ed., *Viṣṇupurāṇam,* 2 vols. (Calcutta, 1882). Part of the imagery in this mythological account of the origin of the *sudarśana-cakra* may have been inspired by a metal-forging process.

A slightly varying version of this myth is also found in the *Mārkaṇḍeya*[98] and *Matsya Purāṇas*,[99] while in certain other *Purāṇas* the creator of the discus is said to be not Viśvakarma, but Śiva—suggesting overtones of a deep-seated sectarian rivalry between the two great deities of Hinduism.

The rivalry between Viṣṇu and Śiva is, of course, also manifest in the Epic, particularly in the later strata of the text.[100] In fact, the Purāṇic attribution of the creation of the *sudarśana-cakra* to Śiva is apparently an elaboration upon the interpolated version related in the *Mahābhārata*.[101] According to the *Padma Purāṇa*, Śiva suggests that Brahmā and the other gods all emit flames of anger from themselves, with which to fashion a weapon to combat a demon named Jālandhara:

"Now from these beams let a weapon be formed for my use." On hearing these words, Visvakarma and the gods, beholding the glowing mass, were alarmed, and feared to touch it. Perceiving the deities thus motionless, and knowing their thoughts Shankara [Śiva], laughing at them, said—"If this effulgence cannot be endured, in what manner can it be borne in the hand?" Shiva then placed his left heel on the glowing beams, as if he were crushing a bee buzzing on the ground; and dancing on them, he, by repeated rotations, reduced them to the form of a disc. Thus was produced the disc called *Sudarshana*.[102]

Despite the discrepancy between the various versions of the origin of Viṣṇu's fabled discus, the *Purāṇas* uniformly place great emphasis upon its efficacy as a weapon, both in recounting the numerous mythological exploits of Kṛṣṇa and in technical accounts of the practical uses of the discus. Reference has already been made to the *Matsya Purāṇa*'s literal description of the *cakra* as an eight-spoked wheel smeared with oil.[103] According to the encyclopedic *Agni Purāṇa*, the uses of a discus are "cutting, piercing, felling, whirling and severing." [104] References such as these

98. F. E. Pargiter, trans., *The Mārkaṇḍeya Purāṇa* (Calcutta, 1904), p. 574.

99. See *Matsya Purāṇam*, Sacred Books of the Hindus, Vol. 17 (Allahabad, 1916), p. 33.

100. Hopkins points out that "the Kurus are old Śivaites, and they join with Jarāsandha in not admitting the divinity of Kṛṣṇa as Nārāyaṇa, as they deny that Arjuna is Nara" (*Epic Mythology*, p. 213).

101. Roy, *Anuśāsanaparvan*, XIV, p. 57: "That discus, blazing with energy and like unto fire, was created by the great god having for his device the bull. Wonderful and irresistible in energy, it was given unto thee by that illustrious god. In consequence of its blazing energy it was incapable of being gazed at by any person save [Śiva]. It was for this reason that Bhava [Śiva] bestowed upon it the name of Sudarśanam. From that time the name Sudarśanam came to be current in all the worlds." This account is excluded from the constituted text of the critical edition of the *Mahābhārata* (see starred passage No. 85, inserted after 13.14.54).

102. Translated in Vans Kennedy, *Researches into the Nature and Affinity of Ancient and Hindu Mythology* (London, 1831), p. 471. The *Siva Purāṇa* also contains a decidedly sectarian account of the origin of the *cakra*; see T. A. Gopinatha Rao, *Elements of Hindu Iconography* (Madras, 1914–1916), Vol. 2, pp. 209, 210: "On one occasion Vishnu found himself unable to conquer certain *asuras*, and prayed to Śiva for the grant of the *chakra* which was in Śiva's possession. To his prayer he added a *pūjā* in which he employed a thousand flowers daily. One day he sat for *pūjā* with the required number of flowers but at the end he missed one flower, which to test the strength of his devotion Śiva had secreted; Vishnu at once plucked one of his eyes which are always compared to lotuses (*kamala-locana*) and threw the same in offering on Śiva. Śiva became so pleased with the devotion of Vishnu that he presented him with the *chakra* which was originally in his possession." This story is occasionally depicted in sculpture in South India, where it is referred to as the *cakradānamūrti* (or *viṣṇvanugrahamūrti*) of Śiva.

103. See above, Note 52.

104. Manmatha Nath Dutt, *A Prose English Translation of the Agni Purāṇa*, 2 vols. (Calcutta, 1902–1904), p. 900 (II, 252); for an exhaustive account of the iconographical data of this text, see M.-T. de Mallmann, *Les enseignements iconographiques de l'Agni-Purāṇa* (Paris, 1963).

indicate that the *cakra* was still employed as an actual weapon in the Purāṇic period. When Kṛṣṇa wields the *cakra* against demons, however, the weapon is described as performing utterly fantastic deeds, as in the *Viṣṇu Purāṇa*, when Sudarśana burns the seven thousand sons of Muru "like moths, with the flame of the edge of his discus."[105] Or when the discus by itself chases a demoness all the way from Dvarka to Varanasi so that Kṛṣṇa would not have to interrupt a game of dice.[106] In this encounter, after destroying the entire city single-handedly, Sudarśana then "with unmitigated wrath, and blazing fiercely, and far from satisfied with the accomplishment of so easy a task, returned to the hand of Viṣṇu" (*akṣīṇāmarṣamatyalpasādhyasādhanasaspṛham/ taccakraṃ prasphuraddīpti viṣṇor abhyāyau karam//*).[107] This account reveals the remarkable degree of anthropomorphism which pervades the Purāṇic treatment of Sudarśana. Not only is the discus capable of following Viṣṇu's instructions and acting independently of him, but it is also capable of feeling emotions like wrath and dissatisfaction.

In the *Mahābhārata*, as stated above, the *cakra* is metaphorically described as drinking the "life-blood of enemies like a goblin."[108] In the *Purāṇas*, the metaphor becomes almost a reality—almost, because although human feelings are ascribed to Sudarśana, the discus still does not speak. When, however, Epic legends were transferred to the stage, Sudarśana and the other weapons of Viṣṇu become truly personified. In two of the plays attributed to the Sanskrit playwright Bhāsa—the *Dūtavākyam* and the *Bālacaritam*—Sudarśana actually appears among the *dramatis personae*.[109] In the fragmentary *Dūtavākyam*, Viṣṇu summons onto the scene his fabled weapon Sudarśana, who calls out to his master upon entering:

SUDARŚANA: Hearing the voice of the Blessed One, by his bountiful favour forth do I rush, dispersing masses of clouds. With whom is he wroth, the lotus-eyed. On whose head must I be manifest? . . . Hail, blessed Nārāyaṇa!

VĀSUDEVA: Sudarśana, matchless be your power.

SUDARŚANA: I thank you.

VĀSUDEVA: You have arrived luckily in the nick of time.

SUDARŚANA: What, in the nick of time? Command me, Blessed One, command me. Shall I overturn all the Meru and Mandara mountains? Shall I convulse the whole ocean? Or hurl down to earth all the brood of stars? There is nothing I cannot do, O Blessed One, by thy favor.[110]

105. *Viṣṇu Purāṇa* 5.29.18; this brief episode is translated in Wilson, *The Vishnu Purāṇa*, p. 459.

106. *Ibid.*, 5.34. *passim*; translated in Wilson, pp. 471, 472. The demoness had been created by Śiva and sent to Dvarka to destroy Kṛṣṇa, who "being engaged in sportive amusements, and playing at dice, (merely) said to the discus, 'Kill this fierce creature, whose tresses are of plaited flame.' Accordingly, Sudarśana, the discus of Vishnu, immediately attacked the fiend fearfully enwreathed with fire, and wearing tresses of plaited flame. Terrified at the might of Sudarśana, the creation of Maheśvara [Śiva] awaited not his attack, but fled with speed, pursued by him with equal velocity, until she reached Vārāṇasī, repelled by the superior might of the discus of Vishnu."

107. *Ibid.*, 5.34.44; translated in Wilson, p. 472. Sudarśana had "consumed the whole of the [army of Varanasi] by his radiance,

and then set fire to the city, in which [the demoness] had concealed herself."

108. *Mbh*.1.17.15 (see above, Note 63).

109. See A. G. Woolner and L. Sarup, trans., *Thirteen Trivandrum Plays Attributed to Bhāsa*, Panjab University Oriental Publications, No. 13, 2 vols. (London, 1931); the *Dūtavākyam* and the *Bālacaritam* are translated in Vol. 2, pp. 1–15 and pp. 109–141 respectively. For a résumé of the controversy surrounding these plays, see M. A. Mehendale, in *The Age of Imperial Unity*, pp. 260–264. It has been pointed out that on the basis of literary style, vocabulary, and content, the plays appear to be contemporaneous with the later Epic and therefore date somewhere between the second and fourth centuries A.D.

110. Woolner and Sarup, *Thirteen Trivandrum Plays*, Vol. 2, p. 12.

Following this flowery exchange, Sudarśana introduces each of the other personified weapons in turn as they come on stage—Śārṅga (bow), Kaumodakī (mace), Pāñcajanya (conch), and Nandaka (sword).[111] Sudarśana's devotion to Viṣṇu is also made apparent in the *Bālacaritam*, when he and the other weapon personifications announce that they will descend to earth disguised as cowherds so that they might actively participate in Kṛṣṇa's boyish adventures—thus doubly manifesting themselves in human form.[112]

By stressing his cosmic nature the *Purāṇas* raised Viṣṇu to such exalted heights that he gradually became somewhat remote and unapproachable. Paralleling the development of the concept of Viṣṇu as an unfathomable being, however, the *Purāṇas* began to place greater emphasis upon the *avatāras*.[113] This was probably because the *avatāras* served as Viṣṇu's intermediary agents for the eradication of evil and the dispensing of divine grace and compassion. It is interesting to note that two of the theriomorphic *avatāras*—Matsya and Varāha—originally figured in cosmogonic myths. When transferred to Viṣṇu, however, the myths took on a soteriological connotation, thus reinforcing the notions of the *avatāras* as embodiments of the deity's benevolence.[114] In effect, the *avatāras*—including especially Rāma and Kṛṣṇa—constituted hypostases of Viṣṇu's dynamic potentiality. The concept of the *avatāras* taking on the functions of the deity himself established a precedent for the later ability of the personified weapons to also act as independent agents. Eventually, as we shall see, the hypostatization of Viṣṇu's destructive power in the form of Sudarśana led to the actual deification of the personified discus.[115]

111. *Ibid.*, p. 13. All of the weapons appear at the wish of Vāsudeva, but Sudarśana is the first to arrive.

112. *Ibid.*, p. 120. The discus says: "I am Krishna's discus gleaming in his fingers. Dazzling is my lustre like the noon-day sun. At the three steps and the churning of the ocean, I slew hoardes of demons and evil sprites." In this passage the weapons are already personified; by assuming the guise of cowherds, they take on a double human identity.

113. Many of the *Purāṇas* contained detailed accounts of the exploits of the *avatāras*. In the *Bhāgavata Purāṇa*, which may date to about 1000 A.D., the human appeal of the life of Kṛṣṇa is greatly stressed, thus providing a corrective to the relatively more austere scholastic conception of Visnu himself. Note, however, that the content of other late *Purāṇas*, such as the *Agni* and *Garuḍa Purāṇas*, tends more toward technical and ritualistic matters than to appealing narrative.

114. For a summary of the myths, see Dowson, *Classical Dictionary of Hindu Mythology*, pp. 34–36. Macdonell notes that the "boar appears in a cosmogonic character in the ṢB. [*Śatapatha Brāhmaṇa*] where under the name of Emūṣa he is stated to have raised the earth from the primeval waters" (*Vedic Mythology*, p. 41). In the Purāṇic version, Varāha is implored by the Earth (Pṛthivī) to bring about her salvation. Similarly, Viṣṇu's all-powerful nature was invoked by his devotees to bring about their salvation; their belief in his benevolence helping to institutionalize the concept of *bhakti* ("devotion" or spiritual "attachment") within the Vaiṣṇava sect.

115. Within speculative Pāñcarātra literature, Sudarśana came to be regarded as superior in power to even the *avatāras* since they constituted only a part of the deity's divine potency, while Sudarśana symbolized Viṣṇu's power (*śakti*) in its entirety. Cf. *Brahmāṇḍa Purāṇa* 2.3.121ff: "All that is manifestation of might and abundance, spiritual essence and energy, prosperity and illustriousness, strength and importance has arisen from, or owes its existence to its being, an integral part of Viṣṇu's fiery energy" (translated in Gonda, *Aspects of Early Viṣṇuism*, p. 121).

II The *Cakra* as Esoteric Symbol

Purāṇic Period-II (*ca.* 600–1000 A.D.)

AT THE SAME TIME that the remarkable anthropomorphizing tendencies described above were manifesting themselves in the literature of the Purāṇic period, a new symbolic interpretation of Viṣṇu's weapon-attributes was also beginning to find expression. By the seventh or eighth century, as a result of the apotheosis of Kṛṣṇa-Viṣṇu-Nārāyaṇa in the *Purāṇas*, the literal interpretation of the attributes as weapons was apparently considered inappropriate by those devotees and Vaiṣṇava theologians who regarded the deity as having a completely transcendent and noumenal nature. In fact, the iconographic conception of Viṣṇu as a heavily-armed warrior, which was prevalent in the period, seems to have provided cause for embarrassment. In the *Viṣṇudharmottara Purāṇa*[116]—which is regarded as supplementary to the *Viṣṇu Purāṇa*—the sage Mārkaṇḍeya is asked (85.15):

What is the fear of that god [Viṣṇu] that he is always with all weapons ready? [117] (*kim bhayaṃ tasya devasya nityaṃ sarvāyudhodyataḥ*)

Mārkaṇḍeya replies that the weapons are not really weapons at all. They are pantheistic symbols pertaining to the material elements of the worlds which Viṣṇu permeates and upholds. Thus the *śankha* represents sky (*kha*), the *cakra* air (*pavana*), the *gadā* fire (*tejas*), and the *padma* water (*āpas*).[118] The *Viṣṇu Purāṇa* itself—in a dialogue between the two sages Parāśara and Maitreya—gives a more philosophical interpretation of the attributes in connection with the glorification of Viṣṇu as the Supreme Deity (1.22.61–69):

116. See Priyabala Shah, ed., *Viṣṇudharmottara-Purāṇa, Third Khaṇḍa*, Gaekwad's Oriental Series, Vols. 130, 137, 2 vols., (Baroda, 1958, 1961); cf. Stella Kramrisch, trans., *The Vishnudharmottara*, Part III (Calcutta, 1928).

117. Kramrisch, *Vishnudharmottara*, p. 111.

118. *Viṣṇudharmottara Purāṇa* 80.16–18. Shah (Vol. 2, p. 182) comments: "When these main elements are abandoned by Hari, they become quickly scattered. So Hari keeps them together in Himself. Viṣṇu is identified with the human soul. When he leaves the body, all elements residing in the body become scattered. The world is supported by the elements when held together by god Viṣṇu. Their power of holding together is caused by Him. This philosophical explanation constitutes the Hetus of the images, their signs and symbols."

PARĀŚARA: This Hari [Viṣṇu], who is the most immediate of all the energies of Brahma, is his embodied shape, composed entirely of his essence; and in him therefore is the whole world interwoven; and from him, and in him, is the universe; and he, the supreme lord of all, comprising all that is perishable and imperishable, bears upon him all material and spiritual existence, identified in nature with his ornaments and weapons.

MAITREYA: Tell me in what manner Vishnu bears the whole world, abiding in his nature, characterized by ornaments and weapons.

PARĀŚARA: Having offered salutation to the mighty and indescribable Vishnu, I repeat to you what was formerly related to me by [the Sage] Vasishta. The glorious Hari wears the pure soul of the world, undefiled, and void of qualities, as the Kaustubha gem [on his chest]. The chief principle of things (Pradhāna) is seated on the eternal, as the Śrīvatsa mark [on his shoulder]. Intellect abides in Mādhava [Viṣṇu], in the form of his mace. The lord supports egotism (Ahankāra), in its twofold division into elements and organs of sense, in the emblems of his conch-shell and his bow. In his hand Vishnu holds, in the form of his discus, the mind, whose thoughts (like the weapon) fly swifter than the winds. . . .[119]

The notion of the *cakra* as a symbol of mind will be greatly elaborated upon in later literature.

Yet another interpretation of the *cakra* is found in the *Varāha* and *Vāmana Purāṇas*, where it is equated with the Wheel of Time, probably because of its destructive power being analogous to that of time itself.[120] The *Vāmana Purāṇa* extends this interpretation by relating the spokes of the discus to various astrological concepts and to the cycle of the seasons (56.24–27):

This swift Sudarśana having twelve spokes, six naves and two axles, is the best of weapons and destroyer of all other weapons. In its spokes reside gods, months, signs of the zodiac and the six seasons for the protection of the [wise]. Agni, Soma, Mitra, Varuṇa, Lord of Śacī, Indrāgni, Viśvadevāḥ, Prajāpatis, the mighty Hanumān, the god Dhanvantari, Tapas and Tapasya—these twelve [Vedic and Epic deities] are established (there); also established there are the months beginning with Caitra [March–April] and ending with Phalguna [February–March].[121]

To the speculative mind of the Hindu scholastic, a complex explanation was obviously preferable to a simple one—the esoteric apparently being regarded as more palpable than the mundane.

Whatever the contributing cause, there was a great outpouring of recondite interpretations of Viṣṇu's attributes during the later Purāṇic period, perhaps largely as a result of the emergence of Tāntrism as a new force in Indian religions.[122] At first, the interpretations were extremely varied

119. Wilson, *The Vishnu Purāṇa*, p. 129.

120. For the *Varāha Purāṇa* reference, see N. K. Bhattasali, *Iconography of Buddhist and Brahmanical Images in the Dacca Museum* (Dacca, 1929), p. 78; in the Purāṇic passage cited, "Sword is explained as the cleaver of the darkness of ignorance. The sounding Conch is the dispeller of illusion. The Discus is the wheel of time. The Mace is for destroying evil. The garland which Viṣṇu wears is Nature. His vehicle Garuḍa is the wind personified. . . . The sun and moon are his two jewels, Kaustubha and Śrīvatsa." For the reference to the *Vāmana Purāṇa*, see V. S. Agrawala, *Vāmana Purāṇa—A Study* (Varanasi, 1964), p. 170, where the passage cited states that Śiva presented the *cakra* to Viṣṇu.

121. A. S. Gupta, ed., *The Vāmana Purāṇa*, p. 459. The rationale behind the list of twelve deities who reside in the spokes is unclear. The description in the text is being furnished by Śiva on the occasion of his presenting the *cakra* to his rival Viṣṇu. Upon receiving the invincible weapon, Viṣṇu hurls it at Śiva, cutting him into three—only to discover that Śiva's real form (*svabhāva*) remains unaltered (*ibid.*, p. 460).

122. The Tāntric cult of esoteric knowledge seemingly precluded the possibility of a literal interpretation of the attributes of the deity; since the deity's essential nature was noumenal, nothing phenomenal could be associated with him.

and eclectic. In some *Purāṇas*, two or more explanations are sometimes provided for the same symbol, without much concern for consistency of interpretation. Thus in the *Viṣṇudharmottara Purāṇa*, the *cakra* is, as we have already seen, a symbol of air (*pavana*). In addition, the *cakra* in the hand of Viṣṇu is said (65.5) to represent the

rotation of the world . . . the Wheel of the Law, the Wheel of Time and the circular path of the planets.[123]	(*saṃsārabhramaṇaṃ cakraṃ cakraṃ viṣṇukare sthitam dharmacakraṃ kālacakraṃ bhacakraṃ ca. . . .*)

In contrast to these intangible abstractions, the anthropomorphized *gadā* is identified with actual female divinities, as well as with personified abstract concepts.[124] Elsewhere the text states that *cakra* and *gadā* in the hands of Vāsudeva stand for spirit (*puruṣa*) and matter (*prakṛti*), the two creative principles in the classical dualistic systems of Hindu philosophy.[125] The *cakra* as a symbol of creative energy also figures importantly in later Tāntric literature.

Tāntric Period (*ca.* 800–1600 A.D.)

Elements of Tāntrism, with its emphasis upon esoteric symbolism and occult practices, appear frequently in Indian religious and mythological texts as early as the seventh or eighth century, or about the middle of our Purāṇic period. By the tenth or eleventh century, Tāntric elements almost completely dominate Vaiṣṇava speculative literature.[126] It is in the *Garuḍa Purāṇa* that we find, perhaps for the first time, evidence for the existence of a Tāntric cult of the *sudarśana-cakra*.[127] Apparently, at the time this *Purāṇa* was written, Sudarśana was worshipped in the form of a personified multi-armed image, since the text states that "invoking . . . the deity of gentle form, adorned with a crown and holding conch-shell, discus, club and lotus, in the mystic diagram he [the devotee] should worship him" (33.4.5).[128] The Tāntric liturgical ritual consisted

123. Shah, *Viṣṇudharmottara*, Vol. 2, p. 141; the passage cited continues (60.6): "the god Viṣṇu himself is immovable and he moves the wheel" (*dhruvo hi viṣṇurbhagavānpradiṣṭaḥ/ cakraṃ sadā bhrāmayate sa vīraḥ//*).

124. *Viṣṇudharmottara Purāṇa* 60.4; Shah comments that "Gadā is also Lakṣmī, Dhṛti, Kīrti, Puṣṭi, Śraddhā, Sarasvatī, Gāyatrī the mother of the Vedas, and also Kālarātri" (vol. 2, p. 141).

125. Shah, *Viṣṇudharmottara*, Vol. 2, p. 143: "The sun and the moon represent Puruṣa and Prakṛti. These are symbolized by *cakra* and *gadā* in the hands of Vāsudeva." The concepts of *puruṣa* and *prakṛti* are employed in Tāntric literature as symbols of the male and female principles; as Raychaudhuri points out, "the influence of the Sankhya doctrine of Purusha and Prakriti on the neo-Vaishnavism may also be detected in the Lakshmī-Nārāyaṇa cult" (*Early History of the Vaishnava Sect*, p. 106).

126. There exists no adequate historical survey of Tāntric literature, probably because few of the texts can be dated precisely. Schrader's *Introduction to the Pañcarātra* is still the most thorough and competent survey of the later Vaiṣṇava *Tāntras*, or *Saṃhitās*, and their philosophical content. However, although Schrader believes that Tāntric elements may have existed in Vaiṣṇava literature contemporaneously with the later Epic, the historical evidence which he adduces for the chronology of the texts does not seem to warrant assigning them to a period earlier than the seventh or eighth century A.D.; on the contrary, the majority of the datable literary allusions to the Vaiṣṇava *Tāntras* occur between the tenth and fourteenth century (Schrader, pp. 16–18).

127. See Manmatha Nath Dutt, trans., *The Garuḍa Purāṇam*, 2nd ed., Chowkhambha Sanskrit Series, Vol. 27, (Varanasi, 1968), Chapter 33, pp. 181, 182; for the Sanskrit text see Ramshankar Bhattacharya, ed., *Garuḍa Purāṇam*, Kashi Sanskrit Series, No. 165 (Varanasi, 1964).

128. Dutt, *Garuḍa Purāṇam*, p. 81. It should be noted that the four-armed form of Sudarśana is described as *saumya*, or "placid"; the word *maṇḍala* has been translated as "mystic diagram."

in large part of the recitation of *mantras,* or formulaic utterances, often consisting only of semantically meaningless syllables.[129] Many *mantras* clearly fall into the category of spells or incantations that are designed to produce a specific magical effect.[130] According to the *Garuḍa Purāṇa,* recitation of the *mantra* of Sudarśana—*oṃ sahasrāraṃ huṃ phaṭ namas*—is supposed to destroy all wicked beings,[131] while the devotee who desires to erase his own wrongdoing and achieve salvation has simply to pronounce the following ode of praise 108 times:[132]

> Salutation unto Sudarśana, effulgent like a thousand suns, lighted up with a garland of flames, having a thousand blades for eyes, the destroyer of all wicked beings, the grinder of all sins. . . .[133]

Although the later *Purāṇas* frequently include references to esoteric practices within the Vaiṣṇava tradition, Tāntric doctrines and modes of worship are most extensively expounded in the numerous medieval texts belonging to the Pāñcarātra literary corpus.[134] Pāñcarātra theological and cosmogonic speculations are essentially derived from the early Bhāgavata concept of the four-fold nature (*catur-vyūha*) of the Supreme Deity Vāsudeva-Kṛṣṇa-Viṣṇu. Indeed, portions of certain Pāñcarātra texts are probably contemporaneous with the later strata of the Epic—though the references to the *vyūha* doctrine in the *Mahābhārata* may be apocryphal—or the earliest *Purāṇas.*[135] Whatever the date of the first Pāñcarātra texts, those works which contain references to the elaborate rituals of the Sudarśana cult are probably not earlier than the tenth or eleventh century.[136]

129. See Agehananda Bharati, *The Tantric Tradition* (London, 1965), pp. 101–163. Bharati quotes K. G. Diehl's definition of *mantra*: ". . . the *mantras* are instruments. Partly they are without meaning and often they are not understood by him who reads them. They have fixed places in the ritual and varied effects and cannot be interchanged" (p. 111). See also Alain Daniélou, *Hindu Polytheism* (London, 1963), pp. 334–339.

130. Bharati states that "there are only three possible purposes of *mantra,* divisible no doubt into many sub-categories. These are: propitiation, acquisition, and identification, or introjection" (*The Tantric Tradition,* p. 111).

131. Dutt, *Garuḍa Purāṇam,* p. 81. Two elements of the *mantra* are translatable—*sahasrāram,* which means "thousand-spoked"; and *namas,* which means "salutation." Traditional meanings are also ascribed to the other three components of the *mantra,* which are referred to as *bīja,* or seed *mantras. Oṃ,* of course, is well known. Bharati points out that the ancestry of the syllable *phaṭ* is very ancient, occurring as an undeclinable with the meaning "crack" in the *Atharva Veda;* furthermore, it seems to have onomatopoetically conveyed the idea of "explosion" from ancient times down to the present (*The Tantric Tradition,* p. 116). It is known as the *astra* ("weapon") *bīja;* while *huṃ* is traditionally referred to as the *varma* ("warrior") *bīja* (Bharati, p. 119). According to Daniélou, *huṃ* "protects from anger and demons"; and *phaṭ* "is the weapon which can destroy anything" (*Hindu Polytheism,* p. 343). Hence all of the elements of the *mantra* are explicitly and succinctly appropriate to the invocation of the deified discus Sudarśana. The magical service which he is

expected to render is an extension of his mythological character as the personified fabled weapon of the omnipotent deity Viṣṇu.

132. Dutt, *Garuḍa Purāṇam,* p. 82: "The self-controlled man who reads this prescription of the adoration of the discus, reduces his sins to ashes and reaches the region of Vishnu."

133. *Ibid.,* p. 81. This portion of the ode to Sudarśana corresponds to *Garuḍa Purāṇa* 33.8, 9ª (the Sanskrit text of these verses is printed in Devanāgarī script as the epigraph to the Introduction to this monograph).

134. See Schrader, *Introduction to the Pāñcarātra,* pp. 2–26. For an annotated bibliography of some relevant Pāñcarātra texts, see H. Daniel Smith, ed., *Pāñcarātraprāsādaprasādhanam, Chapters 1–10 of the "Kriyāpāda," Padmasaṃhitā* (Madras, 1963), pp. 185–197; also his *A Sourcebook of Vaiṣṇava Iconography* (Madras, 1969), pp. 298–306.

135. The earliest formulation of the *catur-vyūha* doctrine seems to be in the Nārāyaṇīya section of the *Mahābhārata* (see above, Note 85). In this study it is assumed that the date of the Nārāyaṇīya is roughly the third to fourth century A.D.; in any event, considerably later than the *Bhagavad Gītā.*

136. Many of the Pāñcarātra texts give elaborate iconographical descriptions of multi-armed cult images of Sudarśana. As will be pointed out in Part Two, the earliest known Sudarśana icon in South India may be assigned to the thirteenth century (Figure 46); in North India, multi-armed images of Sudarśana are unknown before the eleventh century (see Part Two, discussion of Figures 41–44).

For elucidation of the esoteric significance of the *sudarśana-cakra,* the most important Pañcarātra text is the *Ahirbudhnya-Saṃhitā.*[137] Although this *Saṃhitā* (literally "compendium") has been roughly assigned by various scholars to the period from the fourth to the eighth century, the text's preoccupation with esoterism seems instead to place it within the later Pañcarātra tradition.[138] Surprisingly, no attempt has hitherto been made to utilize the iconographic information contained in the text as evidence bearing on its date.[139] In fact, certain iconographic data in the text clearly point to a date much later than the eighth century for its composition. In Chapter 44 of the *Ahirbudhnya-Saṃhitā,* for example, there is explicit evidence that at the time the text was composed, multi-armed personifications were regarded as the norm. There, the personified *cakra* with only two arms is described as appearing to the sage Bṛhaspati. When Bṛhaspati sees this form of Sudarśana, he is amazed and asks (vv. 25,26):

How is it, O Bhagavān, that you, being known as eight-armed in the World, now stand before me in human form? [140]

(kimidaṃ bhagavam̐lloke prathito'ṣṭabhujo bhavān manuṣyarūpasaṃsthānaḥ prādurāsīḥ puro mama)

In response to the query of Bṛhaspati, "the Sudarśana-puruṣa declares that He has four forms (*vyūha*) showing respectively two, eight, sixteen, and sixty-two arms, and moreover a fifth form in which He appears as the All (*viśvamayarūpa*)." [141] As we shall see in Part Two of this study, these multi-armed forms of Sudarśana are described in great detail in the *Saṃhitā* text. The descriptions correspond closely to icons of a type not found before the thirteenth century, and then only in South India.[142] These facts strongly suggest that the *Ahirbudhnya-Saṃhitā* (and perhaps many other "early" works of the Pañcarātra literary corpus) cannot be much earlier than the twelfth or thirteenth century, and that South India—where the majority of the texts survive

137. See M. D. Ramanujacharya, ed., *Ahirbudhnya-Saṃhitā of the Pañcarātrāgama,* 2 vols. (Madras, 1916; 2nd ed. 1966); the contents of the text are summarized in Schrader, *Introduction to the Pañcarātra and the Ahirbudhnya-Saṃhitā,* pp. 99–146. As Schrader points out, the term *saṃhitā* ("compendium") is virtually synonymous with *tantra* ("treatise") in the Pañcarātra literary corpus.

138. See M. Winternitz, *History of Indian Literature,* Vol. 1 (Calcutta, 1927), pp. 589–590. Winternitz estimates that the *Ahirbudhnya-Saṃhitā* "originated not long after the fourth century A.D.," while according to Schrader's own more realistic estimate, the eighth century A.D. is suggested as the *terminus ad quem,* with the qualification that one passage may suggest a later date (*Introduction to the Pañcarātra,* pp. 97, 98).

139. An attempt was made by V. S. Agrawala, but he has interpreted the iconographic information in a fallacious manner (see below, Part Two, Note 208).

140. Cf. Schrader, *Introduction to the Pañcarātra,* p. 131. Bṛhaspati was able to summon the two-armed *sudarśana-puruṣa* through the recitation of the great Sudarśana *mantra* (for which see Chapter 18 of the text discussed in Schrader, p. 121). This

form of Sudarśana is described as placid in appearance, having a shining effulgence, and holding the *cakra* and *śaṅkha* in his two arms (44.22,23):

cakravartī sa bhagavān saumyarupaḥ sudarśanaḥ
tam dṛṣṭvā dīptavapuṣam prasannam kuṅkumaprabham
dvibhujam sarvabhūtānāmanugrahakaram param
śaṅkhacakradharam devam divyamālyavibhūṣitam

141. Schrader, *ibid.,* p. 131. *Ahirbudhnya-Saṃhitā* 44. 27, 28:

vyūhaḥ sahasraśaḥ santi mama klṛptā yathecchayā
teṣām pradhānato vyūhāścatvāro mama vākpate
dvibhujam prathamam viddhi tato'ṣṭabhujameva mām
tataḥ ṣoḍaśahastam tu mām dvīṣaṣṭibhujam tataḥ

At the request of Bṛhaspati, Sudarśana "appears to him in the All-form and finally as eight-armed" (Schrader, 132).

142. See below, Part Two, discussion of Figure 46; cf. W. E. Begley, "The Earliest Sudarśana-cakra Bronze and the Date of the *Ahirbudhnya-Saṃhitā,*" *Proceedings of the 27th International Congress of Orientalists* (Wiesbaden, 1971), pp. 315–316.

along with flourishing Pāñcarātra systems of worship—is the most likely place of its composition.[143]

The entire *Ahirbudhnya-Saṃhitā* is framed around a dialogue dealing with the metaphysical interpretation of Viṣṇu's discus and the esoteric modes of worshipping it.[144] At the beginning of the text the question is raised concerning the power of the *sudarśana-cakra* (1.10,11):

Due to whom (or what) is its majesty? Is it innate or created? What is that Sudarśana? What is the meaning ascribed to the word? What work does it perform? How does it pervade the universe? [145]

(kiṃkṛtaṃ tasya māhātmyaṃ svataḥ saṃsargato'pi vā kiṃ tat sudarśana nāma kaśca śabdārtha iṣyate tena kiṃ kriyate karma jagad vyāpnoti tat katham)

The etymology of the word *sudarśana* is explained as deriving from "*darśana* (seeing, sight) meaning *prekṣaṇa* (prospective thought), and *su* (well, perfectly) expressing its being unimpeded by time and space." [146] The *cakra* is further interpreted as a symbol of Viṣṇu's "will-to-be" (*syām iti saṃkalpa*),[147] which is identical to his *kriyā-śakti,* defined as the creative feminine principle of Tāntrism, and personified as Lakṣmī, the consort of Viṣṇu.[148] Lakṣmī and Sudarśana both represent the active side of Viṣṇu's transcendental nature, which functions independently of him. Since Sudarśana is totally independent, his power is, therefore, "natural (*sāṃsiddhika*) and not created." [149] The creative power of Sudarśana is characterized as "will (*icchā*) embodied in wisdom (*prekṣā*) and resulting in action (*kriyā*)." [150] Sudarśana is, ultimately, the primary motivational force which "of its own accord conceived the idea of expanding into space . . . thus bringing into existence the universe." [151]

Beyond his initiatory functions Sudarśana also possesses regulative power (*pramāṇa*) and "renders possible the continuance of the world by means of the divine Śastras," or weapons used

143. It is possible that much of the philosophical content of the *Ahirbudhnya-Saṃhitā* belongs to an earlier phase of compilation; it seems indisputable, however, that the iconographic portions of the text must be approximately contemporaneous with the images described. A continuous and logical sequence of representations of personifications of Sudarśana that can be traced from the fifth to the nineteenth century makes it extremely unlikely that there may once have existed multi-armed images substantially earlier in date than the one referred to in the preceding note.

144. Within this frame, however, there is much excursus into other topics, which are typical of the scope of many Pāñcarātra texts. Ten such topics are listed by Schrader (p. 26), who estimates that "roughly speaking . . . half of the Saṃhitā deals with occultism, theoretical and practical, one fourth with philosophy, and one fourth with the remaining subjects" (p. 99). Compared to numerous other Pāñcarātra texts surviving in South India, the *Ahirbudhnya-Saṃhitā* devotes relatively little attention to temple building and image making.

145. Schrader, *Introduction to the Pāñcarātra,* p. 100. The question is also posed as to the nature of Sudarśana's relation to

Viṣṇu, and whether it is "necessarily and always found in connection with Him (alone) or elsewhere too" (*ibid.*).

146. *Ibid.,* p. 101.

147. *Ibid.*

148. *Ibid.,* p. 102. Schrader defines the *kriyā-śakti* as the "*causa instrumentalis* . . . of the world" (p. 31), and remarks it is manifested at the time of "pure creation" (*śuddhasṛṣti*), in which the six *guṇas* of the cosmic being make their first appearance (see above, Note 87). As is invariably the case in Hindu Tantrism, the female element, Lakṣmī (here equated with Sudarśana), is regarded as active; and the male element, Viṣṇu, as passive. In effect Viṣṇu and Lakṣmī are separate entities, although "owing to over-embrace (*ati-saṃśleṣāt*) the two all-pervading ones, Nārāyaṇa and his Śakti, have become, as it were, a single principle (*ekaṃ tattvam iva*)" (Schrader, p. 103).

149. *Ibid.,* p. 101; in effect, "everything in the world [is] dependent on the Sudarśana."

150. *Ibid.,* p. 102.

151. T. A. Gopinatha Rao, *Elements of Hindu Iconography,* Vol. 1, p. 291n.

by the *avatāras* of Viṣṇu to rout the wicked.[152] Following the *Varāha, Vāmana,* and *Viṣṇudharmottara Purāṇas,* the discus is also associated with the *kālacakra,* whose endless cycle of death and destruction paradoxically brings in its wake cosmic renewal and continuation.[153] It is difficult to account for the multiplicity of symbolical interpretations of the *sudarśana-cakra* found in the *Ahirbudhnya-Saṃhitā.* The multiplicity may derive partly from the fact that the circular *cakra* constituted the major formal element in the ritualistic diagrams known as *maṇḍala* ("circle") or *yantra* ("instrument"), which are described in exhaustive detail in the *Saṃhitā* and in other Tāntric texts.[154] In addition to the devotee's preparation of diagramatic *yantras,* Sudarśana worship also consisted of yogic meditation, *pūjā* performed to icons, the recitation of *mantras,* and, finally, total "surrender" (*nyāsa*) to the deity—the last being expressed by the following invocation given in the *Ahirbudhnya-Saṃhitā* (37.32):

O Lord who art invincible through the all-conquering (*bhagavan sarvavijayisahasrārāparājita*
thousand spokes, I am taking refuge in thee. . . .*[155]* *saraṇaṃ tvāṃ prapanno'smi. . . .*)

It is apparent that, theoretically at least, Sudarśana was regarded as an independent deity, and not merely a subordinate agent of Viṣṇu's destructive power. This view is substantiated by the evidence in the *Saṃhitā* for the existence of a *bhakti* cult centered on Sudarśana, who, according to the text, is equal in importance to Lakṣmī, the speculatively all-powerful *śakti* of the deity.[156]

There exist, in fact, several devotional hymns to Sudarśana which were probably composed in the same period as the great bulk of the Pāñcarātra texts. The *Vāmana Purāṇa* (67.6–19) includes a lengthy *stotra,* or hymn to Sudarśana, in a narrative account of the discus's appearance to Bali, the king of the demonic underworld:

On the discus entering the nether world, in the city of the demons, there was a great halloing like that of the agitated ocean. On hearing the loud noise, Bali drew his sword and the great demon thus enquired "What is it?"

Then his virtuous wife Vindhyāvalī putting the

sword in the scabbard, spoke appeasingly to her husband: "This discus of the Great Lord Vāmana, the Destroyer of the race of the demons is worthy of being worshipped." Saying this the pretty-limbed lady went out with the pot containing respectful offering.

Then the thousand-spoked Sudarśana, the discus of

152. Schrader, *Introduction to the Pāñcarātra,* p. 108: the *śastras* are defined as "weapons," which, "in contradistinction to the Astras, can never be used by mortals, but only by their divine bearer with whom they are inseparably connected."

153. *Ibid.,* pp. 106, 132. The Wheel of Time is turned by the Supreme Being "who appears as Brahmān, Viṣṇu, and Śiva at the time of the creation, continuance, and dissolution of the world" (p. 132). For references to the *Varāha* and *Vāmana Purāṇas,* see above, Note 120.

154. Chapters 21 to 27 of the *Ahirbudhnya-Saṃhitā* are devoted to *yantras*; cf. Schrader, *Introduction to the Pāñcarātra,* pp. 122, 123ff. For detailed explanations of the form and meaning of *maṇḍalas,* see Giuseppi Tucci, *The Theory and Practice of the*

Maṇḍala (London, 1969); Daniélou, *Hindu Polytheism,* pp. 350–361; H. Zimmer, *Myths and Symbols in Indian Art and Civilization* (New York, 1962), pp. 140ff.

155. Schrader, *Introduction to the Pāñcarātra,* p. 128.

156. *Ibid.*: "Nyāsa which is declared to be a third *sādhana* (religious expedient) in addition to worship [*pūjā*] and Yoga . . . is here understood in the sense of *bhakti.* . . ." In terms of the role played by the concept of *bhakti* in the Vaiṣṇava sect, the religious expedient of *nyāsa* may perhaps have been the most important form of worship of Sudarśana, as evidenced by the numerous devotional hymns to him written in the medieval period.

Viṣṇu approached, and the chief of the demons bowing humbly and with hands folded worshipped the discus in accordance with the procedure prescribed and recited the following hymn.

Bali said: *"I bow down to the Thousand-rayed, Thousand-coloured, Thousand-spoked, Extremely pure, Destroyer of the race of the demons, the Discus of Hari. I bow down to the Discus of Hari, in the nave of which is Brahman, in the mouth of which is Śaṅkara [Śiva] the Trident-holder, and at the root of spokes the major mountains. In the spokes of which are present the gods including Indra, the Sun and Fire. In its motion exist wind, Water, Fire, Earth, Sky. At the ends of the spokes are present the clouds, lightning, stars, planets; and in its border allude*

the Bālakhilya and other [Vedic] sages. I bow down with devotion to the great weapon of Vāsudeva. The sins that are born of my body, speech and mind, O radiant Sudarśana Discus, consume them and rid me of sins born of the family and sins that relate to my father and mother. Destroy them without delay. I bow to you, O weapon of Viṣṇu. May my mental agony be destroyed and may my ailments perish. O Discus, may my calamities disappear by recitation of your name."

Having said this, worshipping with devotion, and remembering Nārāyaṇa, the Destroyer of all sins, Bali worshipped the Discus. The discus then came out of the nether world rendering the demons spiritless, on the day of the Southern Equinox.[157]

The most famous of these devotional hymns, however, is the *Ṣoḍaśāyudhastotram*, which is traditionally attributed to the South Indian philosopher Vedāntadeśika (?1269–1369), the most important of the Vaiṣṇava scholastics who followed the medieval theologian Rāmānuja (?1017–1137). Vedāntadeśika was born at Kanchipuram, but spent a substantial portion of his life at Srirangam, one of the four most important pilgrimage centers of the Vaiṣṇava faith in South India.[158] His hymn, the *Ṣoḍaśāyudhastotram*, is traditionally said to have been inspired by weapons held in the hands of a sixteen-armed image of Sudarśana set up in a special shrine in the Srirangam Temple sometime before 1300 A.D.[159] Because of its literary interest and relevance to the study of the iconographic development of the sixteen-armed images of Sudarśana, a translation of the entire poem is given.[160]

157. Translated in A. S. Gupta, *The Vāmana Purāṇa*, pp. 527, 528. This hymn parallels the *Garuḍa Purāṇa* ode discussed above (Notes 132, 133), in which Sudarśana is described as the "grinder of all sins."

158. For a biographical study, see Satyavrata Singh, *Vedānta Deśika*, Chowkhamba Sanskrit Studies, Vol. 5 (Varanasi, 1958). For the Sanskrit edition of the *Ṣoḍaśāyudhastotram*, see P. B. Annangaracarya, ed., *Stotrāvalī Vibhāgaḥ, Śrīmadvedāntadeśika-granthamālāyām* (Kanchipuram, 1958), pp. 47–48. The four chief Vaiṣṇava pilgrimage centers are Tirupati in Andhra Pradesh, Srirangam and Kanchipuram in Tamil Nadu, and Melukote in Mysore.

159. Singh, *Vedānta Deśika*, pp. 61–62, under *Ṣoḍaśāyudha Stotra*: "It is a hymn on the 16 weapons accompanying the Sudarśana of Śrī Viṣṇu, installed in the Śrīraṅgam Temple. . . . As the poet does not suggest any purpose such as the destruction of the Turuṣkas or the Moslem Vandals, we may presume it to have been written before the sack of Śrīraṅgam in A.D. 1310." Elsewhere, reference is made to a more devastating assault on Srirangam in 1327 (p. 26).

160. The Sanskrit text of the hymn is as follows:

1) *svasaṃkalpakalākalpairāyudhairāyudheśvaraḥ*
 juṣṭaḥ ṣoḍaśabhirdivyair juṣatāṃ vaḥ paraḥ pumān

2) *yadāyattaṃ jagaccakraṃ kālacakraṃ ca śāśvatam*
 pātu vastatparaṃ cakraṃ cakrarūpasya cakriṇaḥ

3) *yatprasūtiśatairasan rudrāḥ paraśulañchitāḥ*
 sa divyo hetirājasya paraśuḥ paripātu vaḥ

4) *helayā hetirājena yasmindaityāḥ samuddhṛte*
 śakuntā iva dhāvanti sa kuntaḥ pālayeta vaḥ

5) *daityadānavamukhyānāṃ daṇḍyānāṃ yena daṇḍanam*
 hetidaṇḍeśadaṇḍo'sau bhavatāṃ daṇḍayeddviṣaḥ

6) *ananyānvayabhaktānāṃ rundhannāśamataṅgajān*
 anāṅkuśavihāro vaḥ pātu hetiśvarāṅkuśaḥ

7) *sambhūya śalabhāyante yatra pāpāni dehinām*
 sa pātu śatavaktrāgnihetirhetīśvarasya vaḥ

8) *avidyāṃ svaprakāśena vidyārūpaśchinatti yaḥ*
 sa sudarśananistrimśaḥ sautu vastattvadarśanam

9) *kriyāśaktiguṇo viṣṇoryo bhavatyatiśaktimān*
 akuṇṭhaśaktiḥ sa śaktirāsaktiṃ vārayeta vaḥ

10) *tāratvam yasya saṃsthāne śabde ca paridṛśyate*
 prabhoḥ praharaṇendrasya pāñcajanyassa pātu vaḥ

11) *yam sāttvikamahaṃkāramāmanantyakṣaśāyakam*
 avyādvaścakrarūpasya taddhanuḥ śārṅgadhanvanaḥ

12) *āyudhendreṇa yenaiva viśvasargo viracyate*
 sa vassaudarśanaḥ kuryātpāśaḥ pāśavimocanam

13) *vihāro yena devasya viśvakṣetrakṣivalaḥ*
 vyajyate tena sīreṇa nāsīravijayo'stu vaḥ

1) The Lord of Weapons, who created his sixteen divine weapons with a minute fraction of his own mental energy;
May that most excellent Being grant you favor.

2) The great Discus (*cakra*) having the form of a wheel, greater even than the Wheel of the Universe or the eternal Wheel of Time;
May that discus of the Lord of the Discus protect you.

3) The divine Axe (*parasu*), among whose hundreds of epiphanies are numbered the axes wielded by the Rudras;
May that weapon of the Lord of Weapons guard you always.

4) The regal Lance (*kunta*), the mere sight of which causes the evil Daityas to flee like startled birds;
May that lance of the King of Weapons be your protection.

5) The royal staff (*danda*) which administers punishment to even the foremost of the Daityas and Dānavas;
May that sceptre of the Lord of Punishment also mete out punishment to your enemies.

6) The unimpeded Goad (*ankusa*), which restrains noble elephants and straying followers alike;
May that goad of the Lord of Weapons be your refuge.

7) The Fire with a Hundred Tongues (*satavaktrāgni*) in which the sins of men are consumed like moths attracted to a flickering flame;
May that fiery weapon of the Lord of Weapons keep you from harm.

8) The gleaming Sword (*nistrimśa*) which, taking the form of knowledge, cuts through Ignorance;
May that sword of Sudarśana bring you realization.

9) The Spear (*śakti*) of unchallenged power, which represents the potentiality of Viṣṇu's ultimate power;
May that spear also be your source of power.

10) The resplendent conch-shell (*pāñcajanya*), lustrous in appearance and in quality of sound;
May that emblem of the King of Weapons protect you.

11) The curved Bow (*dhanus*), which is said to represent the essential principle of individuation, having the senses as arrows;
May that implement of the Divine Archer protect you.

12) The celestial Noose (*pāśa*), with which the Lord of Weapons ensnares all of Creation;
May that noose of Sudarśana free you from all bonds.

13) The widely-moving Plough (*sīra*) which the divine being uses to break the ground of the Universe;
May that plough help you to sow the seeds of victory.

14) The Thunderbolt (*vajra*), of which it is sung in the *Gītā*, "Of weapons I am the thunderbolt;"
May that pronged weapon made from the bones of the sage Dadhīca be your protection.

15) The Mace (*gadā*), renowned for its ability to destroy the illusory Universe, in the form of divine Intellect;
May that mace of Sudarśana restore you.

16) The Pestle (*musala*), from which all other pestles derive their power to pound and destroy;
May that pestle of the Lord of Weapons help you to obliterate Delusion.

14) *āyudhānāmaham vajramityagīyata yassa vah
avyāddhetīsavajro'sāvadadhīcyasthisambhavah*
15) *viśvasamhṛtiśaktiryā viśrutā buddhirūpiṇī
sā vassaudarśani bhūyādgadāpraśamani gadā*
16) *yātyatikṣodaśālitvam musalo yena tena vah
hetīsamusalenāśu bhidyatām mohamausalam*
17) *sūlidṛṣṭamanorvācyo yena śūlayati dviṣaḥ*

bhavatām tena bhavatāt triśūlena viśūlatā
18) *astragrāmasva kṛtsnasya prasūtim yam pracakṣate
so'vyātsudarśano viśvamāyudhaih ṣodaśāyudhaḥ*

Note that the order of the weapons, to each of which a separate verse is dedicated, exactly corresponds to the sequence in the iconographical description of the sixteen-armed Sudarśana given in *Ahirbudhnya-Saṃhitā* 37.13–15 (see below, Part Two, especially Note 322).

17) The Trident (*triśūla*), with whose divine assist-
ance Sudarśana, whose *mantra* was revealed by
the Lord of the Trident, threatens the enemy;
May that trident assuage your pain.

18) The divine Being, who is the source of all the
sixteen weapons which he bears;
May that Sudarśana protect and uphold the
Universe with those selfsame arms.

In addition to the above, Vedāntadeśika wrote another devotional hymn to Sudarśana in eight
verses called the *Sudarśanāṣṭakam*, in which every stanza ends with the lyric refrain: *jayajaya
śrīsudarśana, jayajaya śrīsudarśana* ("Victory, Victory O Sudarśana; Victory, Victory O Sudar-
śana").[161]

Attributed to an otherwise unknown author by the name of Kūranārāyaṇa is a collection of one
hundred hymns to Sudarśana called the *Sudarśanaśataka*.[162] Judging from the more elaborate *kāvya*
style of these hymns, the collection may tentatively be assigned to the sixteenth or seventeenth
century; the introductory hymn is translated as follows:[163]

Emitting in every direction effulgent rays whose fiery
splendor overpowers even the radiant sun;
Possessed of a blazing heat capable of healing the
gaping wounds of the world caused through the
darkness of ignorance within and without;
Eager to make widows of the wives of the loudly
roaring demons spoiling for battle;
That blinding splendor of Sudarśana continuously
burning, may it bestow upon you all of your desires
and more!

(*saudarśanyujjihānā diśi vidiśi tiraskṛtya sāvitramarcir-
bāhyābāhyāndhakārakṣatajagadagadaṅkārabhūmnā
svadhāmnā
doḥkharjūdūragarjadvibudhahripuvadhūkaṇṭhavaikalya-
kalpā jvālā jājvalyamānā vitaratu bhavatāṃ
vīpsayābhīpsitāni*)

In the later medieval period, when Tāntrism reached a peak of development, the devotee
increasingly strove to achieve a mystic vision of the cosmic nature of Sudarśana in order to plunge
himself into indescribable bliss. The most elaborate literary description of the noumenal
Sudarśana is that found in the late Vaiṣṇava *Upaniṣads*:

Flaring with its tens of thousands of spokes, of the
aggregate aspect of tens of thousands of spokes, fully
displaying its unsurpassed glory of the form of the
infinite number of celestial weapons and celestial
powers in their entirety, the embodiment (as it were)
of the unrestricted flow of Mahā-Vishnu's (powers),
extending over tens of thousands of ten-thousands
crores of Yojanas (units of nine miles), adorned with

161. Annangaracarya, ed., *Stotrāvalī Vibhāgaḥ*, p. 48. The
mention of Ahirbudhnya in v. 2 of this hymn apparently is a
reference to the *Ahirbudhnya-Saṃhitā*. According to Schrader, "in
the fourteenth century the famous Vedāntadeśika wrote a special
work on the Pāñcarātra in which he mentions" numerous texts,
including the *Ahirbudhnya-Saṃhitā* (*Introduction to the Pāñcara-
tra*, p. 18). For Vedāntadeśika's study of the Pāñcarātra, see M.
Duraiswami Aiyangar and T. Venugopalacharya, eds., *Śrī Pāñcar-
ātrarakṣa of Śrī Vedānta Deśika*, 2nd ed. Adyar Library Series, Vol.
36 (Madras, 1967).

162. Published in Durgaprasad and K. P. Parab, eds.,

Kāvyamālā, Part 8 (Bombay, 1891), pp. 1–51. For a brief
reference to the author Kūranārāyaṇa, see M. Krishnamachariar,
History of Classical Sanskrit Literature (Madras, 1937), p. 281;
Krishnamachariar's suggestion that Kūranārāyaṇa may also be
the author of a biography of a Vaiṣṇava saint born in 1039
provides no evidence for the dates of Kūranārāyaṇa himself.

163. Concerning the date of the hymns, that in v. 80 of the
collection, the weapons of the personified discus are listed in
exactly the same order as that found in a bronze icon of the
sixteen-armed Sudarśana dating to the seventeenth century (see
Part Two, discussion of Figure 48, and Note 337).

countless multitudes of flame, as the prime cause of the multitudinous forms of well-being of the celestials, as the proper abode of the countless sacred waters of the celestials, in this manner, the great discus, Sudarśana, shines forth in all its glory.[164]

Approaching closer to this great mass of blinding radiance, the devotee perceives that there are five circles within the celestial disk, the outer having 1000 spokes, the next 600, then 300, 100, and finally 60.[165] In the center of the wheel with 60 spokes, "there shines forth the cakra of six corner-angles," within which stands the *sudarśana-puruṣa* "effulgent with the lustre of infinite crores of suns, simultaneously risen."[166]

Despite the hyperbole of this ecstatic vision, it seems almost certain that the author of the Vaiṣṇava *Upaniṣads* was aware of certain iconographical features of actual Sudarśana images.[167] On the basis of the chronological evidence afforded by existing images, it appears that Sudarśana icons began to be produced in greater numbers from about the latter half of the sixteenth century. It is probably not a coincidence that the earliest nonsectarian treatise containing descriptions of multi-armed images of Sudarśana also dates to about this same period. This treatise is the *Śilparatna*, whose author, Śrī Kumāra, was supposedly a Kerala Brahmin who lived toward the end of the sixteenth century.[168] In addition to explicit iconographic descriptions of the eight and sixteen-armed forms of Sudarśana, which will be discussed in Part Two of this study, the text characterizes the deity as the "destroyer of the life of all enemies" (*ripu-jana-prāṇa-saṃhāra-cakram*).[169]

Besides the above allusions to Sudarśana in devotional and iconographic literature, the *cakra* as an actual weapon is also referred to in medieval narratives and even treatises on statecraft. An example of the former is the twelfth-century South Indian narrative *Kaliṅgattu Paraṇi*, which implies that the education of a prince should include training in the "five kinds of weapons, beginning with the discus."[170] In the later medieval period references to the *cakra* are found in the political treatises *Śukranīti* and *Nītiprakāśika*.[171] Like the *Agni Purāṇa*, the *Śukranīti* describes the several "motions connected with the hurling of the weapon,"[172] while the very late *Nītiprakāśika* "enumerates among the projectile . . . weapons four kinds of *cakras:* the

164. T. R. Srinivasa Ayyangar, trans., *The Vaiṣṇavopaniṣads*, Adyar Library Series, No. 52 (Madras, 1945), pp. 158, 159.

165. *Ibid.* Although frequent reference is made in the *Ahirbudhnya-Saṃhitā* to wheels with 1000 spokes, none is described as having 60 spokes; instead we find mention (42.67) of a *cakra* with 64 spokes (see also Part Two, Note 208).

166. *Ibid.*, p. 160. The Sanskrit original for the phrase "cakra of six corner-angles" is *ṣaṭ-koṇa-cakra*; this important symbolic element in the iconography of multi-armed Sudarśana images will be discussed in Part Two (see especially Figure 61, and Notes 366–370).

167. For example, the *ṣaṭ-koṇa-cakra* mentioned in the preceding note.

168. See K. Sambasiva Sastri, ed., *The Śilparatna of Śrī Kumāra*, Trivandrum Sanskrit Series, Nos. 75, 93 (Trivandrum, 1922, 1929); cf. Haridas Mitra, *Contribution to a Bibliography of Indian Art and Aesthetics* (Santiniketan, 1951), p. 215. The first part of the text deals with architectural matters, while the second treats iconography and related topics.

169. *Śilparatna* (Vol. 2) 23.6 (for the complete Sanskrit text of the iconographic references to Sudarśana, see below, Part Two, Notes 329, 346).

170. Cited in Wijesekera, "Discoid Weapons," p. 253. The prestige which attached to the use of the *cakra* as weapon in the *Kaliṅgattu Paraṇi* seems to be a direct survival of its fabled association with the *kṣatriya* deities Indra and Viṣṇu.

171. *Ibid.*, pp. 252, 253.

172. *Ibid.*, p. 253.

daṇḍa-cakra, or the lethal discus, *dharma-cakra,* the wheel of righteousness, *kāla-cakra,* the discus of Death [Time], and *aindra-cakra,* the discus of Indra." [173] These last references indicate that the concept of the *cakra* as a noble instrument of war was never lost sight of, even in the face of the esoteric symbolism which accrued to it in the medieval period.

173. *Ibid.,* p. 252; it is remarkable that this "very late text on diplomacy" would ascribe a special type of *cakra* to the Vedic god Indra; however, it may be that the term *aindra* should be translated in some general sense such as "royal" or "noble"—in which case the *cakra* as a symbol of princely authority may be implied.

The Iconographic Tradition: The *Cakra* As Personification And Icon

I The Two-Armed *Cakra-Puruṣa* in Attendance Upon Viṣṇu

Early Vaiṣṇava Iconography (*ca.* 200 B.C.–400 A.D.)

LITTLE IS KNOWN about the role played by image worship in the early development of the Bhāgavata Sect, primarily because no early Viṣṇu icons survive. As we have seen, the *Mahābhārata* extols Vāsudeva-Kṛṣṇa-Viṣṇu in his syncretistic role as a divine warrior whose chief weapon is the discus, described as a sharp-rimmed wheel with spokes. The *cakra* may have been used as an early aniconic equivalent for the deity since spoked wheels frequently appear as devices on coins in the early centuries before and after the commencement of the Christian era—although in most instances it is uncertain whether these reflect Buddhist or Bhāgavatist symbolism.[174] However, the wheel device on a unique silver coin bearing the legend *vṛṣṇi-rājanya-gaṇa* ("warrior tribe of the Vṛṣṇi"?) and dating to the first century B.C. appears to have definite Vaiṣṇava connotations.[175] On the basis of the legend, this coin has been identified as

Fig. 1. Wheel device on reverse of
vṛṣṇi-rājanya-gaṇa coin

174. Banerjea, *Development of Hindu Iconography*, p. 137: "The commonest symbol to be found on the early punch-marked coins of India, designated by scholars as solar, is the wheel and its numerous variants. Foucher finds in them so many forms of the *Dharmacakra* symbol, but the . . . suggestion that most of them stand for the sun is more acceptable. . . . the spoked wheel and its variants appearing on some tribal coins may stand for the Sudarśana of Viṣṇu, and Vedic Viṣṇu was an aspect of the Sun god with whom Vāsudeva was identified." While the suggestion that many of the spoked-wheel devices on early coins indeed represent the discus is quite plausible, it is unlikely that these same devices function simultaneously as solar symbols.

175. For the numismatic description of the coin, see A. Cunningham, *Coins of Ancient India* (London, 1891), p. 70 and Pl. IV, 5; also John Allen, *Catalogue of the Coins of Ancient India* (London, 1936), pp. clv-clvii, 281, and Pl. XVI, 5. Allen translates the reconstructed legend as "protector of the tribe of Vṛṣṇirājanya (or of the warrior tribe of the Vṛṣṇis?)." Since the legend occurs in Kharoṣṭhī script as well as Brāhmī, Allen suggests that the provenance may be northern Punjab. The iconographical aspects of the coin are discussed in Banerjea, *Development of Hindu Iconography*, pp. 131, 132: "The elaborate wheel appearing on the reverse of the unique silver coin of the Vṛṣṇi Rājanya gaṇa has been described by Cunningham and Allen as a *dharmacakra*; but its appearance on a coin of Vṛṣṇirājanya, with which clan according to consistent Epic and Puranic tradition the name of Vāsudeva-Kṛṣṇa is associated, makes it highly probable that the *cakra* stands for the *Sudarśanacakra* of Vāsudeva-Viṣṇu, one of the best revered symbols among the early Pāñcarātrins and the Vaiṣṇavas."

a local issue of the Vṛṣṇi clan—to which, according to the *Mahābhārata*, Vāsudeva-Kṛṣṇa belonged—and the wheel device on the reverse taken to be a stylized representation of the *sudarśana-cakra*. If this interpretation is correct, then the coin provides valuable evidence attesting to the historicity of the Vṛṣṇi clan, and of course also suggests that the *cakra* had a special significance for the clan members.

However, if we assume that the fragmentary account of Megasthenes, the Seleucid ambassador to India, actually refers to a Kṛṣṇa cult in the region of Mathura about 300 B.C., we would expect to find more concrete archaeological evidence for the cult's existence.[176] In this connection, it should be noted that excavations at Besnagar have recently revealed the outlines of an ancient elliptical shrine dating to the second or third century B.C. which probably once contained an image of Vāsudeva-Kṛṣṇa.[177] Immediately adjacent to the newly excavated shrine stands the well-known inscribed votive pillar of Heliodoros, which was apparently set up about 100 B.C. within the enclosure of a presumably long-established temple of Vāsudeva.[178] In the inscription on the shaft, the pillar is referred to as a *garuḍa-dhvaja,* or Garuḍa standard—probably indicating that there was once a sculptured image (now lost) of the bird emblem of Viṣṇu surmounting the capital.[179] In view of the importance of the *cakra* as the chief symbol of Viṣṇu, it is possible that a wheel device of some sort may also have been placed on top of the pillar in conjunction with the image of Garuḍa.[180]

In addition to Vāsudeva-Kṛṣṇa, each of the other deified heroes associated with him in the *catur-vyūha* doctrine of the Bhāgavata sect seems to have had his own distinctive ensign-pillar (*dhvaja-stambha*). In fact the Besnagar explorations and excavations brought to light two types of

176. See above, Part One, Note 73.

177. M. D. Khare, "Discovery of a Vishnu Temple near the Heliodoros Pillar, Besnagar, Dist. Vidisha (M.P.)," *Lalit Kalā,* No. 13 (1967), pp. 21–27. Khare apparently dates the earliest phase of the temple to the "end of the 3rd century B.C." (p. 24). For earlier excavations at the site, see D. R. Bhandarkar, "Excavations at Besnagar," *Archaeological Survey of India, Annual Report 1913–14,* pp. 186–226. Bhandarkar uncovered remains of a stone railing surrounding a large quadrangular enclosure, which he assigned to the same period as the Heliodoros pillar, i.e., second century B.C.

178. Bhandarkar, "Excavations at Besnagar," pp. 185–189, and Pl. LIII; for the inscription, see Raychaudhuri, *Early History of the Vaishnava Sect,* p. 59; see also Chanda, *Archaeology and Vaishnava Tradition,* pp. 151, 152. Chanda translates the inscription as follows:

This Garuḍa column of Vāsudeva the god of gods was erected here by Heliodoros, a Bhāgavata, the son of Dion, and an inhabitant of Taxila, who came here as Greek

ambassador from Mahārāja Antialkidas to King Kāsiputra Bhāgabhadra.

It is remarkable that Heliodoros, who was a non-Indian by birth, should profess to be a follower of the Bhāgavata faith. His conversion probably attests to the widespread popularity of theistic *bhakti* cults as opposed to—in the words of Raychaudhuri—the "sacrifice-ridden religion of the Brāhmaṇic period" (*Early History of the Vaishnava Sect,* p. vii). For a recent estimate of the date of the Heliodoros inscription, see D. C. Sircar, *Select Inscriptions* (Calcutta, 1965), p. 88.

179. Since the earliest surviving Garuḍa images date from a much later period, it is difficult to say what such a sculpture would have looked like. However, on the analogy of the *makara* capital device also discovered at Besnagar (see below, Note 181), Garuḍa may have been represented in completely theriomorphic guise.

180. See below, the discussion of the Budhagupta pillar at Eran (Figure 13).

capitals which were probably also associated with the Vāsudeva shrine;[181] these are in the form of a *tāla* (fan-palm) and *makara* (mythological aquatic animal), known in Vaiṣṇava literature as the ensigns of Saṅkarṣaṇa and Pradyumna respectively.[182] The archaeological evidence indicates, therefore, that before the beginning of the Christian era in North India, at least three of the four deified Epic heroes of Bhāgavatism had votive pillars dedicated to them which were surmounted by their appropriate symbolic emblems. Further evidence for the existence of early cults of Saṅkarṣaṇa and Vāsudeva is found in inscriptions from Ghosundi and Nanaghat dating to the first century B.C.[183] Interestingly enough, both of these inscriptions place the name of Saṅkarṣaṇa before Vāsudeva, the reverse of the order which we would expect to find. The discovery at Mathura of an image of Saṅkarṣaṇa dating to the late second or early first century B.C.—the oldest Brahmanical icon known so far—tends to substantiate the theory that there may once have been a separate cult for the worship of the elder brother of Vāsudeva.[184] Unfortunately, there are no surviving images of Vāsudeva-Kṛṣṇa himself which may be assigned to such an early date.

The earliest extant images of Viṣṇu—or better, perhaps, Vāsudeva-Kṛṣṇa—are found almost exclusively at Mathura and date to the early Kushan period.[185] The Mathura image of the first or second century A.D. shown in Figure 1 is typical of the numerous early Viṣṇu icons produced at

181. Alexander Cunningham, *Archaeological Survey of India, Reports*, Vol. X (Calcutta, 1880), pp. 41-43, and Pl. XIV; Bhandarkar, "Excavations at Besnagar," pp. 189, 190, and Pl. LIV a, b; cf. also Chanda, *Archaeology and Vaishnava Tradion*, pp. 161-163.

The recent excavations at Besnagar appear to indicate that as many as eight pillars were aligned on a north-south axis at the eastern entrance of the shrine, with perhaps two dedicated to each of the four deified Epic heroes.

182. Bannerjea, *Development of Hindu Iconography*, p. 104; cf. *Sāttvata-Saṃhitā* 5.9-21, translated in Schrader, *Introduction to the Pāñcarātra*, pp. 152-154. According to this text, the chief weapons and ensigns of the four deified heroes of the Vṛṣṇi clan are:

	Weapons		Ensign	
VĀSUDEVA:	*cakra*	(discus)	*garuḍa*	(celestial
	gadā	(mace)		bird)
SAṄKARṢAṆA:	*hala*	(plough)	*tāla*	(fan-palm)
	musala	(pestle)		
PRADYUMNA:	*dhanus*	(bow)	*makara*	(mythical
	śara	(arrow)		aquatic animal)
ANIRUDDHA:	*khaḍga*	(sword)	*ṛṣya*	(antelope)
	carma	(shield)		

183. For the Ghosundi inscription, see Chanda, *Archaeology and Vaishnava Tradition*, p. 163; where the following translation is given: "A stone enclosure of worship for Bhagavats Saṃkarshaṇa and Vāsudeva . . . has been erected within the enclosure of Nārāyaṇa by the Bhāgavata Gājāyana, son of Pārāśarī . . ."

Chanda comments that the term *"Nārāyaṇavāṭa* or the enclosure of Nārāyaṇa denotes the compound of a temple or place of worship of Nārāyaṇa"; but cf. Raychaudhuri, *Early History of the Vaishnava Sect*, pp. 64, 65: "The name Nārāyanbāta, applied to the village mentioned in the Ghasundi inscription in which the pūjā stone wall in honour of Saṅkarshaṇa and Vāsudeva was built, does not necessarily prove any connection between the worship of Nārāyaṇa and the cult of Saṅkarshaṇa and Vāsudeva." Sircar assigns the Ghosundi inscription on paleographic grounds to the second half of the first century B.C. (*Select Inscriptions*, p. 90).

For the Nanaghat inscription, see G. Bühler, in James Burgess, *Report on the Elura Cave Temples*, Archaeological Survey of Western India, Vol. V (London, 1882), pp. 59-74; the reference to Saṅkarṣaṇa and Vāsudeva occurs in the opening invocation, which Bühler translates as follows: "[Om adoration] to Dharma [the Lord of created beings]; adoration to Indra, adoration to Saṃkarshaṇa and Vāsudeva, the descendants of the Moon, (who are) endowed with majesty, and to the four guardians of the world, Yama, Varuṇa, Kubera and Vāsava [Indra] . . ." See also Sircar, *Select Inscriptions*, pp. 192ff; where the Nanaghat inscriptions—usually dated to the second century B.C.—are assigned to the latter half of the first century B.C.

184. See V. S. Agrawala, "Brahmanical Images in Mathura Art," *Journal of the Indian Society of Oriental Art*, 5 (1937), 122-130. Discovered a few miles from Mathura in 1929, the image is now in the Lucknow Museum. It is two and one-half feet in height and depicts a two-armed figure standing under a canopy of six serpent hoods and holding a *musala* (pestle) and *hala* (plough), the typical attributes of the deity.

185. *Ibid.*; see also V. S. Agrawala, *A Catalogue of the Brahmanical Images in Mathura Art* (Lucknow, 1951).

this important center of Hindu, Buddhist, and Jain iconography. The deity is shown with four arms, in accordance with the description of him as *catur-bhuja* ("four-armed") in the *Bhagavad Gītā*.[186] According to the developed Bhāgavata, or Pāñcarātra, doctrine of the *vyūhas*, Vāsudeva-Krsna's essential nature was four-fold, a synthesis of the four deified heroes into one godhead. The four arms of Visnu may perhaps have been partially inspired by the *vyūha* doctrine, but more probably this iconographic feature was invented as a solution to the problem of representing the deity's superhuman prowess.[187] The figure is dressed in princely attire and wears a turban similar to those worn by early Kushān images of Bodhisattvas. The right hand held in *abhaya-mudrā* almost certainly points to an artistic and iconographic borrowing from Buddhism. In the front left hand resting on the hip, the figure holds the *śankha*(?). In the rear hands he holds the *gadā* and *cakra* as emblems of his original heroic nature. The *gadā* is shown as a massive club, greater than the height of the figure itself. The *cakra* appears to be an actual wheel, which is grasped by the rim with the fingers placed between the spokes. Although the weapon-attributes thus clearly define the warrior nature of the deity, the image is far from compelling and completely fails to evoke the grandeur and charisma of Visnu as described in contemporary Epic literature.[188]

For approximately two hundred years at Mathura and other sites, this basic iconographic type of four-armed Visnu prevailed. Recently, however, there was discovered at Kondamotu in Andhra Pradesh an unusual Vaisnava relief, dating to the late third or early fourth century, which contains a unique two-armed representation of Visnu (Figure 2).[189] The slab depicts a seated Narasimha—the fourth *avatāra* of Visnu in the traditional list—flanked by five figures standing in greatly varied postures. These five figures are undoubtedly to be equated with the Five Heroes (*pañcavīra*)—consisting of the four *vyūhas* plus Sāmba—whose images are referred to in the Mora inscription of the early first century A.D.[190] The *pañcavīras* stand on either side of Narasimha, who is represented as a real lion with two human arms holding *gadā* and *cakra*. As already mentioned, Visnu, or Vāsudeva-Krsna—who stands to the left of Narasimha—is shown with only two arms,

186. *BhG* 11.46; see above, Part One, Note 84. Besides the image of Sankarsana already referred to, the earliest known four-armed sculpture having Vaisnava affiliations is the so-called *catur-bhuji-bhagavān* at Burhikhar, which has an insription dating to the close of the first century B.C.; see D. C. Sircar, "Burhikhar Inscription," *Quarterly Journal of the Mythic Society,* 46 (1956), 221–224. Although the stone figure carries *gadā* and *cakra* in the two rear hands, the two front hands are held in *añjali-mudrā* (gesture of adoration), ruling out the possibility that either Visnu or Vāsudeva-Krsna is represented.

187. See above, Part One, Notes 85–87. It should be noted that subsequently, in the fifth century A.D., a special iconographic type of Visnu image called Vaikuntha was developed to portray the four-fold nature of the deity expressed in the doctrine of *catur-vyūha* (see below, the discussion of Figure 5). In addition

to holding the emblems of his military might, the four arms of Visnu may also have allegorically referred to his conquest over the four directions, since as we know from Buddhist art, directional symbolism played an important part in the concept of the *cakravartin,* or universal sovereign (see above, Part One, Note 12).

188. For example, the radiant vision of Krsna as All-god described in the *Bhagavad Gītā*, which may antedate the present Mathura image by only a few generations.

189. See Abdul Waheed Khan, *An Early Sculpture of Narasimha,* Andhra Pradesh Government Archaeological Series, No. 16, Hyderabad, 1964.

190. For the Mora inscription, see above, Part One, Notes 88, 89.

with the right hand upraised in *abhaya-mudrā* and the left placed akimbo on the hip holding a *śankha*.[191] The figure also wears Viṣṇu's distinctive cylindrical crown, or *kirīṭa-mukuṭa*.[192] By transferring the rear weapon-bearing human arms of Narasimha to the adjoining figure of Vāsudeva-Kṛṣṇa, the composite four-armed figure would be virtually identical to the iconographic conception of the Viṣṇu images of the Kushān period from Mathura.[193]

Fifth–Sixth Century

In contrast to the not very impressive icons of Viṣṇu produced from the first to the fourth century A.D., the craftsmen of the Gupta period (*ca.* 320–500 A.D. and later) created a type of Viṣṇu icon that is far more powerful and dignified. The Gupta type was destined to serve as an artistic and iconographic model for centuries to come, epitomizing the importance of this period as a "classical" phase of Indian art. An early example of the developed Viṣṇu image of this period is found to the left of the doorway, on the façade of Cave 6 at Udayagiri, which probably dates to 401–402 A.D. (Figure 3).[194] This image shows a different disposition of the arms from that found in the Kushan period, especially those holding the weapon-attributes. The massive *gadā* is held downward by the right rear hand, while the left rear hand is placed on top of the spoked *cakra*, which is supported by a small pedestal stand. The *kirīṭa-mukuṭa* crown was apparently tied into place by means of streamers, the ends of which are seen fluttering behind the head. The figure also wears a *vanamālā*, or long garland, which constitutes another important attribute of the standardized Viṣṇu image. Unfortunately, the face and both of the front hands are damaged, but the figure itself conveys an impression of dignity and massive strength, enhanced by the stability

191. The identification of the five figures in the relief presents some difficulty. It would be reasonable to assume that the deified heroes would be represented in order of "seniority," beginning with Saṅkarṣaṇa (the elder brother of Vāsudeva), then Vāsudeva himself, then his two sons Pradyumna and Śāmba, and finally his grandson Aniruddha. In the relief, except for Vāsudeva and Aniruddha—the second and fifth figures, respectively, discounting Narasimha—the identity of the other heroes is uncertain. Waheed Khan (*An Early Sculpture of Narasimha*, p. 3) has identified the first figure as Pradyumna, taking the object held in the left hand as a *makara-dhvaja*; however, the more usual attributes of Pradyumna are bow and arrow, which are held by the figure standing at Narasimha's left side. The fourth figure holds what appears to be a wine cup, an attribute of Saṅkarṣaṇa, who is described in literature as being much given to drink. Saṅkarṣaṇa is usually depicted holding a *hala* and *musala*, or sometimes a club. The object held in the right hand of the first figure is surely a club of some sort. If the object held in the left hand represents a *tāla-dhvaja* instead of a *makara-dhvaja*, then the first figure could be identified as Saṅkarṣaṇa. It is possible that the sculptor may have confused some of the identifying attributes

(for the weapon-attributes of each of the four *vyūhas*, see above, Note 182).

192. Note that in most of the Mathura images of Viṣṇu, the figure wears an elaborate turban headdress, instead of the *kirīṭa-mukuṭa*, which is one of the noble insignia which Vāsudeva-Kṛṣṇa appropriated from Indra in the Epic period. Since Indra is depicted wearing the *kirīṭa-mukuṭa* in reliefs dating to the first century B.C., it seems strange that it is frequently absent in Mathura images. Could this mean that the Mathura images are based on an iconographic type of Vāsudeva-Kṛṣṇa which was developed in the region prior to the Epic identification of Kṛṣṇa with Viṣṇu?

193. However, the weapon held in the Narasimha's hand is quite different from the massive *gadā* held by the Mathura Viṣṇu; it may instead be a short sword (*khadga*), or perhaps a pestle (*musala*).

194. See Alexander Cunningham, *Archaeological Survey of India, Reports*, Vol. 10, pp. 49, 50; also D. R. Patil, *The Monuments of the Udayagiri Hill* (Gwalior, 1948), pp. 33, 34. For the inscription of Candragupta II, dated 401–402 A.D., see Fleet, *Inscriptions of the Early Gupta Kings*, pp. 21–25.

of the triangular composition. Despite a certain amount of stiffness of pose and execution, the style is essentially sophisticated, and contrasts greatly with the artistic naivete of the Kushān Viṣṇu from Mathura (Figure 1).

In the late fourth century a new iconographic type showing Viṣṇu flanked by personifications of two of his weapons, the *gadā* and *cakra,* developed contemporaneously with this traditional type of Viṣṇu image. Perhaps the earliest surviving examples of Viṣṇu's weapons shown in human form are those found in the other relief of Viṣṇu on the facade of Cave 6 at Udayagiri, at the right of the doorway (Figure 4).[195] The personifications are depicted as small attendant figures standing on either side of the monumental figure of Viṣṇu. The hierarchically greater size of the central figure now for the first time effectively conveys the impression of a superhuman being. By their proximity to divine Viṣṇu, these small figures add to the regal grandeur of the image. Their more relaxed postures also tend to mitigate somewhat the rigid hieratic frontality of the central figure of the triad. The personifications are substituted for the actual weapons held by Viṣṇu in the preceding relief (Figure 3). The sex of these personifications, and in fact of all *āyudha-puruṣas,* was determined quite arbitrarily by the gender of the Sanskrit word for the weapon-attribute.[196] Thus, the personification of the mace is shown as a female figure (*gadā-devī*) standing at Viṣṇu's right hand, while the personification of the discus (*cakra-puruṣa*) is shown as a two-armed, slightly dwarfish male figure (theoretically, of course, the figure should be a eunuch, since the word *cakra* is neuter).[197] Behind these small damaged figures are placed the actual weapons which they personify. With his two rear hands Viṣṇu grasps the fluted top of the mace projecting above the head of *gada-devī* and the spoked wheel which encircles the head of the *cakra-puruṣa* like an aureole. From a religious point of view, the presence of the *āyudha-puruṣas* may have provided a psychological stimulus to greater devotional involvement of the worshipper with the icon. By identifying with the personifications, the devotee could not only comprehend more easily the deity's cosmic nature but could also perhaps find spiritual reassurance in the gentle and protective gesture with which Viṣṇu seemingly draws the small figures to himself. This impression of compassion may have been reinforced by the position of the now destroyed front right hand. This hand presumably would have been held in the gesture signifying free bestowal of divine grace to the faithful devotee.[198] Throughout the long history of development of the attendant *cakra-puruṣa*

195. Cunningham, *loc. cit.*; see also Pl. XVII. This relief is directly beneath the inscription referred to in the preceding note.

196. See Gopinatha Rao, *Elements of Hindu Iconography,* Vol. 1, pp. 287ff.

197. See Sivaramamurti, "The Weapons of Vishnu," p. 128: "The first variety [of the *āyudhapuruṣas*] is dwarfish answering the description in Kālidāsa's verse" (*Raghuvaṃśa* 10.60: *guptam dadṛśurātmānaṃ sarvaḥ svapneṣu vāmanaiḥ/ jalajāsigadāśārṅga cakralāñcitamūrtibhiḥ//*). However, *gadā-devī,* though always hierarchically smaller than Viṣṇu, is never represented as a dwarf. It

is possible that the dwarfish form of the *cakra-puruṣa* (and certain other personifications) may be an attempt to convey the idea of some sort of physical abnormality, in substitution for the abnormality implied by the neuter gender of the word for discus. However, the dwarfish form does not become a rigid iconographic convention.

198. Cf. Figures 21 and 22, where the front right hand holds a lotus-bud (*padma*); however, the gesture itself, with the open palm of the hand extended outward toward the devotee, probably also represents the *varada-mudrā.*

motif—from the fifth through the thirteenth century—the underlying devotional significance of the personifications remained essentially unaltered, even though its impact gradually diminished in intensity.[199]

Other fifth-century Viṣṇu icons conform fairly closely to the type first encountered at Udayagiri, although of course there are stylistic and certain minor iconographic differences in the various regional sculptural traditions. The late fifth-century standing Viṣṇu from Mathura shown in Figure 5 is more sophisticated but somewhat less dynamic than the Udayagiri relief. The figure is more suave in appearance and more attenuated, with a vertical emphasis that is enhanced by the thin sacred thread (*upavīta*) and hanging garland (*vanamālā*), which here falls almost to the ankles. The figure of *gadā-devī,* though much worn, is greatly similar to her counterpart in the Udayagiri relief, except for the pose of the hands, which here are clasped together (in *añjali-mudrā?*). The *cakra-puruṣa,* who is much more noticeably dwarfish in appearance, folds both arms across his chest in a gesture of uncertain significance.[200] The Viṣṇu image itself is of the composite type, with boar and lion heads emerging from the neck of the deity (another face is supposed to be at the back), that has been referred to as Vaikuṇṭha.[201] This four-fold face (*catur-mūrti*) of the deity apparently symbolizes the Pāñcarātra doctrine of the four *vyūhas,* or emanations, of the godhead Vāsudeva-Kṛṣṇa-Viṣṇu.[202] However, the boar and lion probably refer as well to the Varāha and Narasiṃha *avatāras* of the deity. Also from Mathura is an unusual relief depicting a Viṣṇu seated in a crouching position with knees spread wide apart, dating to the first half of the fifth century (Figure 7). The front right hand is upraised in *abhaya-mudrā,* while the outstretched rear left and right hands are placed on the weapon attributes projecting above heads of the personified *gadā* and *cakra.* Both personifications sit at Viṣṇu's feet in postures of ease, suggestive of their relationship of intimacy with the deity.[203]

199. The *cakra-puruṣa* and the *gadā-devī* served, in effect, as models of piety to be emulated by the devotee; later, when numerous other attendant figures were added to the stele, the clarity of these models was obscured.

200. Although it would be tempting to interpret the crossed arms as a visual metaphor for the spokes of a wheel, it seems more probable that the gesture is merely a conventional one, signifying self-assurance, or perhaps merely devotion. It also occurs in representations of the *triśula-puruṣa* of Śiva; see Agrawala, "Cakra Puruṣa in Early Indian Art," Figs. 7 and 8 (cf. Fig. 6); cf. also the Deogarh *cakra-puruṣa* (Figure 18 in this text).

201. See Banerjea, *Development of Hindu Iconography,* pp. 409, 410.

202. *Ibid.*; cf. Shah, *Viṣṇudharmottara-Purāṇa,* Vol. 1, p. 163. According to these sources each of the four *vyūhas* has a distinctive countenance and is associated with a particular *guṇa* (divine "characteristic") and direction; these are given in the following table.

For the full list of the six *guṇas* of the transcendental deity, see above, Part One, Note 87 (for the ensigns and weapons of the

	Countenance	*Guṇa*	Direction
VĀSUDEVA:	human	*bala* ("strength")	East
SAṄKARṢAṆA:	lion	*jñāna* ("knowledge")	South
PRADYUMNA:	boar	*aiśvarya* ("lordship")	North
ANIRUDDHA:	horrific	*śakti* ("potency")	West

vyūhas, see above, Note 182).

203. The feeling of intimacy, or being at ease with the deity, is an important part of the iconographic conception. The Bhāgavata sect emphasized the doctrine of *bhakti,* or loving devotion to the deity. This doctrine stands in marked contrast to the precepts of the orthodox Brāhmaṇical religion since it maintains the greater efficacy of devotion over ritual sacrifice in the attainment of salvation.

The *cakra-puruṣa* in all periods is placed almost invariably at Viṣṇu's left side. However, in a fifth-century stucco image of Viṣṇu from the Maṇiyār Maṭha at Rajgir, the usual positions of the personified *gadā* and *cakra* are reversed (Figure 6).[204] Instead of grasping the tops of the weapon-attributes behind the heads of the personifications, Viṣṇu places his hands directly on their shoulders. This gesture of affection, along with the winsome facial expressions on all three figures, creates a mood of pleasant companionship that exemplifies the underlying humanistic approach to religious imagery during the Gupta period. The aristocratic bearing and elegant attire of the figures seem to reflect the importance of courtly fashions on the development of iconographic types. Indeed the urbanity of the devotional images reveals the special synthesis of secular and religious values that is a hallmark of the civilization of the Classical Age.

Of the fairly extensive and widely distributed group of *cakra* personifications of the Gupta period, the example most frequently referred to by scholars is that depicted on a unique type of Gupta gold coin which was recovered from the important Bayana hoard unearthed in 1946 (Figure 8).[205] This coin has been attributed to the emperor Candragupta II (*ca.* 376–415), partly on the basis of typology but largely because of the similarity of the reverse legend *cakravikrama* to other coin epithets of this great Vaiṣṇava ruler.[206] The obverse of the coin contains a tableau with two figures facing each other. At the left a two-armed figure stands in front of an elliptical rayed disk which entirely surrounds the upper part of his body. This disk is quite obviously a stylized—and perhaps foreshortened—representation of a wheel, which apparently has a double rim pierced by numerous spokes that terminate in small projecting knobs. The figure stands in a conventionally elegant pose, with hips thrust to one side and the axis of the body exaggeratedly bent. With the left hand he holds a downward pointing club or mace, while with the extended right hand he offers three small round objects to the princely figure (presumably Candragupta II) standing on a slightly lower level at the right. The divine personage standing within the rayed disk was at first equated by scholars with Viṣṇu himself; subsequently, however, the figure was identified as Viṣṇu's personified discus, in the role of intermediary between the king and the deity.[207] This tableau has been explained as an allegorical interpretation of the epithet

204. See M. H. Kuraishi and A. Ghosh, *Rajgir* (Delhi, 1944), pp. 19–21, and Pl. V, c. Most scholars seem to agree that these now destroyed stucco reliefs belong to the fifth century; in this study, a late fifth century date is preferred.

205. See A. S. Altekar, *Catalogue of the Gupta Gold Coins in the Bayana Hoard* (Bombay, 1954), pp. xci–xciii, and Pl. XVIII, 14; also *The Coinage of the Gupta Empire*, Corpus of Indian Coins, Vol. 5 (Varanasi, 1957), pp. 145–149.

206. Altekar, *Coinage of the Gupta Empire*, p. 146: "*Chakravikrama* is similar in composition to (the epithets) *Ajitavikrama* and *Siṃhavikrama*, which occur on the Horseman and the Lion-slayer types of Chandragupta II."

207. The identification of Viṣṇu was suggested by A. S.

Altekar, "Rare and Unique Coins from the Bayana Hoard," *Journal of Numismatic Society of India*, 10 (1948), 103–104; cf. C. Sivaramamurti, "Chakravikrama Type," *Journal of the Numismatic Society of India*, 13 (1951), 180–182, where it is proposed that the figure more probably represents the *cakra-puruṣa* of Viṣṇu. The same interpretation is found in V. S. Agrawala, "An Explanation of the Chakravikrama Type of Chandragupta II," *Journal of the Numismatic Society of India*, 16 (1954), 97–101. The *cakravikrama* coin was long thought to be unique, but another example was discovered a decade ago; see R. G. Chanda, "A New Chakravikrama of Chandragupta II," *Journal of the Numismatic Society of India*, 22 (1960), 261–263.

cakravikrama, which refers to one whose valor is comparable to or derived from the invincible discus of Viṣṇu.[208]

Although the peculiar elliptical form of the disk behind the body of the *cakra-puruṣa* on the *cakravikrama* coin had not been noticed previously, two other Gupta period sculptures showing figures in front of spoked elliptical disks have recently been adduced as parallels.[209] The first of these is the partially destroyed fifth-century image of Neminātha on the Vaibhāra hill at Rajgir, on the pedestal of which is a small, slightly dwarfish figure apparently representing the personification of the Jaina *dharma-cakra* (Figure 9).[210] The *dharma-cakra* is shown as an oval spoked disk placed behind the figure and flanked by two conches. The Jaina *cakra-puruṣa* is similar in many respects to the one flanking the Maṇiyār Maṭha Viṣṇu (Figure 6), with which it is probably roughly contemporary.[211] The Jaina personification, however, displays the *abhaya-mudrā* and stands more frontally erect, although the flowing lines of the scarf trailing from the shoulders soften the effect of the stiff posture. The second parallel is provided by a double-sided stone relief from Salar in West Bengal, showing on each side a figure in front of a rayed disk (Figure 10).[212] This handsome sculpture, which dates to about the early sixth century, probably once served as a pillar capital device. It was unconvincingly identified some years ago as the Buddhist deity Ārya Avalokiteśvara,[213] but it is almost certainly a *cakra-puruṣa.* The sculptor has taken considerable pains to suggest an actual wheel by piercing the slab between each spoke where it joints the outer rim. The personifications, like the others discussed above, are figures of youthful appearance, with hardly any suggestion of dwarfishness. Suave in expression, with downcast eyes and smiling slightly, the figures are almost exact mirror images of each other, with the result that one figure places his right hand on his hip instead of using it to hold the lotus—an unusual departure from

208. Altekar, *Coinage of the Gupta Empire,* p. 148. The divine favor of Viṣṇu is symbolically bestowed upon his devotee Candragupta II through the agency of the personified discus. The three round pellets which the *cakra-puruṣa* offers to the great Vaiṣṇava emperor have been identified by Agrawala *et al.* as the "three symbols of royal power, viz. *prabhu-śakti, utsāha-śakti* and *mantra-śakti,* i.e. the kingly virtues of authority, energy and counsel" ("Explanation of the Chakravikrama Type," p. 97). In his article, Agrawala suggests that the inspiration for the iconographic conception of the personification standing within a spoked wheel is to be found in the *Ahirbudhnya-Saṃhitā,* and that therefore "on the basis of its internal evidence bearing on the religious conditions portrayed in it [the text] should be assigned to the Gupta period" (*ibid.*). But he misconstrues this internal evidence when he implies that the text describes a two-armed personification standing within a wheel with 64 spokes (the approximate number of spokes on the elliptical disk on the *cakravikrama* coin), citing *Ahirbudhnya-Saṃhitā* 42.67, 42.22–23, and 42.26 (*ibid.,* p. 99). The first of these passages explicitly states that it is the sixty-two armed personification that

should be depicted within a wheel having 64 spokes, while the other two passages make it quite clear (as we have shown above in Part One) that the two-armed personification was not the "norm"—as Agrawala claims—at the time of the composition of the text. For further iconographic details in the *Ahirbudhnya-Saṃhitā,* see the discussion below of the South Indian multi-armed cult images of Sudarśana (especially Notes 322, 346).

209. See R. C. Agrawala, "Cakra Puruṣa in Early Indian Art," p. 43.

210. *Ibid.*; cf. U. P. Shah, *Studies in Jaina Art* (Banaras, 1955), p. 14, and Fig. 18.

211. However, see Ramprasad Chanda, "Jaina Images at Rajgir," *Archaeological Survey of India, Annual Report,* 1925–26, pp. 125ff. Chanda assigns the image to the reign of Chandragupta II on the basis of the very damaged inscription on the pedestal.

212. See Ajit Ghose, "An Image of Ārya Avalokiteśvara of the Time of Vainyagupta," *Journal of the Indian Society of Oriental Art,* 13 (1945), 49–54, and Pl. IV (and illustration on p. 54).

213. *Ibid.,* especially p. 51.

convention. Unusual also are the earrings of strikingly different size, and the sacred thread (*upavīta*) which seems to be worn by only one of the figures.

Although the Rajgir and Salar images are the only known parallels to the elliptical disk of the *cakravikrama* coin, mention should also be made of another double-sided pillar capital with *cakra* personifications at the Basheshar Mahādev Temple at Bajaura, in the Kulu Valley (Figure 11).[214] Here also the body of the *cakra-puruṣa* is entirely surrounded by a disk, which is, however, completely circular, with petal-like rays instead of spokes. The figure is frontal and hieratic and somewhat stiffly executed. The hands are held in *añjali-mudrā,* and a scarf is knotted across the waist, with the ends hanging symmetrically down beside the legs. All of these features, however, suggest a date considerably later than the Gupta period, in any event not earlier than the seventh century.[215]

The use of the *cakra* as a heraldic emblem surmounting a pillar erected in the precinct of a Viṣṇu temple was apparently fairly common in the Gupta period. As we have already mentioned, the Heliodoros pillar of about 100 B.C. was referred to in the votive inscription as a *garuḍa-dhvaja,* or standard bearing the Garuḍa device. But in the Gupta period, the spoked disk by itself, and in conjunction with the personified *cakra,* became an equally important insignia of the deity. The Buddhist pillars surmounted by spoked wheels which were set up during the Maurya period may have served as the prototypes of the Vaiṣṇava standard-pillar with *cakra* emblems.[216] In both instances the distinctive circular form of the discus would have been immediately recognizable even from a distance. This would have been so even when the *cakra* device behind the head of the personification was relatively small, like the spoked wheel in the well-known sculpture from Pawaya with two figures standing back to back, dating to the fifth century and now in the Gwalior Museum (Figure 12).[217] This image, which was probably placed on top of a free standing pillar, was formerly identified as Sūrya, and more recently as Indra-Viṣṇu.[218] The latter identification was probably suggested by the slight similarity of the small headdress (worn by only one of the two-armed figures) to the typical crowns of both Indra and Viṣṇu.[219] The unusually diminutive size of this crown, however, coupled with the absence of other iconographic traits of Viṣṇu—such as four arms, *vanamālā,* and *kaustubha*—strongly suggests that the sculpture represents not the deity himself, but his personified weapon. The gesture of *abhaya-mudrā* is apparently employed here not only because of its symbolic appropriateness, but perhaps also

214. See Jagdish Mittal, "The Temple of Basheshar Mahadev in Kulu," *Roopa-Lekha,* 32 (1961), 66–68. Mittal says that "around the site are lying many sculptures" including an image of Pāṇḍuraṅga, which seems related in style to the *cakra-puruṣa* (p. 67).

215. The sculpture quite obviously has no relationship to the existing temple, which Mittal dates to the fourteenth century (*ibid.*).

216. See Agrawala, *Chakra-Dhvaja,* pp. 17ff; Agrawala points out that the Buddhist pillars themselves go back to prototypes in the Vedic period.

217. See S. K. Dikshit, *A Guide to the Central Archaeological Museum, Gwalior* (Bhopal, 1962), pp. 13, 14, and Pl. 1.

218. *Ibid.*

219. However, the headdress worn by the image on the reverse side is in the form of a knotted turban. Dikshit also remarks that the reverse figure originally held a *vajra* in his right hand, but this is purely speculative.

because of its visual similarity to the usual *mudrā* of upraised right hand (along with the left hand on hip) of a *cakra-puruṣa* in attendance upon Viṣṇu (see Figure 6).[220]

The most famous Vaiṣṇava pillar of the Gupta period still *in situ* is that set up at Eran in 484–485 A.D., during the reign of Budhagupta.[221] Surmounting its capital is a double-sided relief of a standing figure, with a large stone wheel placed behind the head and shoulders, assumed to be Garuḍa, the anthropomorphized bird emblem of Viṣṇu (Figure 13).[222] The invocation to Viṣṇu at the beginning of the inscription states that Garuḍa is Viṣṇu's banner-ensign (*ketu*), but the pillar is referred to only as the *dhvaja-stambha* (standard-pillar) of the deity.[223] Because of the prominence of the stone disk, the figure might immediately be identified as a *cakra-puruṣa* were it not for the wing-like projections emerging from either side of the slab supporting the *cakra* and for what appears to be a serpent held in the figure's hands. Both of these have been taken to be the attributes of Garuḍa. However, the projections, whatever their function, are not wings; and the "serpent" may perhaps be a garland or lotus-stalk.[224] If the image does represent Garuḍa, it functions in relation to the stone disk almost exactly as a *cakra-puruṣa*. The conjoining of Garuḍa and the *cakra* would also anticipate the rare iconographic type which we find in later periods showing Garuḍa carrying the personified *cakra*. It is of course not surprising that Garuḍa and the *sudarśana-cakra* would be linked symbolically. The ability of the discus to fly to distant places for the purpose of destroying enemies is analogous to the mythological function of Garuḍa in his capacity as Viṣṇu's aerial *vāhana*.[225]

In addition to the above described functions of the personified discus—heraldic device, allegorical epitomization of Viṣṇu's power, and attendant figure in Viṣṇu icons—the *cakra-puruṣa* is also found in early representations of Viṣṇu reclining upon the cosmic serpent (*anantaśayin*).[226] These tend to be almost narrative in character, in contrast to the pronounced hieratic quality of icons of the standing Viṣṇu. The earliest representation of this important mythological theme, dating to the early fifth century A.D., is found at Udayagiri, carved into the face of the rock in a

220. Interestingly enough, the *abhaya-mudrā* is also displayed by the fifth-century Jaina *cakra* personification at Rajgir (Figure 9).

221. See Cunningham, *Archaeological Survey of India, Reports*, Vol. 10 (Calcutta, 1880), pp. 81, 82 and Pl. XXVI. For the inscription, see Fleet, *Inscriptions of the Early Gupta Kings*, pp. 88–90, and Pl. XIIa.

222. However, this identification of the figure as Garuḍa has not been formally proposed, but seems rather to have been taken for granted by present-day scholars; neither Cunningham nor Fleet (see preceding note) ventured any identification.

223. Fleet, *op. cit.*, pp. 89–90 (the invocation has been quoted above, in Part One). The expression *garuḍa-ketu* occurs in line 2; the reference to the dedication of the *janārddanasya dhvaja-stambha* ("flag-staff of . . . Janārdana") in line 9.

224. The projections are at about the level of the figure's waist and appear to have no physical connection with the image. Because the sculpture is at such a great height, it is impossible to

see the object held in the right hand clearly enough to make a positive identification. However, the way it falls across the torso is admittedly suggestive of a serpent; cf. the serpent held by the figure standing at the feet of the deity in the Viṣṇu-Anantaśayin relief at Deogarh (Figure 16).

225. By extension, Garuḍa could have also been regarded as the *vāhana* of the discus acting independently of Viṣṇu.

226. Banerjea (*Development of Hindu Iconography*, pp. 275–276) explains this iconographic type as an "elaborate plastic representation of the cosmic god Nārāyaṇa who is one of the constituent elements comprising the developed cult picture of Bhāgavatism or Vaiṣṇavism, the others being Vāsudeva and Viṣṇu." For the Vedic antecedents of the cosmogonic myth of Nārāyaṇa floating on the waters, see A. K. Coomaraswamy, *Yakṣas*, Part 2 (Washington, D.C., 1931), pp. 2–3ff. For a recent account of the iconographical development of Viṣṇu-Anantaśayin images, see K. V. Soundararajan, "The Typology of the Anantaśayī Icon," *Artibus Asiae*, 29 (1967), 67–84.

narrow ravine at the site (Figure 14).[227] Viṣṇu is depicted in a state of cosmic slumber, from which he will soon awaken to bring about the creation of the universe. The deity holds no weapon-attributes. However, among the figures on the back wall of the niche directly above the damaged recumbent Viṣṇu are personifications of both *gadā* and *cakra,* turned toward Viṣṇu with their hands held in *añjali-mudrā* (see detail in Figure 17).[228] The presence of the personified weapons in this scene serves both a devotional and a mythological function. According to the mythological tradition, the personifications will act as the agents of Viṣṇu to bring about the destruction of the demons Madhu and Kaiṭabha, who are shown at the far right. However, the confrontation with these demons hardly seems to be imminent. There is in fact no psychological interaction between any of the diminutive figures on the back wall of the niche. They stand in a continuous row, forming a stilted tableau which contrasts greatly with the prone yet paradoxically far more dynamic figure of Viṣṇu below.

The dramatic potential of the *anantaśayin* aspect of Viṣṇu was more effectively realized about a century later in the famous relief on the south wall of the Daśāvatāra Temple at Deogarh (Figure 16).[229] This magnificent relief epitomizes the apotheosis of Viṣṇu achieved by the Bhāgavata cult in the *Purāṇas,* where he embodies Vaiṣṇava conceptions of cosmic origins and universal sovereignty. Like the treatment of Viṣṇu in the *Purāṇas,* the relief conveys both the awesome timelessness of cosmic events occurring in remote eons past and the sensuous immediacy of a theophany unfolding before the very eyes of the devotee. The immediacy of the scene is augmented by the frieze of figures carved on a narrow ledge beneath the regally reclining body of Viṣṇu (detail in Figure 18). This frieze depicts a confrontation between personifications of four of Viṣṇu's weapons and the demons Madhu and Kaiṭabha, who are shown standing at the left.[230] Only the personification of the sword (*khaḍga*) actually prepares to do battle with the demons, and even this figure's heroic pose and gesture of drawing his sword are largely for theatrical effect. The other personifications—bow (*dhanus*), who holds his right arm as if it were the missing weapon-attribute, and *cakra* and *gadā* at the far right—strike poses of decorous elegance more suitable to courtiers than warriors. The Deogarh *cakra-puruṣa* holds both arms folded across his

227. Soundararajan, without explanation, dates the relief to the end of the fifth century ("Typology of the Anantaśayī Icon," p. 82 and Pl. V). Surprisingly, the most exhaustive account of the Udayagiri caves is the modest guidebook by D. R. Patil, *The Monuments of the Udayagiri Hill* (Gwalior, 1948), the Anantaśayin relief being described on pp. 38, 40, and illustrated in Pl. XIII.

228. Garuḍa, who stands immediately to the left of *gadā-devī* and *cakra-puruṣa,* is depicted in the same *kinnara* guise (human-headed bird) frequently encountered on Gupta coins and seals.

229. This famous relief has been frequently reproduced. For a detailed architectural account of the temple, see M. S. Vats, *The Gupta Temple at Deogarh,* Memoirs of the Archaeological Survey of India, No. 70 (Delhi, 1952). The date of Deogarh is highly

controversial, with estimates ranging from 450 to 600 A.D., or later. Most scholars, however, tend toward the early sixth century; in this study the date is assumed to be about 540 A.D.

230. A brief resume of the myth of the combat with these two demons is given in Dowson, *Classical Dictionary of Hindu Mythology,* p. 139: "Kaiṭabha and Madhu were two horrible demons, who . . . sprang from the ear of Vishnu while he was asleep at the end of a kalpa, and were about to kill Brahmā, who was lying on the lotus springing from Vishnu's navel." Zimmer (*Myths and Symbols in Indian Art and Civilization,* pp. 61, 62) misidentifies the frieze of six standing figures below the recumbent Viṣṇu as the five Pāṇḍava heroes with their common wife Draupadī.

chest in a manner identical to that previously referred to in connection with the fifth-century Viṣṇu image from Mathura (Figure 5). The *cakra* emblem is treated in a unique fashion, as a small wheel disk with rim turned to the front and set like a diadem in the center of the elegant coiffure.

Fig. 2. Wheel device in headdress of
cakra-puruṣa at Deogarh

Aesthetic considerations—the desire to treat the *āyudha-puruṣas* in a visually uniform manner—probably led the sculptor to devise some alternative to the large circular disk usually associated with the personified *cakra*.[231] The fluted mace-head placed above the coiffure of the personified *gadā* is similarly unobtrusive. Consideration of the overall effect created by even small details seems characteristic of classical Indian sculpture of the fifth and sixth centuries, which combines richness of detail with a sensitive concern for harmony and order.

Seventh–Eighth Century

An even greater concern with visual unity and the integration of all elements of the relief—including the illusion of three-dimensional space—is evident in the more intensely dramatic version of the *anantaśayin* theme in the Mahiṣāsuramardinī Cave at Mamallapuram, dating to the second half of the seventh century A.D. (Figure 15).[232] Greatly simplified in its surface texture, the relief partially relies upon the available light, which enters the cave from the left side, to achieve its remarkable spatial effect. There are three distinct relief planes, as opposed to essentially only one in the Deogarh panel. Viewed from a distance the lower frieze at Deogarh

231. The inclusion of a large spoked wheel behind the head of the *cakra-puruṣa* would have destroyed the isocephalic pattern. Cf. the completely human depiction of Garuḍa, who is shown standing at Viṣṇu's feet with a serpent wrapped around his neck and only a beaklike ornament placed in his coiffure to indicate his theriomorphic nature.

232. See K. R. Srinivasan, *Cave Temples of the Pallavas* (New Delhi, 1964), p. 155 and Pl. XLVII. Srinivasan dates the cave to the reign of Narasimhavarman I Māmalla (*ca.* 630–668); while Soundararajan ("Typology of the Anantaśayī Icon," p. 77) suggests a date sometime before 700 A.D.

appears to belong to the same plane as the upper portion of the relief; even the recumbent body of Viṣṇu is made to conform with the rigorous frontality of the relief plane, largely forestalling any recession into depth. At Mamallapuram the *cakra-puruṣa*—who is shown as a pot-bellied dwarf—and the personified *gadā* play an important role in the creation of the scene's atmosphere of dramatic intensity. The personifications are shown on the back wall of the niche as if flying through empty space toward the right where the figures of the demons Madhu and Kaiṭabha—now greatly increased in size—loom up menacingly.[233] The overlapping of these two figures heightens their sinister appearance, even though the one in front seems about to retreat from the divine weapon personifications hurtling toward them. Both of the personifications have their right arms upraised to strike, as if in response to the slight gesture of Viṣṇu's left hand which impels them forward. The source of the pot-bellied dwarfish *cakra-puruṣa* at Mamallapuram can probably be traced back to the relief of Narasiṃha in Cave 3 at Badami, dating to about 578 A.D. (Figure 19).[234] The right rear arm of the standing Narasiṃha in this relief is upraised, with a hovering dwarfish *cakra-puruṣa* substituted for the actual weapon-attribute.

The iconography of standing Viṣṇu images of the seventh and eighth centuries A.D. throughout the subcontinent does not deviate greatly from the type which was developed in the early fifth century at Udayagiri, with the triad of Viṣṇu and two weapon personifications serving as attendants. There are nevertheless noticeable differences in the religious expressiveness of the later images which are partially attributable to the basic changes in style which distinguish Indian sculpture of the "classical" phase (fifth to sixth century) from that of what may tentatively be labeled the early "baroque" phase (seventh to eighth century). In the relief of Viṣṇu from an exterior niche of the upper cella of the Lāḍ Khan Temple at Aihole, which probably dates to the early seventh century, we are immediately aware of the balanced composition and richness of sculptural detail (Figure 21).[235] At Udayagiri (Figure 4) and Rajgir (Figure 6) the upper corners of the shallow niche were left empty with the result that the blank wall heightened the sense of isolation of the figures from their architectural environment. At Aihole, the sculptor has positioned the upper arms of Viṣṇu so as to fill the relief format in a decorative way and also to balance the two weapon personifications in the lower half of the relief. This essentially decorative approach, however, does not diminish the grandeur and expressive power of the regal central figure of Viṣṇu, whose bearing has, if anything, increased in imperiousness. The hauteur of *gadā-devī* also seems appropriate within this context, while the pose of the dwarfish

233. Srinivasan (*Cave Temples of the Pallavas*, p. 155) misiden-tifies the flying dwarfish *cakra-puruṣa* as the personification of the *śaṅkha* attribute.

234. Cave 3 at Badami is a key monument in the reconstruc-tion of the historical development of Indian sculpture of the "classical" period, not only in the Deccan, but in North India as well. A comparison of the sculptural styles of Badami and Deogarh (cf. Figures 18, 19) suggests that, although Badami is

more developed, the time interval between the two sites should be only slightly more than a generation.

235. See S. R. Balasubrahmanyam, "The Date of Lad Khan (Sūrya-Nārāyaṇa) Temple at Aihole," *Lalit Kalā*, No. 10 (1961), pp. 41–44. Balasubrahmanyam proposes a date in the mid-sixth century; he also suggests that the iconographic evidence of the sculptures in the three niches of the upper cella indicates that the temple was dedicated to Sūrya-Nārāyaṇa.

cakra-puruṣa—who leans forward against a club with his right arm resting upon the handle—seems somewhat clumsy by comparison. The presence of the club held by the *cakra-puruṣa* is an iconographic innovation, as is the omission of the wheel device behind the head of the figure.[236] Viṣṇu, who does not wear a *vanamālā*, carries the *śaṅkha* in the back left hand and holds the *cakra* with the rim turned toward the viewer—all innovative features. The position of the discus is similar to that of the small *cakra* fixed obliquely in the coiffure of the *cakra* personification at Deogarh (Figure 18).

The immediate prototype of the Aihole image may be the previously misidentified sculptural fragment of a Viṣṇu icon from Elephanta, now in the Prince of Wales Museum, Bombay, which also belongs to the period of Cālukyan rule in the Deccan (Figure 20).[237] The sculpture shows the lower part of a standing figure of Viṣṇu flanked by a headless personified *gadā* at his left and a *cakra-puruṣa* at his right. The dwarfishness of the *cakra-puruṣa* seems almost grotesque in its exaggeration.[238] The lower part of the Elephanta fragment is similar to the Aihole relief—with the exception of the club held by the *cakra* personification—thus corroborating its identification as a Viṣṇu image. In both sculptures Viṣṇu's *vanamālā* is absent. Further evidence in support of the identification of the Elephanta dwarf as a *cakra-puruṣa* is perhaps provided by the broken-off projection on top of the figure's head, which may have been a *cakra* device turned on edge like that worn by the Deogarh personification.[239]

Another important example of a Cālukyan image of Viṣṇu accompanied by personified *gadā* and *cakra* is found at Badami in a relief on the exterior of the Mālegitti Temple, dating to the third quarter of the seventh century (Figure 22).[240] In contrast to the clearly defined separation between sculpture and architectural setting—usually a shallow niche with simple frame—which we notice in Viṣṇu reliefs of the fifth century, this relief is more expressively coordinated with its architectural surroundings, in an attempt to integrate the design and structural articulation of the entire wall elevation.

236. It seems unlikely that the figure represents Garuḍa. However, the omission of the wheel attribute is puzzling; it seems to be an iconographic peculiarity of the early Cālukyan period. The addition of the club is an important iconographic innovation. Apart from the *cakravikrama* coin of Chandragupta II (Figure 8), this is the earliest occurrence of a weapon held by the *cakra-puruṣa*, whose iconographic function as a placid attendant upon Viṣṇu becomes subtly altered, anticipating the later transformation of Sudarśana into a formidable deity of destruction.

237. See Pramod Chandra, *A Guide to the Elephanta Caves*, The Heritage of Indian Art Series (Bombay, 1958), Pl. XXVI, where the sculpture is identified as a broken image of Śiva. The date of Elephanta, where this fragment was discovered, is also much debated by scholars, with estimates ranging from the mid-sixth to the eighth century. In this study the date is assumed to be about 600 A.D.

238. The degree of dwarfishness in the representation of the *cakra-puruṣa* seems to depend upon both chronological and regional factors; for a hypothetical explanation of the dwarfish-

ness of this and other personifications, see above, Note 197.

239. A further possible iconographic parallel between Elephanta and Deogarh is found in another fragment of a Viṣṇu icon in the Prince of Wales Museum. This fragment, which is unpublished, shows only a small portion of the probably dwarfish *cakra-puruṣa* which originally stood at the left side of the deity. Unlike the hand positions of the personification in Figure 20, it appears that the *cakra-puruṣa* in this fragment held his arms folded across his chest, in the same manner as the Deogarh figure (Figure 18).

240. See H. Cousens, *Chālukyan Architecture of the Kanarese Districts* (Calcutta, 1926), pp. 53–54 and Pl. XXXIII (the accompanying text illustration showing the elevation of the north side of the temple is derived from Cousens, Pl. XXXII). The Mālegitti "Śiva" temple, which appears—despite its present associations—to have been originally dedicated to Viṣṇu, is usually assigned to about 600 A.D., but comparison with the Meguti temple at Aihole dated 634 A.D. clearly points to a relatively later date, i.e., not earlier than about 675 A.D.

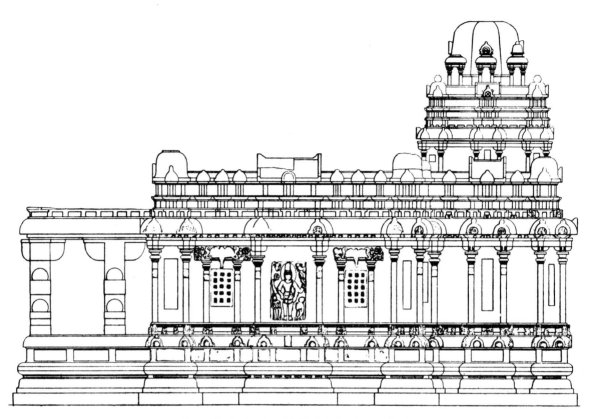

Fig. 3. North elevation of Mālegitti Temple at Badami

Although compositionally similar to the Aihole Viṣṇu, this relief is clearly later, as evidenced by its elaboration of both iconographic and stylistic features. While the Aihole relief is recessed into the architectural niche, the figure of Viṣṇu at Badami appears to project out from the wall of the temple. The flying dwarfish *gaṇas* in the upper corners of the relief impart a new quality of movement to the relief that is echoed by the contorted bodies of both the voluptuous *gadā-devī* at the left and the dwarfish personified *cakra* at the right. Both are turned obliquely into the concave recesses at the lower part of the relief slab. As in the Aihole relief, the usual wheel device behind the head of the *cakra-puruṣa* is conspicuous by its omission. The personified *gadā* wears the same sort of stylized, fluted mace device in her distinctive headdress as in the earlier relief. Concerning other attributes carried by Viṣṇu at both Aihole and Badami, the slightly uplifted front right hand apparently holds a *padma,* or lotus. The earlier, more damaged Viṣṇu images discussed above may also have held this emblem.[241] At both Aihole and Badami the *śaṅkha* has been transferred to the upper left hand, with the result that the figure places the front left hand on the hip instead of using it to hold an attribute. The Badami Viṣṇu holds the *cakra* at a slight angle and not

241. Thus it seems very likely that the two reliefs at Udayagiri (Figures 3, 4), the Mathura images (Figures 5, 7), and the stucco figure at Rajgir (Figure 6) would all have depicted Viṣṇu holding a lotus in his front right hand.

vertically, as in the earlier Aihole relief.[242] On the analogy of the Badami Narasiṃha relief (Figure 19), in which personifications are substituted for the actual weapon-attributes held in the upper hands, it is possible that the flying dwarfish figures placed behind the *cakra* and *śaṅkha* in the relief on the Mālegitti Temple also represent the personifications of these attributes.[243]

The stance and disposition of the hands of the Badami *cakra-puruṣa* are paralleled in an apparently unfinished Viṣṇu icon of the seventh century from Kanauj, now in the Baroda Museum (Figure 23).[244] Although the Kanauj *cakra-puruṣa* is not depicted in dwarfish guise, the two images have much in common stylistically. The attributes of the Kanauj Viṣṇu are held in different positions, but the lack of the distinctive discus emblem behind the head of the *cakra-puruṣa* constitutes another iconographic parallel with the Cālukyan images. The *gadā* personification also seems to lack an emblem, although both personifications have simple circular halos behind their heads, and—following North Indian tradition—Viṣṇu's right hand is actually placed on the head of *gadā-devī*.[245]

The absence of a spoked wheel behind the head of the Kanauj *cakra-puruṣa* is difficult to explain, for it is almost invariably present in other seventh- and eighth-century Viṣṇu images from North India. The discus emblem is especially prominent, for example, in a seventh-century bronze Viṣṇu from Kashmir, now in Berlin (Figure 24 and detail in Figure 25). This remarkable bronze was formerly dated to the fourth century because of supposedly Gandhāran features in the treatment of the physiognomy of Viṣṇu—especially the pronounced musculature of the torso—and the archaized character of the turban headdress (whose central portion suggests a stylized *cakra*).[246] The heads of a lion and boar projecting from Viṣṇu's neck identify the figure as Vaikuṇṭha, or the embodiment of the *catur-vyūha* doctrine of the Pāñcarātra sect, which was

242. In the iconographic evolution of Viṣṇu images from the Pallava to the Cōla period, the strictly vertical, edge-on position has long been regarded as an early form, with the frontal position indicating a later development. See G. Jouveau-Debreuil, *Iconography of Southern India* (Paris, 1937), Fig. 17, and pp. 59–62; also see C. Sivaramamurti, "Geographical and Chronological Factors in Indian Iconography," *Ancient India*, No. 6 (1950), p. 48 and Fig. 31, where drawings are given of examples of the appearance of the *cakra* in different periods and regional styles.

243. Cf. the image in Figure 32, which definitely depicts the *cakra-puruṣa* twice, once standing at Viṣṇu's left side, and again on the halo surrounding the deity's head.

244. The archaeological and sculptural remains from this important and extensive site have not been systematically studied; the best known example of a Viṣṇu icon from Kanauj is the Viśvarūpa image dating to about the eighth or ninth century—see C. Sivaramamurti, *Indian Sculpture* (New Delhi, 1961), Pl. 33. The present damaged image is obviously of earlier date, perhaps from the time of Harṣa (ca. 606–647 A.D.), the great ruler of Kanauj. There are several indications that the sculpture is unfinished—the undecorated *kirīṭa-mukuṭa* and the

visible chisel marks on the left front and right rear arms being the most conspicuous.

245. Possibly the halo behind the head of the *cakra-puruṣa* was meant to suggest the circular discus device. Note that the entire image is virtually freestanding, or rather that all of the upper part of the stele slab has been cut away to free the upper head, shoulders, and arms of the central figure—a characteristic feature of some early images (cf. Figures 5, 20), as well as of others also of seventh century date (Figures 32, 33). The pose and hand positions of the Kanauj *cakra-puruṣa* are virtually identical to those found in a sculptural fragment from Aphsad (Figure 30), which also dates to the seventh century.

246. The early date is given in C. Sivaramamurti, *Indian Bronzes* (Bombay, 1962), p. 14, Fig. 2. A date in the seventh century is assigned by H. Härtel, "Zur Datierung einer alten Viṣṇu-Bronze" in E. Waldschmidt, ed., *Indologen-Tagung 1959* (Göttingen, 1960), pp. 165–168; cf. also his *Indische Skulpturen*, Vol. 1 (Berlin, 1960), Pls. 42, 43. R. C. Agrawala ("Cakra Puruṣa," p. 42) agrees with the early date assigned by Sivaramamurti, referring to the style of the bronze as "late-Gandhāra."

evidently strongly established in the Himalayan region.[247] Between Viṣṇu's feet is a female figure representing the earth goddess Pṛthivī, who symbolically supports the deity.[248] The positioning of Viṣṇu's arms follows the classical prototypes of North India. The rear left hand is placed upon the rim of the large spoked wheel behind the head of the *cakra-puruṣa* (the figure of *gadā-devī* is missing). The front arms are extended outward holding a *śaṅkha* in the palm of the left hand, and a *padma* in the slightly upraised right hand. The gesture of the right hand, as well as the shape of the lotus (here an open flower instead of the lotus bud seen in Figures 21, 22), differs from that found in all preceding images. The spoked-wheel device of the dwarfish *cakra-puruṣa* is the most elaborate type encountered so far. The style of the personification shows obvious affinities with the late classical idiom of North India, especially in the treatment of the *cakra-puruṣa*'s ringlets of hair. Like Viṣṇu himself, the personification wears a mustache, a feature which is also found in another seventh-century *cakra-puruṣa* from Kashmir, now in the Royal Ontario Museum, which was once part of a now lost bronze Viṣṇu icon (Figure 26).[249] Here also the dwarfishness of the personification is exaggerated, and the broken perforated wheel is provided with arcuated ornamentation on the rim.

The contorted figure of the Berlin *cakra-puruṣa* is placed farther forward on the pedestal than the image of Viṣṇu and stands at an oblique angle, with head tilted back so as to gaze upward toward the face of the deity. This complicated posture of devotion seems to be implicitly referred to in the iconographic description given in the *Viṣṇudharmottara Purāṇa* (85.13,14):

Placed on the left side [of Vāsudeva] should be *chakra* with a big belly, furnished with all ornaments, with eyes wide open (as) in dancing. He should carry a *chāmara* and should be engaged in looking at the god. The left hand of the god should be placed on the head of that (*chakra*).[250]

(*vāmabhāgagataścakraḥ kāryo lambodarastathā
sarvabharaṇasamyukto vṛttavisphāritekṣaṇaḥ
kartavyaścāmarakaro devavīkṣaṇatatparaḥ
kāryo devakaro vāmo vinyastastasya mūrdhani*)

Although the *Viṣṇudharmottara Purāṇa* is usually dated to about the seventh century, the *cāmara*, or ceremonial fly whisk, mentioned in the above textual extract is not found as an attribute of the *cakra-puruṣa* until about the ninth century—and then only in conjunction with Viṣṇu images from

247. Schrader, who believes the provenience of the *Ahirbudhnya-Saṃhitā* to be Kashmir (*Introduction to the Pāñcarātra*, pp. 96, 97), mentions that the oldest literary work surviving in North India which quotes from the Pāñcarātra "seems to be the *Spandapradīpikā* of Utpalavaiṣṇava, who lived in Kashmir in the tenth century A.D." (*ibid.*, p. 18). For the iconography of Vaikuṇṭha, see above, Note 187.

248. In the Epic, the Sky is said to be the head of the All-god, and the Earth his feet (Hopkins, *Epic Mythology*, p. 207), while in the Varāha myth, Pṛthivī is rescued by Viṣṇu, in the form of the cosmic boar. Eventually the goddess becomes—along with Lakṣmī—one of the female consorts of the deity, and in medieval

South Indian icons is almost invariably shown standing beside Viṣṇu.

249. See Sherman Lee, "A Bronze Yaksha Image and its Significance," *Bulletin of the . . . Royal Ontario Museum*, No. 24 (1956), pp. 23–25 and Pl. 9. Lee's identification of the bronze figure as Kuvera was corrected by Härtel, "Zur Datierung einer alten Viṣṇu-Bronze," p. 176.

250. Kramrisch, *Vishnudharmottara*, p. 111. Regarding the phrase "with eyes wide open (as) in dancing," Shah remarks that Kramrisch "accepts the reading nṛtta instead of vṛtta" (*Viṣṇudharmottara-Purāṇa*, Vol. 2, p. 142n).

Kashmir and other Himalayan regions. An impressive example of this iconographic type is a ninth-century bronze Viṣṇu image inlaid with silver, originally from Kashmir and now in the Los Angeles County Museum (Figure 27).[251] In this image—which depicts Viṣṇu as Vaikuṇṭha—both the *cakra-puruṣa* and *gadā-devī* stand in contorted positions with their gaze directed upwards toward the countenance of the deity. Both also carry *cāmaras*. The wheel device behind the head of the *cakra-puruṣa* is so faintly adumbrated that it seems to be merely a halo.[252] The iconographic evidence of this and other images suggests that some portions at least of the *Viṣṇudharmottara Purāṇa* were composed in Kashmir, and that these are probably not to be dated earlier than about the eighth or ninth century.[253]

From Eastern India, there are very few examples of the personified *cakra* dating to the early post-"classical" period. The most important of these is the *cakra-puruṣa* from Aphsad in Bihar, now in the Cleveland Museum, which once formed part of a large Viṣṇu image, probably dating to the seventh century (Figure 30).[254] Stylistically this elegant figure is quite close to the sixth-century *cakra-puruṣa* at Deogarh (Figure 18). Both wear the same type of costume, the most important feature of which is the scarf hanging loosely about the hips and knotted at the figure's left thigh with the ends trailing downward. The rounded fullness of the face and the treatment of the ringlets of hair are also strikingly similar. Noticeably dissimilar is the relative proportioning of the bodies. The Aphsad *cakra-puruṣa* is far more attenuated as well as more illogical and vague in the articulation of the limbs.[255] When the full icon was intact, the left hand of Viṣṇu would have been placed on the rim of the elliptical disk behind the head of the personification.

The Aphsad slab was evidently pierced on both sides of the central figure, thus isolating the personifications in a manner similar to that of the well-known Viṣṇu image from Chaitanpur in West Bengal, now in the Indian Museum, Calcutta, which may also date to the seventh, or possibly the early eighth century (Figure 32).[256] This unusual icon has been unconvincingly identified as a unique example of an *abhicārika-mūrti* ("inauspicious-form") of Viṣṇu, mainly on

251. See John Rosenfield *et al.*, *The Art of India and Nepal: The Nasli and Alice Heeramaneck Collection* (Boston, 1966), pp. 62, 63 (Cat. No. 51). The earliest known example of a Kashmir Viṣṇu bronze accompanied by a *cakra-puruṣa* holding a *cāmara* is the damaged image in the Nelson Gallery in Kansas City; see Douglas Barrett, "Bronzes from Northwest India and Pakistan," *Lalit Kalā*, No. 11 (1962), p. 43 and Figs. 28, 29. Barrett dates this bronze to about 800 A.D.

252. See A. K. Coomaraswamy, "A Statuette of Vishnu from Kashmir," *The Museum Journal* (University of Pennsylvania), 17 (1926), 91–93. Instead of explicit attributes, the sculptor has placed identical aureoles behind the heads of the personifications in order to create a more symmetrical arrangement.

253. That the date of the *Viṣṇudharmottara* is later than the seventh century is also suggested by the text's inclusion of the aesthetic theory of *śāntarasa*, which was probably not fully

developed until the time of the Kashmiri scholar Abhinavagupta, who lived in the tenth century; see J. L. Masson and V. Patwardhan, *Śāntarasa and Abhinavagupta's Philosophy of Aesthetics* (Poona, 1969), pp. 36, 37.

254. See H. Hollis, "The Angel of the Discus," *Bulletin of the Cleveland Museum of Art*, 33 (1946), 164, 165; cf. Frederick M. Asher, "The Former Broadley Collection, Bihar Sharif," *Artibus Asiae*, 32 (1970), p. 123 and Pl. XIX, where a large Viṣṇu image from Aphsad is illustrated to which Asher believes the Cleveland *cakra-puruṣa* was once attached.

255. For a study of the transition between sculpture of the fifth to sixth century and that of the Pāla period, see Sheila Weiner, "From Gupta to Pāla Sculpture," *Artibus Asiae*, 25 (1962), 167–182.

256. See J. N. Banerjea, "An Abhicārika Viṣṇu Image," *Journal of the Indian Society of Oriental Art*, 7 (1940), 159–161.

account of the exaggerated musculature of the central figure and its general lack of artistic excellence.[257] Iconographically, of course, it is based completely on the classical type of the fifth century, retaining even the awkward positioning of the front hands holding *padma* and *śankha*. It is only in the treatment of the personifications of *gadā* and *cakra* that iconographic innovations are introduced. Both of the personifications stand in identical postures leaning toward the left and holding large staffs as tall as the figures themselves. Apparently the personifications were meant to be more aggressive in their demeanor, though the artist's lack of skill precluded the achievement of this effect. The artist also seems to have misunderstood the mace device behind the head of *gadā-devī,* which is given a strange lumpish form. Of particular iconographic interest is the second representation of the personified *cakra*—shown as a two-armed flying figure holding a discus—on the circular aureole behind Viṣṇu's head.[258]

In an approximately contemporaneous Viṣṇu image from Benisagar, and now in the Patna Museum (Figure 33), the *cakra-puruṣa* standing to the deity's right also holds the discus attribute in his hand.[259] The personification of the mace does the same with her attribute, thus providing a further iconographic precedent for the later conception of the personifications as independent agents of the divine power of Viṣṇu—whose weapons they manipulate as well as embody.[260]

Of about the same date (seventh century) as the two preceding images is a stele from Bihar, now in the Cleveland Museum, representing Viṣṇu seated on Garuḍa (Figure 34).[261] Garuḍa is shown as a large human-headed bird with outstretched wings, conforming to the iconographic type developed in the classical period. The rounded top of the stele consists of Garuḍa's tail feathers arranged in a decorative array behind the unusual crown worn by the deity. While the disposition of Viṣṇu's front hands is similar to that in the Chaitanpur image, the rear hands are placed on actual examples of the discus and mace, whose usual positions are here reversed, as they are also in the Benisagar relief. Although the male and female figures kneeling at the feet of Garuḍa appear to be donors or idealized devotees, it is possible that each of these figures also

257. Banerjea, *Development of Hindu Iconography*, p. 404, where the image is described as "sparsely ornamented, a curious string of amulets round the neck replacing the usual *hāra* and *vanamālā*; the loin-cloth devoid of any artistic arrangement is treated in a very uncouth manner; the elongated and drawn face, the big protruding eyes, the muscles and bones shown prominently and the partially emaciated belly—all these features correspond to a great extent to the *Vaikhānasāgama* description of the *Abhicārikasthānakamūrti* of Viṣṇu."

258. The dynamic flying position of this personification and the more or less aggressive stance of the *cakra-puruṣa* standing at Viṣṇu's left side reinforce the destructive connotation of the *cakra* as weapon, and provide a significant contrast to the earlier iconographic conception of the *āyudhapuruṣas* as placid devotees.

259. See Sheila Weiner, "From Gupta to Pāla Sculpture," pp. 175, 176, and Fig. 25—where the image is assigned to the first half of the seventh century.

260. That the *cakra-puruṣa* actually holds the discus attribute in his hand instead of having it placed behind his head constitutes an important change in the iconography of the personified attributes. However, the psychological implications of this change were not realized immediately, and the *cakra-puruṣa* continued for several centuries to be treated as a fundamentally placid personification. Nevertheless, it seems likely that the antecedents of the later iconographic (as opposed to literary) conception of the personified discus—as a destructive being who manipulates the weapons of Viṣṇu—are to be traced back to images like the present one (see below, Note 275).

261. In the Cleveland stele, the necklace and armbands worn by Viṣṇu are virtually identical to those of the Chaitanpur image; notice also the similar use of incised lines to emphasize the eyes and to represent the eyebrows. The beaklike device worn by Garuḍa resembles the one depicted at Deogarh (Figure 16).

symbolically represents the personification of the weapon held by Viṣṇu directly above his or her head.

However, in another stele from Bihar depicting Viṣṇu seated on Garuḍa, a male figure (similar to the preceding) who is obviously a donor appears directly below the *cakra* personification (Figure 35).[262] This massive image, which is now in the Indian Museum in Calcutta, is an important work of the early Pāla period, probably dating to the late eighth or early ninth century.[263] Compared to the Cleveland stele—which represents a continuation of the classical style—the present image shows important divergences in both style and iconography. The problem of placing a powerful figure on Garuḍa's back has been more successfully dealt with by placing Viṣṇu's feet directly on the base of the stele (instead of tucked up against Garuḍa's outstretched wings). Thus Viṣṇu sits more erectly and with greater dignity. Above the heads of the personified *cakra* and *gadā* are their identifying devices, the tops of which are held by Viṣṇu. Although the upper portion of the stele is broken, a plain halo behind Viṣṇu's head is clearly visible, superimposed against the decorative pattern of feathers. At the upper left side of this is a flying *vidyādhara* paying homage to the deity. The *cakra-puruṣa* is also shown in adoration, with his hands clasped together in *añjali-mudrā*.[264]

Ninth–Tenth Century

The images so far discussed belong to a period of Indian art sometimes labeled as classical (*ca.* 400–800 A.D.), the succeeding period usually being referred to as medieval (*ca.* 800–1200 and later). This latter, complex phase of Indian civilization was characterized by, among other things, prolific temple building, the dissemination of esoteric Tāntric doctrines, the cult of orthodoxy, and the gradual rigidification of artistic and cultural norms. The Hinduism of the *Purāṇas* became institutionalized, thus validating a multitude of mythological and ritualistic accretions to the cults of the two Supreme Deities, Viṣṇu and Śiva.[265] The Vedic sacrificial observances—which survive in remnants even today—were all but replaced by the Purāṇic practices of *pūjā* and pilgrimages to

262. See Stella Kramrisch, "Pāla and Sena Sculpture," *Rūpam*, No. 40 (1929), Fig. 3; also R. D. Banerji, *Eastern Indian School of Mediaeval Sculpture*, Archaeological Survey of India, New Imperial Series, Vol. 47 (Delhi, 1933), p. 106, and Pl. XLVIII,c. On the analogy of the later stele from Bihar, the two kneeling figures in the Cleveland sculpture are most likely donors; however, it is probably not completely coincidental that the positions of the male and female donor would also be appropriate for the weapon personifications.

263. Nalanda may be the provenance of this large image; see Asher, "The Former Broadley Collection, Bihar Sharif," p. 111 and Pl. XV.

264. The *añjali-mudrā* is not typical; the only other early sculptures in which it occurs are those shown in Figures 11, 17 (the former being a pillar-capital emblem, the latter a pseudo-narrative scene). In the Calcutta stele, the devotion of the *cakra-puruṣa* is literally emulated by the worshipping figure kneeling on the pedestal.

265. Beginning in the Epic, and continuing throughout the Purāṇic period, numerous legends which were probably originally associated with other minor deities were assimilated by both Śiva and Viṣṇu, each of whom was regarded by his devotees as the only Supreme Deity—the other being considered merely an aspect of his syncretistic nature.

holy places.[266] The "classical" and "baroque" norms of sculpture (fifth to eighth century) were lost sight of, relatively quickly in some regions and more gradually in others. Icons lost much of their humanistic character. They came to be regarded by most worshippers as sanctified ritualistic instruments or as deities incarnate.[267] The complex images of the gods which were placed on the exteriors of temples greatly increased in number. Sculpture took on an increasingly architectonic function as, coincidentally, the form of the temple itself became more sculpturesque. Thus the lucid volumes of the relatively compact shrines of the classical period metamorphosed into the ambiguous rococo masses of the towering medieval edifices.

Although the term medieval is a convenient designation, its connotations do not hold equally true for the artistic traditions in all regions of the Indian subcontinent. In at least two major regions, in fact, a classicized tradition in sculpture continued to exercise strong artistic influence from the ninth to the twelfth century. The two regions were South India under the Cōla hegemony, where the earlier Pallava artistic tradition was followed, and Eastern India under the Pāla dynasty, where the classical style of the Gupta period was revived and transformed.[268] There are no known Pallava or Cōla examples of the two-armed *cakra-puruṣa* in attendance upon standing Viṣṇu images. Throughout the Pāla period, however, images of Viṣṇu flanked by weapon personifications were produced in great numbers in Bihar and Bengal, which were important centers of both Vaiṣnavism and Mahāyāna Buddhism until the extinction of the latter following the Muslim conquest (*ca.* 1200 A.D.).[269]

One of the earliest Pāla images from East Bengal is the huge stele depicting Viṣṇu seated on Garuḍa from Lakshmankati, dating to the ninth or the tenth century (Figure 36).[270] Unlike the two preceding versions of this iconographic type (Figures 34 and 35), Garuḍa is shown kneeling in adoration in human form, supporting Viṣṇu on the outstretched wings attached to his back. The bird's beak in place of a nose serves as an identifying attribute of this partly theriomorphic personification. Despite its colossal proportions, the effect of the stele is not oppressively heavy, due to the deity's relaxed posture and the apparent ease with which Garuḍa carries his burden. With regard to the form and treatment of the attributes held in the four hands, the stele is

266. Although the Pāñcarātra doctrines are essentially non-Vedic, the other major Vaiṣnava tradition prevailing in South India—the Vaikhānasa—continues to follow many of the Vedic practices. With respect to image-worship, however, the Pāñcarātra and the Vaikhānasa traditions are essentially identical. For a study of Vaiṣnava ritual practices in South India, see K. Rangachari, *The Sri Vaishnava Brahmans* (Madras, 1931).

267. See Stella Kramrisch, *Indian Sculpture* (Calcutta, 1933), p. 93: the medieval "image fulfills the function of a Yantra. As such it has to guarantee a definite result. Each image with its exact measure and attributes, serves as a means or instrument, as limited as the average man, within the sect to which he belongs, can make use of it towards the achievement of an ultimate goal." Although the Pāñcarātra texts maintain that the image is the lowest manifestation of the deity, the elaborate rituals connected with the worship of the image assume that the deity and image are one.

268. For general surveys of the development of Indian sculpture, see Kramrisch, *Indian Sculpture*; S. K. Saraswati, *A Survey of Indian Sculpture* (Calcutta, 1957); and C. Sivaramamurti, *Indian Sculpture* (Delhi, 1961).

269. See S. K. De, *Early History of the Vaishnava Faith and Movement in Bengal*, 2nd ed. (Calcutta, 1961).

270. See Bhattasali, *Iconography of the Buddhist and Brahmanical Sculptures in the Dacca Museum*, pp. 86, 87, and Pl. XXXII; also R. C. Majumdar, ed., *The History of Bengal*, Vol. I (Dacca, 1943), p. 431, and Pl. LXI, 149. Bhattasali assigns the sculpture to the "pre-Pāla period."

iconographically unique. In his front right hand, Viṣṇu holds a spoked discus, with a diminutive two-armed *cakra-puruṣa* shown as a flying figure in the center. The flying position—which probably refers allegorically to the flight of the discus through the air—may be compared with that of the small two-armed flying figure holding a *cakra* on the aureole of the Chaitanpur Viṣṇu (Figure 32). Standing in the palm of the front left hand is the tiny female figure of *gadā-devī*, shown holding an actual mace. The positioning of *cakra* and *gadā* (whether personified or not) in the front hands of Viṣṇu is iconographically rare.[271] Because of this positioning, however, we would expect the *padma* and *śaṅkha* to be held in the deity's rear hands. Instead Viṣṇu holds—by means of stalks attached to their lotus bases—diminutive steles with images of Gaja-Lakṣmī in the right hand, and in the left, Sarasvatī playing a musical instrument.[272] Both Lakṣmī and Sarasvatī are consorts of Viṣṇu, and their inclusion here reflects the influence of Tāntric beliefs upon Vaiṣṇava imagery. In Tāntric literature, the female consorts are speculatively regarded as hypostases of the divine energy (*śakti*) of the gods. The substitution of the consorts for two important attributes (*padma* and *śaṅkha*) of the deity apparently constitutes an allegorical reference to the concept of *śakti*.[273] The consorts, of course, also function as symbols of the actual lotus (Padmā is another name of Lakṣmī) and conch (which like a musical instrument also produces sound). The small figure seated in meditating posture on the front of Viṣṇu's tapered crown probably represents the deity as Yoga-Nārāyaṇa.[274]

In contrast to the recondite symbolism of the Lakshmankati stele, an approximately contemporary image of Viṣṇu with personified *gadā* and *cakra* from Bihar, now in the Indian Museum, Calcutta, is iconographically rather close to classical prototypes of the fifth century (Figure 37). When we compare the Bihar stele with, for example, the relief of Viṣṇu at Udayagiri (Figure 4), the iconographic conception at first seems essentially unaltered, despite the interval of five hundred years between the two sculptures. Artistically, however, they are quite far apart. The style of the Pāla Viṣṇu may perhaps be described as "neo-baroque" rather than "medieval"; that is, it closely recalls the classicized sculptural tradition of the seventh and eighth centuries. Typical of Pāla sculpture of the early tenth century, the stele from Bihar combines a massive image with an ornate, decorative background, harmonizing the two largely through the architectonic device

271. The *cakra* and *gadā* theoretically occur in these positions in representations of some of the *catur-viṃśati-mūrti* ("twenty-four forms") of Viṣṇu; cf. B. B. Bidyabinod, *Varieties of the Vishnu Image*, Memoirs of the Archaeological Survey of India, No. 2 (Calcutta, 1920); and Banerjea, *Development of Hindu Iconography*, pp. 410ff. Although each of the *catur-viṃśati-mūrti* is assigned a specific name, they are all virtually identical except for the positions of the four attributes *cakra*, *gadā*, *śaṅkha*, and *padma*.

272. Sarasvatī usually holds a *vīṇā*, but here the musical instrument resembles some sort of lyre.

273. The fact that the figures of both goddesses are attached to miniature steles indicates that each was conceived of as the icon of an independent deity, linked symbolically to Viṣṇu; as pointed out above, the Tāntric literature of the Vaiṣṇava sect regards Lakṣmī as the active and creative aspect of the transcendent deity. For an iconographically unique stele in which Lakṣmī and Sarasvatī subsume the functions of the *gadā-devī* and *cakra-puruṣa*, see Figure 38.

274. See Banerjea, *Development of Hindu Iconography*, p. 405. Due to the indistinctness of the attributes held in the two rear hands of this tiny figure, it is impossible to make a positive identification; the idea of placing a tiny figure seated in yogic posture on Viṣṇu's headdress seems to be a borrowing from Buddhist iconographic conventions.

of the vertical throne-back carved with a foliate design. On closer examination of the iconographic refinements of the stele, we notice that the rear hands are placed directly on the heads of the personifications, who hold the stalks of lotuses that are placed behind Viṣṇu's front hands. The attributes of the two personifications are no longer attached to the figures, but are shown as actual detached weapons. The mace stands vertically at the right side of *gadā-devī,* while the discus—so enlarged as to suggest a shield—is placed behind the legs of the *cakra-puruṣa,* with the rim resting on the stele base.[275] On this base, directly beneath the *cakra-puruṣa,* is carved a winged Garuḍa kneeling in adoration to Viṣṇu. The position of Garuḍa in relation to the *cakra-puruṣa* above seems to anticipate two unusual reliefs, to be discussed below, in which Garuḍa is shown as the actual *vāhana* of Viṣṇu's personified discus (see Figures 43 and 59; also Figure 75).

Eleventh–Twelfth Century

The placement of the *cakra* attribute behind the legs of the personification in the preceding stele is iconographically unusual. In Pāla sculpture, the typical position of the *cakra* device is behind the head of the personification, as in the *cakra-puruṣa* fragment from Kasiabari in East Bengal, now in the Rajshahi Museum (Figure 31). This magnificent image, which was once part of a large Viṣṇu icon, probably dates to the eleventh century.[276] The great majority of twelfth-century Viṣṇu steles also depict the *cakra* attribute as a small disk behind the head of the personification, as in Figure 39, a detail of a stele in the Indian Museum, Calcutta. Another contemporaneous Viṣṇu icon in Calcutta, however, shows the *cakra-puruṣa* carrying the discus on top of a lotus stalk held in the left hand—an obvious borrowing from the Buddhist iconographic convention for representing the attributes of the Bodhisattvas (Figure 40).[277] In these two steles, the *cakra-puruṣas* are no longer shown standing immediately adjacent to Viṣṇu; they reflect the fact that in the medieval period, the personifications of *gadā* and *cakra* ultimately relinquished their priority of place beside Viṣṇu to his female consorts, Lakṣmī and Sarasvatī. While the weapon personifications are still retained in the new hierarchical arrangement of the

275. Although the distinction is a subtle one, the fact that the weapon-attribute is no longer invariably attached directly to the personification seems to indicate a significant change in the iconographic conception of the *āyudhapuruṣas.* From the direction which the later development of the *cakra-puruṣa* took, we may presume that at some point the personification came to be regarded as a heroic warrior who could independently manipulate the discus, and not as merely the literal embodiment of the deity's attribute. In effect the earlier personification actually was the discus; while the later *cakra-puruṣa* became, as it were, the deity's designated tactical agent in charge of the weapon. This transformation of the role of the *cakra-puruṣa* was of course a gradual one, and was effected in the literary tradition before the

iconographical implications came to be fully realized.

276. See Kramrisch, "Pāla and Sena Sculpture," Fig. 8, where the sculpture is assigned to the ninth century. On both stylistic and iconographic grounds, however, it appears rather to belong to the late Pāla period, being certainly more developed than the *cakra-puruṣa* in the preceding Viṣṇu stele (Figure 37), which dates to the tenth century.

277. This convention was developed earlier than the Pāla period in other parts of India; for examples dating to the eighth century in Cave 12 at Elura, see James Burgess, *Report on the Elura Cave Temples,* Archaeological Survey of Western India, Vol. 5 (London, 1822), Pl. XX, 1.

twelfth-century images, they pass almost unnoticed because of their small size and insignificant positions at the outer edges of the stele, beside the towering goddesses flanking Viṣṇu. The introduction of the deity's consorts constitutes one of the few significant changes since the fifth century in the basic iconographic conception of the Viṣṇu image, and epitomizes the increased importance of the Tāntric cult of the feminine principle.

Concerning this iconographic development, it should be noted that images of Viṣṇu flanked by his wives (but without the tiny accompanying weapon personifications) occur in Eastern India as early as the tenth century.[278] And in one exceedingly unusual late tenth-century Viṣṇu stele from Deo Barnarak in Bihar (Figure 38), the figures of Lakṣmī and Sarasvati have abrogated not only the usual positions of the personified weapons but also their iconographic functions—the goddesses being depicted standing in front of the *gadā* and *cakra* emblems respectively.[279]

Elsewhere in North India during the "medieval" period, the iconography of the Viṣṇu image was altered sooner than in Pāla art by the addition of numerous attendant figures standing beside the deity, along with *vidyādharas* (celestial garland-bearers) and a profusion of other motifs on the upper part of the stele. Compared to the simpler Viṣṇu icons of the "classical" period, the "medieval" images are bewildering in their array of subsidiary figures flanking the central deity. Some of the medieval steles might almost be described as iconographic encyclopedias; iconologically the conception of Viṣṇu as an autocratic ruler surrounded by his divine retinue reflects a decline in the humanistic values of an earlier age in which the deity was represented in a less imperious and therefore potentially more compassionate guise. In an image of Harihara, dating to the ninth century from Rajasthan, we see a youthful crowned *cakra-puruṣa* standing at Viṣṇu's side, along with two other attendants (Figure 29). Similarly, other attendants besides the personified weapons are present in a damaged Viṣṇu image from Uttar Pradesh, dating to the tenth or eleventh century (Figure 28). It is interesting to note that the *cakra-puruṣa* in both of these images actually carries the discus in hand instead of wearing it behind the head. This fact, combined with the generally more complex and stereotyped iconographic conception of the Viṣṇu image, suggests that the personification was no longer regarded literally as the actual anthropomorphized embodiment of Viṣṇu's *cakra*. Rather, he functions as a courtly attendant who bears the discus as if it were a jewel-like emblem of the regality of the deity, who stands in majestic splendor in the midst of his divine entourage.

278. See Banerji, *Eastern Indian School of Medieval Sculpture*, p. 36, and Pl. IV, d. In this sculpture, which is dated to the third year of the reign of Mahīpāla, the consorts are merely substituted for the weapon personifications. Since later Pāla Viṣṇu icons almost invariably depict the personifications in addition to Viṣṇu's wives, we can only assume that their omission in the tenth century was dictated by aesthetic factors, i.e., the desire not to overcrowd the stele.

279. The conjoining of Viṣṇu's consorts with the emblems of the personified *gadā* and *cakra* is difficult to explain. However, we have pointed out in Part One of this study that the *Ahirbudhnya-Saṃhitā* virtually equates the creative power of the discus with that of Lakṣmī, the deity's *śakti*. But if the conjoining were intended to convey this metaphysical concept, then Lakṣmī and not Sarasvatī should stand against the discus emblem. The strange iconography of the Viṣṇu stele from Lakshmankati discussed above (Figure 36) may be related to that of the present image.

In the later medieval period the female personification of the *gadā* is seldom found; in both North and Eastern India, the two personifications shown in attendance upon Viṣṇu are usually the *cakra-puruṣa* and the *śaṅkha-puruṣa,* both male figures. The partiality for two attendant male personifications holding objects of somewhat similar shape was probably motivated by a desire to achieve a completely symmetrical arrangement of the attendants flanking the deity. In view of the great numbers of medieval Viṣṇu steles which bear these two personified attributes, it is surprising that some scholars believe that "anthropomorphic representations of the *āyudhas* of Viṣṇu do not occur after the seventh-eighth centuries." [280]

Through the long development of the *cakra-puruṣa* which we have outlined, the personification is invariably shown in normal human guise, with only two arms. Until very recently, no multi-armed image of *cakra-puruṣa* had ever been noticed in North India, with the exception of the four-armed personification depicted on a stone disk from Sharishadaha in West Bengal, now in the Asutosh Museum, Calcutta (Figure 43).[281] The disk, which is provided with twelve lotus-petal spokes, is carved on both sides and obviously served as a pillar-capital device. In the center of the wheel, on both sides, is depicted a four-armed figure standing on the back of Garuḍa. Although the figure resembles Viṣṇu with respect to the rear arms which hold the *gadā* and *cakra,* the two front hands are raised up above the head in a gesture of adoration (*añjali-mudrā*). This gesture, combined with the absence of the typical *kirīṭa-mukuṭa* headdress rules out the possibility that Viṣṇu himself is represented. Incontestably, therefore, it is the deity's personified discus which is being carried through the air on the shoulders of Viṣṇu's *vāhana.*

This sculpture remained the only known example of a multi-armed *cakra-puruṣa* from North India until the recent discovery of an unusual eleventh-century Viṣṇu image from Bengal, now in the National Museum, New Delhi (Figure 41).[282] Standing regally beneath the foliate pattern issuing from the mouth of the *kīrtimukha* at the apex of the stele, the deity does not hold his distinctive emblems *gadā* and *cakra* in hand, but carries them on top of lotus stalks which appear like twin ceremonial scepters. The lower left hand, placed against an open lotus, holds the *śaṅkha.* The right is extended outward in *varada-mudrā,* just touching another open lotus. Flanking Viṣṇu are a youthful crowned *cakra-puruṣa* at his right side, and the personification of the *śaṅkha* at his left. Both carry their identifying attributes in hand, and not placed behind the head. On the pedestal of this unique stele and within a circular frame is seated a ten-armed figure (detail in Figure 42) which apparently represents the *cakra-puruṣa,* even though the normal two-armed

280. Sivaramamurti, "Geographical and Chronological Factors in Indian Iconography," p. 51; a similar view is stated by Härtel, "Zur Datierung einer alten Indische-Bronze," p. 177: "Die Darstellung von *āyudhapuruṣas* beschränkt sich auf die Zeit vom 5.-7. Jh. n. Chr."

281. See Banerjea, *Development of Hindu Iconography,* pp. 538, 539; Banerjea suggested that the sculpture "is a new variety of

Sudarśana, and was either set up as a main image in a subsidiary shrine in a Vaiṣṇava temple, or it served as the capital piece of a column. . . ."

282. See R. C. Agrawala, "Unpublished Sculptures and Terracottas in the National Museum, New Delhi, and Some Allied Problems," *East and West,* 17 (1967), pp. 280, 281, and Figs. 17, 18.

personification is also shown on the stele proper, standing beside Viṣṇu. The multi-armed personification sits in *līlāsana,* with the front left hand upraised and the front right hand extended downward in *varada-mudrā*—paralleling the gesture displayed by Viṣṇu himself.[283] The same *līlāsana* posture may be observed in each of the eight tiny four-armed figures (of uncertain significance) who are arranged in two vertical rows along the edges of the stele. The six middle arms of the encircled pedestal image hold various weapons, while the two rear hands are held above the head in the same gesture of adoration as that displayed by the *cakra* personifications on the Asutosh Museum disk.

This gesture is also found on a small, double-sided stone disk from Deulberia, West Bengal, which depicts two almost identical eight-armed figures, holding weapons and standing in a dancing posture (Figure 44).[284] As in the preceding image, the two rear hands are raised above the head in *añjali-mudrā.* The various weapons held include sword and mace, as well as two types of discus. Attached to the rim surrounding the dancing figures are twelve spokes, whose shape resembles those of the disk in the Asutosh Museum. Obviously the figures on the Deulberia disk are also to be identified as multi-armed *cakra* personifications. Although it is difficult to assign a definite date to the Asutosh Museum and the Deulberia disks, they are probably not too far removed in time from the Viṣṇu stele in the National Museum, which belongs to the latter half of the eleventh century.

The evidence of these three multi-armed personifications suggests that a new and rather esoteric role for the *cakra-puruṣa* was formulated in Eastern India during the late Pāla period. The inspiration for certain visual features of this new iconographic conception is relatively easy to determine. The numerous arms of the Deulberia personification, for example, probably were developed on the analogy of the radiating spokes of an actual wheel, while the dancing posture was possibly devised to metaphorically suggest the movement of the discus through space. However, the religious function and underlying significance of the new multi-armed form of the *cakra-puruṣa* are more difficult to decipher. The fact that the majority of the additional arms of the personifications carry weapons suggests that the primary concern was to symbolically augment the destructive potency of Viṣṇu's discus. As we have shown in Part One, the *sudarśana-cakra* began to be interpreted as an abstruse symbol in the period of the *Purāṇas,* from about the seventh or eighth century A.D. By the time of the *Garuḍa Purāṇa,* the personification was worshipped in a four-armed form identical to that of Viṣṇu himself, even holding the same weapon-attributes as the Supreme Deity.[285] The esoteric nature of Sudarśana was further developed in the sectarian Pāñcarātra literature. However, while this literature describes images of the type found in South

283. The elegant seated pose appears to be borrowed from Buddhist iconographic conventions that signify the princely authority of the Bodhisattva agents of the cosmic Buddhas.

284. See *Archaeological Survey of India, Annual Report,* 1930–34, Part Two, pp. 306, 307, and Pl. CLI, a, b. The disk was discovered in 1931 in a small brick temple in Deulberia village; in the report, the dancing figures are misidentified as representations of Śiva, and the date of the disk estimated to be fourteenth-fifteenth century, which seems far too late.

285. See Part One, Notes 127, 128.

India, it does not furnish an explanation of the above sculptures from Eastern India.[286] Thus, although the three personifications from Bengal antedate the introduction in South India of multi-armed cult images of the *sudarśana-puruṣa*, there seems to be no connecting link between the two iconographic traditions.[287]

286. As we shall see below, the Pāñcarātra texts furnish descriptions of images of Sudarśana with two, four, six, eight, sixteen, and even thirty-two hands; but no text mentions a ten-armed Sudarśana, such as the one on the pedestal of the National Museum Viṣṇu stele. Nor is the unusual gesture of two hands clasped together and held above the head (a variant of *añjali-mudrā* or *namaskāra* displayed in all three of the multi-armed personifications from Eastern India) described in any of the texts. Finally, none of the circular disks surrounding the three Bengal images is provided with the projecting flames which constitute an indispensable part of the iconographical formula prescribed in the Pāñcarātra literature. For a collection of selected textual descriptions of most of the different varieties of Sudarśana image, see Smith, *A Sourcebook of Vaiṣṇava Iconography*, pp. 221–227.

287. However, the religious and cultural repercussions of the Muslim conquest of North India at the end of the twelfth century may have indirectly contributed to the development of multi-armed images of Sudarśana in South India in the thirteenth century.

II The Multi-Armed Cult Images of *Sudarśana-Puruṣa*

Thirteenth–Fourteenth Century

AT THE BEGINNING of this study, it was suggested that the original connotation of the *sudarśana-cakra* as an iconographic attribute of Viṣṇu was that of a highly destructive weapon. In the course of the iconographic evolution which occurred during the early expansion of the Bhāgavata sect, however, the formidable aspect of the four-armed, weapon-bearing Viṣṇu was mitigated by the introduction of personifications of *gadā* and *cakra* in the guise of faithful attendants flanking the image. For the most part, these early personifications are so placid in appearance that they serve to point out the benevolent nature of Viṣṇu the Preserver rather than to illustrate his powers of destruction. Later the personified discus came to be increasingly regarded as the independent agent of Viṣṇu's creative and destructive powers, and in the guise of the *sudarśana-puruṣa,* as a separate deity in his own right. In contrast to the relatively simple religious function of the *cakra-puruṣa,* the iconographic role of the medieval *sudarśana-puruṣa* of South India was exceedingly complex.[288] The medieval Sudarśana was conceived as a terrifying deity of destruction, for whose worship special Tāntric rituals were devised.[289] The iconographic conception of Sudarśana as an esoteric agent of destruction constitutes a reassertion of the original militaristic connotation of the *cakra*.[290] However, the actual multi-armed images, which typically depict Sudarśana as a horrific figure bearing numerous weapons and standing within an upright

288. While the two-armed *cakra-puruṣa* in attendance upon Viṣṇu functioned in a subordinate role as an inspiring model of devotional piety, the multi-armed Sudarśana was regarded as a symbol of absolute power. According to the *Ahirbudhnya-Saṃhitā*, "Vishnu in the form of *Chakra* was held as the ideal of worship for kings desirous of obtaining universal sovereignty. . . . The king who worships him with devout heart attains to the rank of a *Chakravarti* in a short time. . . . It was a new conception by which the Pāñcharātra Bhāgavatas utilized the tenets of their religion in the service of the state and thereby greatly influenced the political thought and ideals of kingly power during that period" (Agrawala, "An Explanation of the Chakravikrama Type of Coin of Chandragupta II," pp. 99, 100). Although elsewhere the *Ahirbudhnya-Saṃhitā* specifically enjoins

kings to worship Sudarśana in times of national emergency, there were also many other motives involved in the veneration of Sudarśana besides political pragmatism.

289. See Part One, Notes 127ff; in addition see Schrader, *Introduction to the Pāñcarātra,* p. 129: "the devotee should meditate on [Sudarśana] as a sacrifice (*yajñarūpadharaṃ devam*): His body being the altar, His mouth the Āhavanīya fire, His heart the Southern fire . . . the enemies of his devotees the sacrificial animals . . . His sixteen arms the priests. . . ."

290. Actually this connotation was never completely lost sight of, despite the great variety of symbolic, and decidedly nonmilitary interpretations of the *cakra* found in Purāṇic and Tāntric literature.

flaming wheel, are, needless to say, quite distinct from the iconographic types whose development we have already traced.

The earliest example of a South Indian Sudarśana image so far discovered is a small eight-armed bronze image in a private collection in Bombay, dating to the thirteenth century (Figure 46).[291] Although only a few inches high, and unfortunately damaged and worn, this image is quite obviously related in style to certain approximately contemporary bronzes of the late Cōla period, such as the more competently modeled two-armed *cakra-puruṣa* in the Madras Museum (Figure 45).[292] Both bronzes depict youthful (but not dwarfish) male figures, wearing similar costumes and ornaments. The crowns are also of the same type, although that of the Sudarśana image is somewhat shorter. By comparison with the Madras bronze the pose of the Bombay Sudarśana is less rigidly hieratic. In fact, the relatively relaxed stance of this figure, which results in a slight tilting of the shoulders, shows a closer resemblance to the poses of earlier *cakra-puruṣas* attendant upon Viṣṇu (for example, Figure 30) than to the stiffly conventionalized postures of later eight-armed Sudarśana icons. The two-armed Madras image is one of a pair of personified weapons, the other being a unique male personification of the *gadā*, both of which are shown in attitudes of adoration, with the hands held in *añjali-mudrā*.[293] Each of the two Madras personifications has the appropriate identifying weapon-attribute placed above his crown, the wheel of the *cakra-puruṣa* being provided with four marginal flames and one in the center of the nave.[294] Although it is not absolutely certain that the Madras bronzes were originally placed on either side of a large image of Viṣṇu, the iconographic function of the *cakra-puruṣa* was obviously that of a subordinate attendant figure.

By contrast, the Bombay Sudarśana, despite its diminutive size, is clearly conceived as an independent cult image, thus providing evidence that the type of multi-armed Sudarśana icon was already fairly well evolved by the late Cōla period. Not only does the figure have eight arms—which is the standard number of arms according to the *Ahirbudhnya-Saṃhitā*—but it stands in front of the Tāntric *ṣaṭ-koṇa* device found in many later Sudarśana icons.[295] The *ṣaṭ-koṇa* (literally, "six-angles") is a star hexagram composed of two interlaced triangles. The upward pointing triangle frames the head of the Sudarśana, the apex being filled with flames

291. This important bronze is being reproduced here for the first time; a brief mention of this image is made in Begley, "The Earliest Sudarśana-cakra Bronze and the date of the *Ahirbudhnya-Saṃhitā*" (see above, Part One, Note 142). Because of its small size, it is unlikely that the bronze was used in a temple; rather it must have been a devotional image used for private meditation, or else carried in procession atop a staff.

292. See C. Sivaramamurti, *South Indian Bronzes* (Delhi, 1963), Pl. 64a. Although the provenance is unknown, Sivaramamurti suggests that the image, which he dates to the thirteenth century, probably comes from Thanjavur District.

293. Sivaramamurti, *South Indian Bronzes*, Pl. 64b. Assuming that both bronzes originally flanked a Viṣṇu icon, aesthetic rather than iconographic considerations may have prompted the representation of the *gadā* as a male figure.

294. The flames projecting from the *cakra* and other weapon-attributes—whether held by Viṣṇu or Sudarśana—is an iconographic convention peculiar to South India; see Jouveau-Debreuil, *Iconography of South India*, pp. 59–62 and Fig. 17.

295. For the *Ahirbudhnya-Saṃhitā* passage, see above, Part One, Note 140; for explanations of the *ṣaṭ-koṇa* device, see below, Notes 366–370.

emerging from behind the crown.[296] Flame-like spokes project in a confused array from behind the *ṣaṭ-koṇa* and across the partially perforated outer angles of the downward pointing triangle.[297] The three upper angles of the inconsistently positioned *ṣaṭ-koṇa* completely overlap the flat surface of the rim of the discus surrounding the personification, while the lower angles only just come into contact with the inner edge of the rim. Originally there were as many as twenty marginal flames projecting from the rim, all approximately equal in size. Although one or two of the weapon-attributes held by the figure are somewhat indistinct, it is possible to arrive at the probable order of the attributes by referring to the descriptions of the eight-armed form of Sudarśana given in the *Parameśvara-Saṃhitā* and other texts.[298] In the following table, the sequence begins with the upper or rear hands and proceeds to the lower or front hands.

Right hands		Left hands	
1. *cakra*	(discus)	5. *śaṅkha*	(conch)
2. *musala*	(pestle)	6. *dhanus*	(bow)
3. *aṅkuśa*	(goad)	7. *pāśa*	(noose)
4. *padma*	(lotus)	8. *gadā*	(club)

It is significant that the four attributes most closely associated with Viṣṇu himself are here given special prominence. Thus Sudarśana's two rear hands hold, in frontal position, a *cakra* and *śaṅkha,* both provided with projecting flames. The upraised right hand holds a *padma,* while the left holds the handle of a downward pointing *gadā,* which rests against the side of the lotus pedestal upon which the figure stands. The important role played in the iconographic conception by the four chief attributes of Viṣṇu suggests that the full powers of the Supreme Deity have been symbolically transferred to the personified Sudarśana.[299]

296. Only the upward pointing triangle is solid; although damaged, the inverted one seems to have consisted of just the outer edge, shown as a raised band overlapping onto the circular rim of the flaming disk.

297. Apparently there were originally as many as twelve flamelike spokes, the same number as in the Deulberia disk (Figure 44); the combination of spokes and *ṣaṭ-koṇa* device presents an exceedingly confused arrangement. It may well be that this is one of the initial experimental attempts to employ the *ṣaṭ-koṇa* device in conjunction with an image of Sudarśana; in any event, the combination of spokes and *ṣaṭ-koṇa* is not encountered in subsequent images.

298. See U. V. Govindacarya, ed., *Śrī Parameśvara Saṃhitā* (Srirangam, 1953), 23.49, 50:

anyathāstabhujo dhatte mukyadakṣakarādikaiḥ
 padmaṅkuśau ca musalam cakramatyugratejasam

śaṅkham ca saśaram cāpam pāśam kaumodakīm kramāt
 kṛtvaivam ardhacitram tu navatālena śilpinā

The *Parameśvara-Saṃhitā* is the only text which lists the weapons held by the eight-armed Sudarśana in the order in which they would be held in actual images; the sequence here gives—in *pradakṣiṇa* order as one faces the image—first the weapons held in the right hands (beginning with the front hand) and then those held in the left hands (beginning with the upper rear hand). Although none of the other Pāñcarātra texts describes the weapons in proper sequence, they all list the same eight weapons. According to Smith, the *Parameśvara-Saṃhitā* "reflects and dictates the worship patterns at the famous Ranganathaswamy temple at Śrīraṅgam" (*A Sourcebook of Vaiṣṇava Iconography,* p. 301).

299. In fact, the *Ahirbudhnya-Saṃhitā* (44.24) speculatively regards Sudarśana as the "support of all weapons and destructive powers" (*ādhāram sarvaśaktināmastrāṇām ca*).

The small bronze Sudarśana image just discussed is perhaps not only the earliest surviving example of a multi-armed *cakra* personification in South India, but is also the only example so far known that dates to the period before 1500. There undoubtedly should exist other Sudarśana images dating to the thirteenth, fourteenth, and fifteenth centuries, but these have not yet been noticed. However, inscriptional and literary evidence proves that images of Sudarśana were in fact worshipped in Śrī Vaiṣṇava temples as early as the thirteenth century. As we have seen above, the

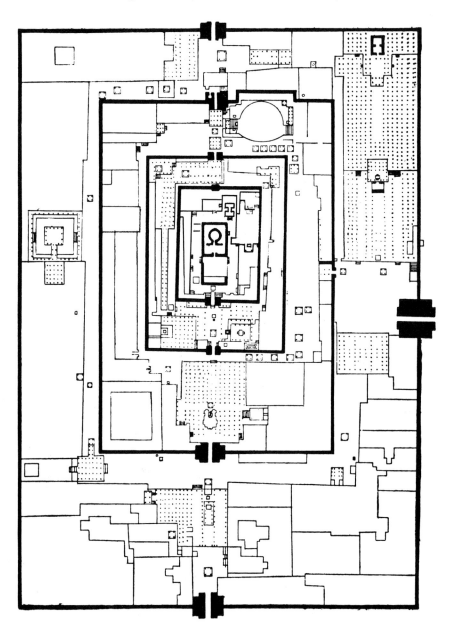

Fig. 4. Plan of Śrī Raṅganātha Temple at Srirangam with four surrounding enclosures

Fig. 5. Sudarśana shrine within enclosure of Śrī Varadarāja
Temple at Kanchipuram

Vaiṣṇava scholar Vedāntadeśika was associated with the Srirangam Temple in the late thirteenth
century and is the author of a hymn to Sudarśana which was inspired by the image in the
temple.[300] Unfortunately, this image was probably destroyed when Srirangam was attacked by the
invading Muslim armies in 1310 and again in 1327. Further proof of the existence of an image of
the sixteen-armed Sudarśana at Srirangam in the thirteenth century is provided by an inscription
at the temple dated in the twenty-first year of Jāṭavarman Vīra Pāndya which records a donation
to the deity.[301]

300. See the translation of the *Ṣoḍaśāyudhastotram* above, Part
One, and Notes 158–160. The present image, of which no
photograph is available, is a later replacement made in the
Vijayanagara or Nāyak period.

301. See *Annual Report on South Indian Epigraphy* for
1938–1939, No. 149. I am indebted to H. K. Narasimhaswami,
formerly of the Archaeological Survey of India, Department of
Epigraphy for the reference to this important inscription, the text

of which is still unpublished. The twenty-first year of Jāṭa-
varman Vīra Pāndya—who was a royal prince of the same family
as the more famous Jāṭavarman Sundara Pāndya (r. 1251–1268)—
apparently corresponds to about 1274 A.D.; see K. A. Nilakantha
Sastri, *A History of South India*, 3rd ed. (Madras, 1966), p. 215.
The Srirangam inscription—which contains perhaps the earliest
such mention of Sudarśana anywhere in South India—refers to
the multi-armed image as *cakrattālvār*, one of the characteristic

The institutionalization of the cult of Sudarśana was made possible by significant changes in the architectural conception of the South Indian temple. Beginning in the late Cōḷa period, the temple complex was gradually expanded outward from the nucleus of the original cella, with more and more subsidiary shrines being added within the enclosure walls (prākāra) of the temple.[302] In this way separate shrines dedicated to Sudarśana came to be erected within the precincts of most of the major Śrī Vaiṣṇava temples of South India, such as the great Temple of Śrī Raṅganātha at Srirangam and the Varadarājaperumāl Temple at Kanchipuram (text figs. 4, 5). Although parts of the existing temple complex at Srirangam go back to the twelfth or thirteenth century, the present Sudarśana shrine—which is located against the west wall of the fourth prākāra enclosure—belongs to a much later architectural phase, and has in fact been remodeled in this century.[303] The Kanchipuram Sudarśana shrine, the most impressive in South India, was probably originally constructed in the late sixteenth or early seventeenth century.[304]

Fifteenth–Sixteenth Century

The worship of the destructive power of the sudarśana-cakra constituted a highly specialized part of the Vaiṣṇava liturgy developed within the Pāñcarātra tradition. The Ahirbudhnya-Saṃhitā and other texts deal in great detail with the esoteric mode of worship, especially with the ritual utterances (mantra) and mystic diagrams (yantra) employed in cult practices.[305] In contrast to the formal complexity and recondite symbolism of the yantras, the Sudarśana icons made from permanent materials are relatively simple and direct. The surviving images almost invariably

names by which the deity is known in Tamil Nadu—others being tiruvāli-āḻvār and cakra-perumāl. For some later inscriptional references to Sudarśana, see below, Note 310.

302. See Percy Brown, Indian Architecture, Buddhist and Hindu Periods (Bombay, 1965), pp. 88ff.

303. See James Fergusson, History of Indian and Eastern Architecture, 2 vols., revised by James Burgess and R. Phene Spiers (London, 1910), Vol. 1, pp. 368–372, and Fig. 218, from which the above plan is taken. The innermost prākāra wall surrounding the shrine proper is 240 x 181 feet; while the fourth enclosure wall is 1,235 x 849 feet. For the Pāñcarātra textual prescription for the location of Sudarśana in the fourth prākāra as guardian of the third gopura, see Parameśvara-Saṃhitā 11.108ff. Although not confirmed by inscriptional evidence, there is a tradition that the fifth prākāra wall at Srirangam was built during the reign of Vikrama-cōḷa (ca. 1118–1133); see K. A. Nilakantha Sastri, The Cōḷas, 2nd ed. (Madras, 1955), p. 345. Thus there is a possibility that some sort of Sudarśana shrine may have been erected in the fourth prākāra enclosure as early as the twelfth century.

304. The Varadarāja temple has been inadequately studied;

Fergusson remarks that "inscriptions of the 13th century show that the temple was then in existence, and it is probably of still earlier date" (History of Indian and Eastern Architecture, Vol. 1, p. 361). The reverse of the large stone Sudarśana image installed in the shrine is illustrated in Figure 65, while two images of the personified discus carved on pillars in the large free-standing maṇḍapa adjacent to the Sudarśana shrine are shown in Figures 58, 59. Both the pillared maṇḍapa—which also dates to the sixteenth or seventeenth century—and the special Sudarśana shrine are located in the outer prākāra enclosure of the temple.

305. For a description of the elaborate Sudarśana yantra, see Ahirbudhnya-Saṃhitā, Chapter 26. This yantra is to be drawn or painted on cloth, using red and gold and other colors. The deity is depicted against a ṣaṭ-koṇa-cakra, in the center of a lotus maṇḍala consisting of concentric rings of petals, eight on the innermost ring, and sixty-four on the outer circle. The numerous lotus petals are all inscribed with mantras and cabalistic syllables, while arranged around the circular portion of the yantra are representations of various forms of Viṣṇu. In the later iconographic development of the multi-armed Sudarśana, some of the large stone and metal images came to be greatly influenced by the diagrammatic yantras (cf. Figures 62, 66, and 70).

depict the deity as either eight- or sixteen-armed and may be classed into three basic types according to their respective functions:

1. large stone icons which are permanently installed (*dhruva-vigrāha*) in special shrines[306]
2. metal icons which can be carried in procession (*utsava-vigrāha*), but which are also kept in the Sudarśana shrines[307]
3. images carved in relief on temple pillars and other architectural members

Icons of the first two types are accorded ritual worship (*pūjā*), while those of the third type perform a more decorative function by filling out the sculptural program of the huge galleries and pillared halls (*maṇḍapa*) within the temple precinct.

The images of Sudarśana with sixteen arms are depicted in one of two postures—either standing frontally with feet together (*sāmapādasthānaka*) or in a striding pose with the left leg advanced (*pratyālīḍha*).[308] Eight-armed Sudarśana images are depicted almost invariably in the *sāmapādasthānaka* posture. This hieratic pose is apparently an earlier conception than the more dynamic *pratyālīḍha* posture. It is found in the thirteenth-century Bombay Sudarśana and also in a somewhat problematic image of Sudarśana with sixteen arms in the Sūrya-Nārāyaṇa Temple at Hampi (Figure 51), possibly dating to the late fifteenth or early sixteenth century.[309] The elaborate costume of the figure and its stylistic treatment are typical of sculpture produced during the Vijayanagara period.[310] The circular disk forms a relatively uncluttered backdrop for the ornate image which is recessed into the surface of the stone slab. Only the flamboyant *kīrtimukha* mask

306. Like the main temple itself, the Sudarśana shrine is referred to as a *vimāna*; it should be noted that the *Ahirbudhnya-Saṃhitā* recommends that "kings and others desirous of material prosperity . . . (should) build a special *vimāna*" or shrine for the installation of an image of Sudarśana; "the very preparation of the soil (*karṣaṇa*) for such a building is a highly meritorious act" (Schrader, *Introduction to the Pāñcarātra*, p. 128).

307. See Rangachari, *The Sri Vaishnava Brahmans*, p. 114 and *passim*; it is interesting to note that at the time of major *utsava* ceremonies, the Sudarśana icon (*cakrattālvār*) is carried outside and placed in front of the *dhvaja-stambha*, a conjunction which perhaps alludes to an earlier period when the *cakra-puruṣa* itself was placed on top of the pillar.

308. This is the usual definition of the *pratyālīḍha* posture, which is the exact reverse of the *ālīḍha* pose in which the right leg is advanced; however, the *Vihagendra-Saṃhitā* interchanges the meanings of the two terms (see Smith, *Vaiṣṇava Iconography*, p. 226). This text, which exists only in manuscript, "deals exclusively with Sudarśana worship" (*ibid.*, p. 304). The *pratyālīḍha* posture may have been derived from the horrific pose of Śiva as *aghoramūrti*.

309. This image was previously identified as Sūrya—presumably giving rise to the local designation of the temple in which it is installed as being dedicated to "Sūrya-Nārāyaṇa." It was impossible to learn anything about this temple which might help corroborate the date suggested here.

310. With the possible exception of the bronze Sudarśana reproduced in Figure 47, which may date between 1550 and 1575, the Hampi sculpture is apparently the only image of Sudarśana that has survived from the Vijayanagara period before the downfall of the empire in 1565. This is surprising in view of the numerous inscriptional references to Sudarśana dating to the sixteenth century, especially those at Tirupati, the most famous pilgrimage center of Śrī Vaiṣṇavism in South India. See S. Subrahmanya Sastry, ed., *Śrī Tirumala-Tirupati Devasthānam Epigraphical Series*, Vol. 1 (Madras, 1930), pp. 59ff. Subrahmanya Sastry points out that the *mūla-mūrti* ("permanent icon") of Sudarśana is installed in a small shrine in the second storey of a *maṇḍapa* adjoining the entrance *gopura* of the Temple of Śrī Govindarāja at Tirupati. Apparently, the earliest inscriptional reference to this image, which is known as *tiruvāli-ālvān*, is dated in correspondence with 1506 A.D. (*Śrī Tirumala-Tirupati Devasthānam Epigraphical Series*, Vol. 3, inscription No. 8, pp. 24ff). Several other sixteenth-century inscriptions also refer to this image, e.g., those dated 1537 and 1538 (*ibid.*, Vol. 4, Nos. 96 and 115; pp. 181ff and 213ff) and those dated 1542, 1543, and 1546 (*ibid.*, Vol. 5, Nos. 3, 9, and 83; pp. 8ff, 25ff, and 216ff). Another image of Sudarśana was installed in the Narasimhasvāmi Temple at Śrīnivāsapuram, a suburb of Tirupati (see *ibid.*, Vol. 3, No. 11). It could not be ascertained whether either of these two icons is still in situ, or whether they have been replaced by later images (an eighteenth-century Sudarśana image at Tirupati is reproduced in Figure 60).

at the top—a typical Vijayanagara decorative motif—interrupts the simple outline.[311] The narrow rim of the wheel is provided with eight marginal flames of equal size and sixteen small rosettes on its facing. The arms of the image are vertically arrayed like the radiating spokes of a wheel, except for the two front hands—held in *varada* and *abhaya-mudrā*—which are possibly recut.[312] The trailing ends of the wide scarf hanging from the waist also conform to this radiating pattern. As in the Bombay Sudarśana, the two rear hands hold *cakra* and *śaṅkha,* both attributes having projecting flames. The Hampi image, however, wears a tall *mukuṭa* headdress, arranged in vertical tiers, that partially obstructs the exceptionally small flames rising from behind the head.[313] Although the figure is generally placid in appearance, the pointed teeth projecting from the mouth reveal the horrific nature of the deity.

Compared to the rather awkward rigidity of the hieratic *samapādasthānaka* posture, the *pratyālīḍha* stance is far more dynamic and expressively appropriate to the iconographic conception of Sudarśana as a menacing force. The earliest surviving example of an icon depicted in this posture is probably the bronze Sudarśana with sixteen arms in the Tanjore Art Gallery, which dates to about the middle of the sixteenth century (Figure 47).[314] This handsome bronze is one of the most dynamic of the multi-armed Sudarśana personifications. Produced in a period in which the artistic tradition was becoming increasingly mechanical and stereotyped in its prolonged adherence to the artistic tradition of the Cōḷa period, the image is supple and compelling, and the sculptor has dealt imaginatively with the problems of fashioning such a complicated form.[315] The figure of Sudarśana dominates the complex configuration of the flaming disk as he advances with right arm upraised threateningly. Shown with feet spread wide apart, the figure pushes against the rim of the disk as if to impel it forward. The fiery disk itself has no clearly visible support and appears to hover above the pedestal. There are twenty-eight flames projecting from the solid rim, the four marking the quadrants of the circle being slightly larger in

311. Note that the foliate projections extending from the *kīrtimukha* cause it to appear more developed than the motif typically is at the site. However, the recession of the image into a circular disk with relatively simple rim has many parallels in Vijayanagara sculpture of the fifteenth and sixteenth centuries. It is possible, of course, that the image may date to the period following the downfall of the Vijayanagara capital in 1565.

312. The arms appear to have been broken off near the elbow, and new hands cut at a later date; this surmise gains plausibility by the fact that in no other image of Sudarśana known in South India are the hands held in these positions. It seems purely coincidental that these are the same *mudrās* displayed by the ten-armed personification on the eleventh-century Viṣṇu stele from Bengal (Figure 42).

313. The degree of prominence of the flames emerging from behind Sudarśana's head has been taken to be an approximate index to the relative date of the image, i.e., the more pronounced the flames, the later the image. It should be pointed out,

however, that images in stone seem to follow a slightly different pattern of development than metal icons, which at any one point in time are stylistically somewhat more advanced. The fact that the image is completely recessed into the surface of the slab seems to be a relatively early feature, while the high *mukuṭa* and decorative scarves of the image clearly place it later in time than the Bombay bronze, which we have estimated to be about two hundred years earlier.

314. See P. R. Srinivasan, *Bronzes of South India*, Bulletin of the Madras Government Museum (Madras, 1963), p. 345, and Fig. 298. Srinivasan dates the bronze to about 1575.

315. The sculptor has broken the hieratic formula to an extent by treating the pose of the figure in an almost naturalistic manner; the pose also helps to organize the array of arms and attributes into an interesting and expressive pattern. For some general remarks on the stylistic qualities of South Indian sculpture of the later periods, see Kramrisch, *Indian Sculpture*, pp. 119ff.

size than the others.[316] Sixteen petal-like divisions decorate the inner portion of the rim. The attribute-bearing arms are positioned laterally in contrast to the almost completely vertical arrangement of the Hampi image.[317] The *cakra* and *śaṅkha* are provided with flames and are held at a slight angle in the two rear hands; the size of these is greater than that of the other weapons.[318] Apart from certain specific details of costume, the most interesting iconographic features are the third eye in the center of the forehead, the exposed teeth, the triangular *śrīvatsa* mark of Viṣṇu near the right shoulder, and the hair shown as large flames rising up behind the cylindrical crown (*kirīṭa-mukuṭa*).[319]

As noted above, the cult of the multi-armed Sudarśana was partially inspired by motives of political pragmatism. The image of the terrible sixteen-armed Sudarśana, in particular, was to be worshipped on account of its military efficacy. The *Ahirbudhnya-Saṃhitā* stipulates the conditions under which this form of Sudarśana should be invoked, in response to the question (37.3): "What is the nature of that [sixteen-armed image], and when, by whom, and for what purpose is it to be made?" (*tatkadā kena kartavyaṃ kimartham kīdṛśam*).[320] The text states (37.5) that the king himself should cause the sixteen-armed image of Sudarśana to be made without delay when the country is "oppressed by the army of the enemy, and the stability of the ruler who has not been able to root out his adversaries is at stake."[321] The appearance of the sixteen-armed form of Sudarśana is then described in exhaustive detail (37.7–17):[322]

316. In almost all later images the four flames at the top and bottom and on either side of the disk are greatly increased in size, the degree of prominence serving as a further index to the relative date of the icon. The mode of representation of the projecting flames seems directly analogous to the fiery circle (*prabhā-maṇḍala*, or *tiruvāsi*) within which Śiva performs his dance of cosmic destruction; cf. Zimmer, *Myths and Symbols in Indian Art*, pp. 151ff; A. K. Coomaraswamy, *The Dance of Śiva* (London, 1958), pp. 66–78. The circle of flames surrounding the dancing Śiva is interpreted as *māyā*, or "cosmic illusion"; in this connection we should note that *māyā* is one of the esoteric epithets of Sudarśana (Schrader, *Introduction to the Pāñcarātra*, p. 113).

317. In both iconography and style, the Tanjore bronze and the Hampi stone icon are largely unrelated, even though they are presumably not separated in time by more than 50 to 75 years. The stylistic differences seem attributable to the fact that these images belong to separate regional artistic traditions; that one image is in bronze and the other in stone probably also accounts for some of the iconographic differences in addition to the stylistic ones.

318. The *cakra* and *gadā* are always given special prominence in images of Sudarśana, probably because they immediately identify the icon as Vaiṣṇava in its religious affiliation; they are also the only two weapon-attributes provided with projecting flames.

319. The third eye is of course usually associated with the god Śiva, from whom many of the horrific (*ugra*) characteristics of

Sudarśana are perhaps derived. The triangular *śrīvatsa* and the tripartite *yajñopavīta* are iconographically characteristic of the Vijayanagara period; see Sivaramamurti, *South Indian Bronzes*, pp. 24–43 for a discussion of the stylistic development of motifs of ornamentation and dress in bronze images of the Cōla and Vijayanagara periods. Note that this is the first instance of Sudarśana actually wearing Viṣṇu's distinctive crown.

320. Cf. Schrader, *Introduction to the Pāñcarātra*, p. 128.

321. *Ibid.*, Chapters 28 and 29. These chapters deal respectively with the obligatory and the "optimal worship which a Kṣatriya is recommended to perform for ensuring victory. In the latter case the rites vary with the region (east, south, etc.) in which the warrior wishes to attack" (Schrader, p. 123). As already pointed out, the ordinary devotee worshipped Sudarśana for his efficacy on a spiritual and moral plane, as the destroyer of sins (see above, Part One, Notes 131ff; also below, Note 378).

322. The Sanskrit text of these eleven verses is as follows:

7) *apāramaparicchedyamavāṅmanasagocaram*
 raktavarṇamudārāṅgam pītakauśeyavāsasam

8) *vidyutpuñjapratīkāśaih keśairūrdhvamukhairyutam*
 piṅgalāghurṇamānogranetratritayabhiṣaṇam

9) *daṣṭādharasphuṭālakṣyadaṃṣṭrāniṣṭyūtapāvakam*
 kvaṇatkiṅkiṇijālena kāñcīdāmnā virājitam

10) *nitambalambinopetaṃ jvalatkaukṣeyakena ca*
 dadhānaṃ kiṅkiṇīmālāṃ tvalimālānināditam

11) *āpādalambinīṃ divyāṃ muktāratnācitāṃ tatha*
 jhaṇajjhaṇitamañjīraśobhamānapadāmbujam

Immeasurable, illimitable, beyond the
 comprehension of mind and speech;
Of reddish color, with large limbs
 wearing a yellow silken garment;

Furnished with hair standing straight up,
 resembling clusters of lightning;
Fierce in expression, with three fiery
 terrible glaring eyes;

Vomiting fire through compressed lips
 with the teeth partially visible;
Wearing a radiant girdle and a number
 of dangling ornaments;

Possessing a gleaming scimitar (*kaukṣeyaka*)
 hanging against his thigh;
Wearing a strap of dangling bells which
 rattle like a garland of bees;

Wearing a necklace bedecked with pearls
 and gems suspended to the feet;

With shining lotus legs adorned
 with jangling anklets;

Wearing a headdress (*mukuṭa*), earrings,
And adorned with diverse other jewelled ornaments;

Holding in order the *cakra, paraśu, kunta,*
 daṇḍa and *aṅkuśa;*
The *śatavaktra* weapon, and *khaḍga* and *śakti*

In the hands of his long outstretched right arms;
And in the left hands, in this order the
 śaṅkha, dhanus, pāśa, hala, vajra;

The terrible looking *gadā, musala* and *śūla;*
His brow distorted by a great anger toward his foes;

His eyebrows crooked, and his fierce-
 looking body bent at an angle;
Standing in the *pratyālīḍha* posture
 encompassed by brilliance;

Destroying this world in the form of
 the terrible, fiery Wheel of Time.

Considering the extravagant language used by the poet to describe the awesomeness of this "illimitable" form of Sudarśana, it is interesting to note that the attributes are methodically listed according to the vertical order of both sets of arms. The positions of these attributes may thus be tabulated as follows.

Right Hands		Left Hands	
1. *cakra*	(discus)	9. *śaṅkha*	(conch)
2. *paraśu*	(axe)	10. *dhanus*	(bow)
3. *kunta*	(lance)	11. *pāśa*	(noose)
4. *daṇḍa*	(staff)	12. *hala*	(plough)
5. *aṅkuśa*	(goad)	13. *vajra*	(prong)
6. *śatavaktra*	(fire)	14. *gadā*	(mace)
7. *khaḍga*	(sword)	15. *musala*	(pestle)
8. *śakti*	(spear)	16. *śūla*	(pike)

12) *hārakeyūrataṅkamukutairupaśobitam*
 anyairmanimayaiścitrairbhūṣanaih samalamkṛtam

13) *kramena cakraparaśukuntadandaṅkuśāni ca*
 śastrāni śatavaktrāni khaḍgaśakti ca bibhratam

14) *karairūrdhvamukhairdīrghairdakṣinairastabhih paraih*
 vāmaih śankhadhanuhpāśahalavajrāni ca kramāt

15) *gadāmusalaśūlāni bhīmanyetāni bibhratam*
 svasamāśritaśatrutthakrodhena mahatā vṛtam

16) *bhugnabhrūkutilam vaktram dhārayantam vibhīṣaṇam*
 pratyālīḍhaviśesena tiṣtantam dīptimālinam

17) *kālāgnirudrarūpeṇa samharantamidam jagat*

This same sequence of sixteen weapons is also found in another Pāñcarātra text, the *Parameśvara-Saṃhitā*,[323] as well as in Vedāntadeśika's devotional hymn *Ṣoḍaśāyudhastotram*.[324] Since this hymn is traditionally said to have been inspired by an actual image of Sudarśana which would have been installed in the Srirangam Temple some time before 1300 A.D., we may conclude that the above list was based upon the actual sequence of attributes occurring in late Cōḷa images of the sixteen-armed Sudarśana.[325]

By the sixteenth century, however, the positioning of the weapons came to be slightly altered. The attributes held by the Hampi Sudarśana are unfortunately too indistinct to be readily identified, but close examination of the bronze Sudarśana in the Tanjore Art Gallery reveals that the order of the weapons which the figure holds corresponds fairly closely to the above list of the *Ahirbudhnya-Saṃhitā*. There are only two, or possibly three, discrepancies. In position number 7, instead of a *khaḍga* the figure holds a *vajra;* while the hand that in the *Ahirbudhnya-Saṃhitā* description holds the *vajra* (position 13) carries here what appears to be a *ṭaṅka,* or double-edged cutting blade. Occasionally this special blade is referred to in iconographic texts as a *śakti,* perhaps because a metal blade of similar shape was sometimes affixed to spears.[326] The figure almost certainly carries a spear or lance of some sort in his upraised front right arm, however, and he appears about to hurl it toward the enemy.[327]

But the above deviations are minor, and in any event, it is probably unjustified to expect that the iconography of Sudarśana images would ever become as canonically fixed as that of the major deities. Except for the three textual descriptions referred to above, all of the other literary sources show considerable variation in the listing of the sixteen weapons. In the *Sudarśanaśataka*, the collection of one hundred hymns to Sudarśana by the poet Kūranārāyaṇa—the date of which is

323. The *Parameśvara-Saṃhitā* (23.39–48) furnishes a lengthy description of the *ugra* Sudarśana similar to that in the passage cited above from the *Ahirbudhnya-Saṃhitā*. The weapons held by the sixteen-armed Sudarśana are described in vv. 46–48, where they are listed in *pradakṣiṇa* order (when viewing the image from the front), beginning with the front right hand:

dvirāṣṭabāhubhirdhatte pradakṣiṇyakramena tu
śaktiṃ khaḍgaṃ tathā cāgnimaṅkuśaṃ daṇḍakuntake
paraśuṃ ca sahasrāraṃ daraṃ ca saśaraṃ dhanuḥ
pāśaṃ halaṃ tatho vajraṃ gadāṃ ca musalaṃ tata
triśūlametānyastrāṇi pratyekaṃ vīryavanti ca
duṣpradharṣaṃ bhayaghnāni vahantamariṣūdanam

The term for *cakra* in this list is *sahasrāram* ("thousand-spoked"), while *dara* designates *śaṅkha*.

324. See above, Part One, Note 160; the sequence of weapons is: right hands—*cakra, paraśu, kunta, daṇḍa, aṅkuśa, śatavaktrāgni, nistriṃśa* (sword), and *śakti;* left hands—*pāñcajanya* (conch), *dhanus, pāśa, sīra* (plough), *vajra, gadā, musala, triśūla*.

325. Unfortunately, no Cōḷa image of the sixteen-armed Sudarśana has survived. However, it seems more than just a coincidence that these three literary descriptions of Sudarśana all

list the attributes in exactly the same order. Moreover, as pointed out above, the order of attributes held by the Bombay eight-armed Sudarśana, which dates to the thirteenth century, seems to correspond to the iconographic description in the *Parameśvara-Saṃhitā* (see above, Note 298). This correspondence tends to substantiate the above hypothesis of the close correlation between the literary and iconographic traditions in the thirteenth century. It should be noted, however, that in most literary descriptions, the sequence of the names of the weapons is determined more by the metrical requirements of the verse than by any desire for iconographic fidelity.

326. See Rao, *Elements of Hindu Iconography*, Vol. 1, p. 7; however, cf. H. Krishna Sastri, *South Indian Images of Gods and Goddesses* (Madras, 1916), p. 267, where the emblem is called a *śakti* or *vel*. This is one of the distinctive attributes, along with the *vajra*, held by Skanda or Kārttikeya; possibly there was some confusion between the *śakti* blade and *vajra*, on account of their approximately similar shape and size.

327. Evidently the *śakti* blade had two distinct uses as a weapon: provided with a long staff, it was used for hurling; attached to a short handle, it was probably used in hand-to-hand combat.

probably substantially later than that of Vedāntadeśika—the weapons are described in a different order from that found in Vedāntadeśika's hymn and the above-mentioned Pāñcarātra texts.[328] Both the *Śilparatna*[329] and the *Śilpasāra*[330] list the weapons with no regard for the order in which they would be held. These two texts also introduce three or four new attributes: arrow (*iṣu* or *bāṇa*), knife, or another type of sword (*asi*), shield (*kheṭa* or *kheṭaka*), and lotus (*padma*). Although the *Śilparatna* is supposedly a work of the late sixteenth century, the description of Sudarśana which it contains corresponds less closely to the sixteenth-century Tanjore bronze than the earlier description in the *Ahirbudhnya-Saṃhitā*.

Seventeenth-Eighteenth Century

The great majority of the scores of Sudarśana images found in Vaiṣṇava temples in South India belong to the period following the downfall of the Vijayanagara Empire in 1565. Among the external factors which contributed to the increased popularity of Sudarśana worship, probably the most important was the continued expansion of the temple complex which resulted in the construction of even more separate shrines to house the cult images of subsidiary deities (*pārśva-devatā*).[331] Concomitantly, the widespread political turmoil and internecine strife in South

328. See below, discussion of Figure 48 and Note 337.

329. For the Sanskrit edition of the text, see above, Part One, Notes 168, 169; the description of the sixteen-armed Sudarśana is found in *Śilparatna* (Vol. 2) 23.6:

śaṅkhaṃ cakraṃ ca cāpaṃ paraśumasimiṣuṃ śūlapāśāṅkuśāgnīn
bibhrāṇaṃ khaḍgakheṭaṃ halamusalagadākuntamatyugradaṃṣṭram
jvālākeśaṃ trinetraṃ kanakamayalasadgātramatugrarūpam
candre ṣaṭkoṇasaṃsthaṃ sakalaripujanaprāṇasaṃhāracakram

Note that the weapons which should be held in the left hands are interspersed in the list with those held in the right hands, a surprisingly chaotic sequence in view of the fact that the text purports to be a technical treatise. The above passage appears to have served as the basis for Rao's description of the sixteen-armed Sudarśana (*Elements of Hindu Iconography*, Vol. 1, pp. 291, 292): "According to another description of Sudarśana, the obverse should exhibit the terrific figure of Vishṇu, with sixteen hands, holding the weapons *chakra*, *śaṅkha*, *dhanus* [the text has *cāpa*], *paraśu*, *asi* (a sword), *bāṇa* [the text has *iṣu*], *śūla*, *pāśa*, *aṅkuśa*, *agni*, *khaḍga*, *kheṭaka*, *hala*, *musala*, *gadā*, and *kunta*. He should have fearful tusks and the hair on his head should be represented as shining and highly towering. He should possess three eyes and have a golden coloured body, resting on the back of a *shat-kona-chakra*." Since the *Śilparatna* includes the shield (*kheṭa*) among the attributes held by Sudarśana, it is unlikely that the text is earlier than the seventeenth century, as that is apparently the date of the earliest occurrence of the shield in actual Sudarśana icons (see Figures 58, 59). We should note that a circular shield is held by one of the left hands of the ten-armed personification carved on the pedestal of the eleventh-century Viṣṇu icon discussed above (Figures 41, 42).

330. The *Śilpasāra*, which is probably contemporaneous with the *Śilparatna*, exists only in manuscript (see Mitra, *Contribution to a Bibliography of Indian Art and Aesthetics*, p. 223); for the list of weapons which it contains, see Krishna Sastri, *South Indian Gods and Goddesses*, p. 66: "The *Śilpasāra* describes Sudarśana to be as brilliant as fire, with sixteen arms holding the weapons conch, discus, bow, axe, sword, arrow, trident, noose, goad, lotus, thunderbolt, shield, plough, pestle, club and spear." This is very nearly the same order as that given in the above *Śilparatna* passage (see preceding note), with the exception of two variant readings: lotus for fire (*agni*), and thunderbolt for sword (*khaḍga*). Thunderbolt (*vajra*) is probably the correct reading, since *khaḍga* and *asi* seem to have the same meaning. The arrow is usually held in the same hand as the bow, but here, both texts imply that they are to be held in separate hands. The lotus is, of course, held by the eight-armed Sudarśana, but this marks its first appearance—assuming the manuscript reading is correct—as an attribute of the sixteen-armed image.

331. Despite the political turmoil attendant upon the disintegration of the Vijayanagara empire, there was no abatement in the construction and refurbishing of temples; in fact the architectural enterprises of the Nāyak period were unparalleled in their extensiveness. As in the preceding period, these enterprises reflected the rulers' awareness of their responsibilities in the "preservation and development of all that remained of Hinduism against the onslaughts of Islam" (Nilakantha Sastri, *A History of South India*, p. 482). For the elaborate Pāñcarātra textual prescriptions regarding the setting up of images of subsidiary deities in the various enclosures surrounding the main shrine, see Smith, *Vaiṣṇava Iconography*, pp. 228ff; see also *Parameśvara-Saṃhitā*, Chapter 11.

India during the Nāyak period, coupled with the threat of imminent invasion from the North, constituted just the sort of national emergency which—according to the *Ahirbudhnya-Saṃhitā*—the king should attempt to resolve by making and worshipping images of Sudarśana.[332] Similar motives had undoubtedly prompted the installation of Sudarśana images earlier, during the Vijayanagara period, but the more precarious situation in the Nāyak period probably contributed to the wider distribution of the cult, with icons being set up in small, out-of-the-way temples as well as in the more important centers.[333]

One of the largest and most handsome of the bronze icons of Sudarśana surviving from the early Nāyak period is the sixteen-armed image formerly in the Tanjore Art Gallery (Figure 48 and detail in Figure 49). Dating to the seventeenth century, this impressive bronze provides an instructive iconographic and stylistic comparison with the preceding Sudarśana, also in the same museum (Figure 47). The later image is far more decorative. Its static symmetry and turgid ornateness contrast greatly with the lithe mobility of the earlier icon. The decorative approach of the later bronze is most noticeable in the treatment of the wide filigreed rim of the disk which serves as an elaborate backdrop for the regal figure of Sudarśana. Projecting from the rim are tiny contiguous flames of equal size, numbering more than one hundred.[334] The rim is circumscribed around a *ṣaṭ-koṇa* device, portions of which are visible behind the figure and beside and between his widely spaced legs. The flaming disk is supported by a lotus pedestal placed on top of a rectangular base. Additional support for the disk is provided by two rampant-leonine *yālis* springing outward from the rectangular base. Two other *yālis*, sitting on their haunches, serve as caryatids for the small platform upon which Sudarśana stands.

Although the general configuration of this image clearly points to its being later in date than the other Tanjore bronze, certain stylistic and iconographic details provide less unequivocal evidence for this chronological relationship. For example, although the garland of bells worn by the later Sudarśana is clearly more developed, this image lacks the bands of cloth which flutter decoratively outward from the sides of the earlier figure.[335] Similarly, while the cylindrical crown of the seventeenth-century image has a more ornate knob on top, the flames behind the head of the sixteenth-century bronze are more numerous, although somewhat less prominent. However, the array of the sixteen arms of the later image is more rigidly symmetrical, especially with respect to the two front arms holding attributes at the level of the shoulders. Since this pattern is followed by all subsequent images, it appears that an iconographical forumla was established in

332. For the history of the Nāyak period, see R. Sathyanatha Aiyar, *History of the Nayaks of Madura* (Madras, 1924); also V. Vriddhagirisan, *The Nayaks of Tanjore* (Annamalainagar, 1941).

333. For example, in the Rāmacandra Temple at Nedungunam, in North Arcot District (Figure 64), and in the Śrī Satyamūrtiperumāl Temple at Tirumayam, in Tiruchirapalli District (Figure 55).

334. Probably 108, which is regarded as a highly auspicious number; this is perhaps due to the fact that the number 108 may be arrived at by the mathematical progression $1^1 \times 2^2 \times 3^3$. Concerning the number of arms of the different forms of Sudarśana, note that these are arrived at by doubling: 2, 4, 8, 16, 32—the 6 and 62-armed forms being exceptions to this rule.

335. These streamers, however, may have been deliberately omitted so as not to obstruct the lower portion of the *ṣaṭ-koṇa* device.

the seventeenth century which constituted a significant departure from the earlier more naturalistic mode of representation.[336]

With respect to the positioning of the attributes, note that the weapons in the later Tanjore bronze correspond exactly with the sequence given in the verse 80 of the *Sudarśanaśataka*, as shown in the following table.[337]

Right Hands		Left Hands	
1. *cakra*	(discus)	9. *śaṅkha*	(conch)
2. *kunta*	(lance)	10. *kodaṇḍa*	(bow)
3. *kṛpāṇa*	(sword)	11. *pāśa*	(noose)
4. *paraśu*	(axe)	12. *hala*	(plough)
5. *hutavaha*	(fire)	13. *musala*	(pestle)
6. *aṅkuśa*	(goad)	14. *gadā*	(club)
7. *daṇḍa*	(staff)	15. *vajra*	(prong)
8. *śakti*	(spear)	16. *śūla*	(pike)

The only slightly doubtful attribute is that held in position 13, which resembles a rod instead of a *musala* as given in the *Sudarśanaśataka* list.

The sixteen-armed images of Sudarśana are invariably represented as horrific (*ugra*) in appearance. With the notable exception of the sixteen-armed Sudarśana in the Sūryanārāyaṇa Temple at Hampi (Figure 51), they are also almost invariably depicted in the dynamic *pratyālīḍha* posture, striding forward aggressively to wreak destruction on the enemies of Viṣṇu and his devotees.[338] Although sixteen-armed icons are found in considerable numbers in South India, the eight-armed Sudarśana is presumably still the more common form, as it was also at the time of

336. We must qualify this statement by mentioning the fact that the sixteen-armed Hampi Sudarśana (Figure 51) also appears to conform to a set formula; however, this is largely due to the unavoidable rigidity of the *samapādasthānaka* stance.

337. See above, Part One, Notes 162, 163. The translation of v. 80 is as follows:

 Holding the weapons discus, lance, sword, axe,
 fire, goad, staff and spear,
 Conch, bow, noose, plough, pestle, club, prong
 and pike (trident)
 In his all-powerful hands, which are capable of
 subduing with incomparable might the arrogance
 of his foes;
 May that radiant emanation of the conqueror of hell,
 possessed of all splendor, cause you to attain
 prosperity!

(*cakraṃ kuntaṃ kṛpāṇaṃ paraśuhutavahāvāṅkuśaṃ daṇ-daśakti śaṅkhaṃ kodaṇḍapāśau halamusalagadāavajraśū-laṃśca hetīn*
dorbhiḥ savyāpasavyairdadhadatulabalasthambhitārātidar-pairvyūhastejobhimāni narakavijayino jṛmbhatāṃ sampade vaḥ)

In addition to the weapons held in its sixteen hands, the Tanjore image also wears a small curved knife at his waist—perhaps the *kaukṣeyaka* referred to in the *Ahirbudhnya-Saṃhitā* passage cited above (see Note 322, v. 10 of this passage).

338. However, the eighteenth-century wall painting of the sixteen-armed Sudarśana in the Padmanabhapuram Palace in Tamil Nadu is depicted in the *samapādasthānaka* pose (Figure 73), as are also the apparently very late images in the Sudarśana shrine at Srirangapatna in Mysore (see below Note 348). A very restrained form of the *pratyālīḍha* (or rather *ālīḍha*) pose is sometimes encountered in sixteen-armed images.

the composition of the *Ahirbudhnya-Saṃhitā*.[339] The images with eight arms are almost always shown standing in a hieratic, frontal pose with feet together (*samapādasthānaka*).[340] As a result of this static posture, the eight-armed form of Sudarśana appears relatively placid in comparison with the dynamic sixteen-armed images. Although both forms possess *ugra* characteristics, the eight-armed images appear to have been less exclusively militaristic in their cult significance. Whereas the sixteen-armed image was primarily invoked to destroy the enemy, the eight-armed form was seemingly regarded as efficacious in bringing about peace and prosperity.[341] This ambivalent emphasis perhaps stems from the Pāñcarātra distinction between the two types of weapons derived from the *sudarśana-puruṣa*, the destructive (*pravartaka*) and the defensive (*nivartaka*).[342] According to the *Ahirbudhnya-Saṃhitā*, the total number of weapons in these categories is more than one hundred.[343] Theoretically, each of the weapons has a personified form (*mūrti*), the weapons in the *pravartaka* category being horrific and those in the *nivartaka* being placid in appearance.[344]

As we have already seen, the sequence of attributes in the eight arms of the thirteenth-century Bombay Sudarśana is apparently identical to that given in the *Parameśvara-Saṃhitā*. Of the several textual descriptions of the weapons held by the eight-armed Sudarśana, only this *Saṃhitā* arranges the attributes in order.[345] All texts, however, list the same eight attributes: *cakra, musala, aṅkuśa,*

339. See Rao, *Elements of Hindu Iconography*, Vol. 1, pp. 290, 291; Rao seems to imply that is the eight-armed form of Sudarśana that is "found in all important Vishnu temples." However, while there may be a larger proportion of the eight-armed form in the total number of Sudarśana images, it seems certain that the special shrines almost invariably contain icons with sixteen arms. For the purposes of private meditation, as opposed to public ritual, the eight-armed form—for reasons to be discussed below—seems to have been preferred.

340. There are, however, at least two late exceptions to this rule: a small metal icon in the Srirangam Museum and a woodcarving from Tirupati in the Madras Government Museum, both of which depict the eight-armed Sudarśana standing in the *pratyālīḍha* pose.

341. This is perhaps a too subtle distinction since all forms are theoretically capable of destroying enemies and granting prosperity to the devotee. However, see the Table of Contents of the *Parameśvara-Saṃhitā*, under Chapter 23; the editor of the text refers to vv. 39ff as a description of the *ugra* (sixteen-armed) form of Sudarśana (*ugrasya sudarśanasya anuvarṇam*), while he characterizes vv. 48ff as a description of a peaceful type (*śāntasya*); cf. also the *Garuḍa Purāṇa* description of the four-armed Sudarśana as placid (*saumya*) in appearance (above, Part One, Note 128). The two-armed form, of course, is never represented in horrific guise.

342. See Schrader, *Introduction to the Pāñcarātra*, pp. 125, 126, where a summary is given of the *Ahirbudhnya-Saṃhitā* account of the origin of the divine *śastras* (weapons) from the body of

Sudarśana himself. While bringing the universe into existence, Viṣṇu discovered that "there was in His creation a tendency towards the bad which could be counterpoised only if He with a portion of Himself would become the protector of His creatures. So He created, as an instrument against the wicked (Daiteyas and Dānavas), His Sudarśana form, and, the gods and kings being able to use the latter, He produced from it the Astras or magical weapons. These, a little over a hundred, are enumerated by name and in five groups as they have sprung from the mouth, breast, thighs, feet, or 'other limbs' of the Sudarśana Puruṣa. The first four classes constitute the Pravartaka (offensive, destructive), the fifth class Nivartaka or Upasaṃhāra (defensive, obstructive) Astras."

343. *Ibid.*; Schrader notes that "Chapter XL enumerates 102, but chapters XXXIV and XXXV mention apparently some more."

344. *Ibid.*: "the second are described as having the hands joined in supplication (*sāñjalinī*), while the first are said to look as though they were to devour all the worlds (*attum ivāśeṣabhuvanāni*)."

345. See above, Note 298. According to Smith (*Vaiṣṇava Iconography*, p. 301), portions of the *Parameśvara-Saṃhitā* appear to be based on the *Īśvara-Saṃhitā*, which also lists the attributes of the eight-armed Sudarśana in apparently the same order (7.200): . . . *gadāṅkuśau ca musalam cakramatugratejasam/ śaṅkham ca saśaram cāpam pāśam kaumodakīṃ kramāt//* .
Note that in this passage (cited by Smith, p. 201), the word *gadā* is obviously a mistaken reading for *padma*.

padma, śaṅkha, dhanus, pāśa and *gadā*.[346] Images of later date frequently alter the positions of two or more of the attributes. However, the eight-armed Sudarśana now in worship in the Nārāyaṇasvāmi Temple at Melukote in Mysore (Figure 53) has the attributes arranged precisely in the prescribed order.[347] Although executed in Hoysala style, this image is probably of a much later period, dating perhaps to the sixteenth or seventeenth century.[348] The figure stands in front of a circular disk which has been cut through, with only the six points of the *ṣaṭ-koṇa* device attached to the narrow rim. The hands are all held up at about the level of the shoulders, with the result that the attributes are arranged in a horizontal row. Like the attributes, the figure's ornaments and crown—which has an attached aureole, or *śiraścakra*—are derived from those found in Hoysala sculpture. The lower part of the image is swathed in an actual cloth garment (*dhotī*). Objects connected with the performance of *pūjā* are visible in the foreground of the illustration.

Two other eight-armed stone Sudarśana images in Vaiṣṇava temples in Tamil Nadu may be briefly noted, both of which adhere fairly closely to the textual prescriptions. The earlier of these, perhaps of the late sixteenth or early seventeenth century, is the icon installed in the Śrī Kannam Temple at Kabistalam in Thanjavur District (Figure 52).[349] Supported by three *yālis*, the solid disk against which the figure stands is provided with a *ṣaṭ-koṇa* device and a wide rim decorated with more than one hundred spokelike rays. In addition to the vertical flames behind the cylindrical crown, there are three small clusters of flames projecting from the rim, at the top and sides. The formal symmetry of the array of arms, especially the two front arms, creates an effect of regal dignity. The stiffness of the hieratic pose is partially offset by the sumptuousness of the folds of cloth arranged at the figure's sides and falling to the ankles.

The Kabistalam icon is installed in a special shrine; an example of a Sudarśana image not so installed, but rather carved in relief on a *maṇḍapa* pillar, is found in the Rāmasvāmi Temple at

346. The *Ahirbudhnya-Saṃhitā* lists the attributes of the eight-armed Sudarśana in three separate passages: 26.6, 32.67, and 33.94. In none of the passages are the attributes given in proper sequence. In *Śilparatna* (Vol. 2) 23.6, the eight-armed form is described as follows:

*avyād bhaskarasatprabhābhirakhilā bhābhirdiśo bhāsayan
bhīmākṣaḥ kṣaradattahāsavilasaddaṃṣṭrāpradīptānanaḥ
dobhiraścakradarau gadābjamusalaprāsāṃśca pāśaṅkuśau
bibhrat piṅgalaśiroruho'tha bhavataścakrabhidāno hariḥ*

Thus the sequence is discus, conch, mace, pestle, arrow (bow), noose, goad; here also there is no relationship to the order in which the attributes are held in actual images. Concerning this passage, we should note that Gopinatha Rao evidently used a corrupt manuscript of the *Śilparatna* since he gives the sequence as "*chakra, gadā,* the *uruga* (a snake), the *padma,* the *musala,* the *tramsa* (sword), the *pāśa* and the *aṅkuśa*" (*Elements of Hindu Iconography,* Vol. 1, p. 291). His text apparently read *uruga* in place of the compound *cakradarau* ("discus and conch"), and *tramsa* instead of *prāsāṃśca* ("and arrows").

347. Melukote is one of the four chief centers of Śrī Vaiṣṇava worship in South India (see above, Part One, Note 158).

348. The absence of projecting flames on the circular rim seems to point to a relatively early date, as does also the fact that the weapons are arranged in the order prescribed in the *Parameśvara* and the *Īśvara-Saṃhitās.* However, this may be due to the fact that textual prescriptions were more conservatively adhered to in the Mysore region than in Tamil Nadu. Note that the *Īśvara-Saṃhitā* "has by tradition been associated with the worship prevailing at Melukote" (Smith, *Vaiṣṇava Iconography,* p. 299). There is a Sudarśana image with sixteen arms in the temple at nearby Srirangapatna which is very close in style to the Melukote icon; its date has also been estimated to be sixteenth or seventeenth century. The motif of the vertical flames behind the head of the Melukote image is similar to that in an image of Sudarśana with eight arms at Kabistalam, dating to about 1600 (Figure 52).

349. Several of the attributes are almost obliterated, but it appears that those held in the right hands conform to the prescribed sequence, while those in the left hands, with the exception of the *śaṅkha,* are uncertain.

Kumbakonam (Figure 54).[350] This image is stylistically more developed, and it probably dates to the late seventeenth or early eighteenth century. The size and decorative quality of certain motifs and ornaments—especially the tall *kirīṭa-mukuṭa* and the iconographic motif of the flaming headdress—have been greatly exaggerated. The prominent flames at the top and sides of the disk surrounding the figure are a hallmark of images of Sudarśana of the late Nāyak period.

The same canonical arrangement of attributes noticed in the Melukote stone image (Figure 53) also seems to be found in an interesting bronze image of the eight-armed Sudarśana which has recently appeared in New York in the collection of William H. Wolff (Figure 50). On stylistic grounds, the bronze should possibly be assigned to the seventeenth century, perhaps to the very end of the century. The iconographic conception of the image is virtually identical to the hieratic forms already discussed. Except for the difference in medium, the bronze is remarkably close in style to the Kabistalam stone Sudarśana (Figure 52). Both are represented standing against *ṣaṭ-koṇa* devices attached to the rim of a disk decorated with spokes and flames. On the rim of the bronze, twenty-nine of these spokes are visible, each terminating in flames of almost equal size.[351] The scarves trailing along the thighs are treated in a similar manner in both images. However, the lotus pedestal base of the bronze is not like that of the Kabistalam stone image; instead it resembles the lower part of the base of the seventeenth-century bronze in the Tanjore Art Gallery (Figure 48).[352] The arrangement of attributes apparently is also based on the textual prescription of the *Parameśvara-Saṃhitā*.[353] The position of the *gadā*, which is held downward in the front left hand of the image, is identical to that in the thirteenth-century bronze discussed above (Figure 46), with which the present image provides an instructive stylistic comparison.[354]

The stylistic and iconographic relationships between the two preceding stone images of Sudarśana with eight arms (Figures 52, 54) are paralleled in approximately contemporary sixteen-armed images of Sudarśana from temples in Tamil Nadu. For example, the late sixteenth or early seventeenth-century Sudarśana (Figure 55) installed in the Śrī Satyamūrtiperumāl Temple at Tirumayam in Tiruchirappali District has, as we would expect, a disk with a relatively simple flat rim and without prominent projecting flames.[355] Although the exaggerated length of the fourteen rear arms imparts a bizarre quality to the image, there are several other indications—besides the

350. Three attributes seem to deviate from the *Parameśvara-Saṃhitā* list: these are in position 2, which resembles an arrow instead of *musala*; and positions 6 and 8 (*dhanus* and *gadā*) which have been interchanged.

351. Taking into account the portion of the rim obscured by the lotus-pedestal, the total number of the flames would probably have been 32. On the inner rim there are 16 stylized lotus-petal divisions, almost exactly like those on the rim of the sixteenth-century bronze Sudarśana in the Tanjore Art Gallery (Figure 47).

352. The pedestal of the Tanjore bronze has more petal divisions, but in both bronzes the ends of the petals curve upward forming a sharp tonguelike projection. Other stylistic correspondences include the cylindrical crowns worn by the

figures and the similarly shaped flames projecting from the rim of the disk.

353. See above, Note 298. Unfortunately, the attributes held in the middle left and right hands are much obscured. Nevertheless, the sequence in the left hands seems clearly to be *śaṅkha, pāśa, dhanus,* and *gadā*, while the right hands hold *cakra, musala*(?), *aṅkuśa*(?), and *padma*.

354. Cf. the late eighteenth-century bronze Sudarśana with six arms in Figure 72, where the deity also holds a downward pointing *gadā*.

355. The outer perimeter of the rim, however, has been cut in saw-tooth fashion, probably to suggest numerous small flames.

lack of prominent flames on the rim of the disk—of a relatively early date. Like the sixteenth-century Sudarśana in the Tanjore Art Gallery, the figure here also stands on the rim itself; and while the two front hands are both held up at the level of the shoulders, they are not as rigidly symmetrical as in later icons. The tiered crown is slightly reminiscent of that worn by the Hampi Sudarśana (Figure 51). The attributes held by the deity are fairly distinct and appear generally to follow the order in the Pāñcarātra texts, especially those in the left hands.[356] In comparison with this image, the late seventeenth- or early eighteenth-century Sudarśana (Figure 56) carved on a pillar in the Rāmasvāmi Temple at Kumbakonam is far more schematic in its iconographic treatment.[357] The fourteen rear arms are arranged in dense horizontal layers on either side of the figure, appearing almost like two thick wings. The *pratyālīḍha* posture of the Kumbakonam image is more pronounced, with the right knee sharply bent and the feet spread far apart. Although prominent flames are lacking at the sides of the convex rim, there is a single large flame at the top of the disk (only a portion of which is visible in the photograph).

Even later in date than the Kumbakonam relief is a large Sudarśana attached to a narrow pillar in the Śrī Alagarperumāl Temple at Dadikkombu in Madurai District (Figure 57). The style of this image, which probably dates to the first half of the eighteenth century, is closely related to sculpture produced at Madurai under the late Nāyak rulers.[358] The Madurai idiom has a strong flavor of folk art and lacks the pervasive influence of the Cōḷa and Vijayanagara artistic traditions, which were retained longer in the Thanjavur district and areas farther to the north in Tamil Nadu. The sculptor of the Dadikkombu image was apparently unaware that the circular disk against which Sudarśana stands should have projecting flames; instead, much attention has been devoted to the charming design of rosettes on the face of the rim.[359] The *cakra* held in the rear right hand—although provided with flames—is similarly inspired by floral motifs. Elsewhere also, there is much emphasis upon decorative details, while certain iconographic conventions are ignored or misinterpreted. Thus, a few attributes which are almost always carried in the left hands

356. With the exception of the attribute held in position 13 (which should be a *vajra*) the sequence of weapons in the left hands corresponds to that given in the *Ahirbudhnya-Saṃhitā*. In the right hands, a knife or sword (or perhaps a *kunta* blade) is substituted for *paraśu* (position 2), which seems to be missing completely; the object held in position 7 (which should be a *khaḍga*) is not readily identifiable. Again, the fairly close adherence to the textual order seems to be a further indication of a relatively early date.

357. Note that this temple contains images of both the eight and sixteen-armed forms of Sudarśana carved on *maṇḍapa* pillars (cf. Figure 54). Only two or three attributes are identifiable; the *gadā* held in the front left hand is unusual and points to a late date.

358. Especially the large images attached to pillars in the covered court in front of the Sundareśvara Temple at Madurai; see, for example, Percy Brown, *Indian Architecture, Buddhist and Hindu Period*, Pl. LXXVI, 1. Although much of this temple and its sculptural decoration was completed during the reign of Tirumala Nāyaka (*ca.* 1623–1659), additions and repairs were made well into the eighteenth century—and for that matter, up to the present day. Although the sculptural idiom is almost completely stereotyped and mechanical, the images obviously required great technical skill to execute, particularly in fashioning the numerous projecting and deeply undercut forms which seem almost to explode outward from their architectonic supports.

359. However, the flattened lumps attached to the outer perimeter of the flowery disk are presumably meant to suggest flames.

have been shifted to the right, and vice versa.[360] Of particular iconographic interest are the large rectangular shield carried in the front left hand and the treatment of the headdress of flames, which here is substituted for the usual crown worn by Sudarśana.[361]

Some stylistic differences between the Southern and the Northern varieties of sculpture of the Nāyak period are revealed by comparing the Dadikkombu image (Figure 57) with the monolithic image of Sudarśana near the Narasiṃhaguṇta Tank in lower Tirupati, the most famous Vaiṣṇava pilgrimage center in South India (Figures 60, 61).[362] This massive sixteen-armed image may be assigned to the late seventeenth or early eighteenth century and is therefore approximately contemporary with the preceding Dadikkombu Sudarśana. Stylistically, the Tirupati image owes much to the artistic heritage of the Vijayanagara period. There is an uncompromising tightness in execution and an almost mechanical precision in the articulation of form. Despite a heavy accumulation of decorative detail, however, the figure's underlying plasticity remains un-confined.[363] Although the iconographic conception is formulaic and the posture static and stereotyped, the image of Sudarśana appears charged with a potential for sweeping movement. In large part, the dynamic quality of the sculpture is due to the flamboyant configuration of the ornate disk surrounding Sudarśana. With its three huge flames thrusting explosively outward from the rim, the disk resembles a colossal pinwheel in a fireworks display. Perhaps for the first time, a complex multi-armed image of Sudarśana has been perfectly intermeshed with an equally elaborate flaming wheel. In addition to the large prominent flames demarcating the quadrants of the circle, there are eight smaller flames projecting from the rim, placed at equidistant points around the circumference. Less noticeable, but just as auspicious numerologically, are the 108 tiny flames which make up the outer edge of the disk. Concentrically aligned with these are small bladelike forms radiating from the wide facing band of the rim. This slightly convex band is decorated with sixteen lozenge-shaped floral motifs. The two concentric rings on the inner edge of the rim have respectively a design of 108 diamond forms and a design of lotus petals totaling half that number. The solid pedestal of the icon is carved with reliefs on front and back. These depict a downward-pointing prominent flame superimposed on a high lotus base and two rampant *yālis* which leap outward in contorted postures. The *yālis* also support the rectangular platform

360. Thus in three of the right hands we notice *pāśa*, *hala*, and *gadā* (positions 4, 6, 7), which in earlier images are invariably carried in the left hands; *kunta* and *aṅkuśa* have been shifted from the right hands to the left (positions 13, 14). The rectangular shield (*kheṭa*) carried in the front left hand is an iconographic innovation.

361. Cf. the similar flame headdress in an eighteenth-century bronze Sudarśana, also from Dadikkombu (Figure 68).

362. See H. Krishna Sastri, *South Indian Gods and Goddesses*, Fig. 43; cf. S. Krishnasvami Aiyangar, *A History of Tirupati* (Madras, 1940), Vol. 1, Pl. XIII. The image is presently in the open, but it is unknown whether it was originally intended to be so placed. The location of the Narasiṃhaguṇta Tank with

respect to either the Govindarājasvāmi or the Narasiṃhasvāmi Temple could not be determined; inscriptional references indicate that both of the temples may contain—if they have not been removed—Sudarśana images dating to the late Vijayanagara period, or about two hundred years earlier than the present monumental icon (see above, Note 310).

363. Kramrisch remarks of South Indian sculpture that it has a tough "vitality" and that its "plastic sense maintains a high level till the seventeenth and eighteenth centuries" (*Indian Sculpture*, p. 119); she describes the treatment of surface decoration (ornaments and so forth) in sculpture of this period as a tendency to "negate what is not of the body by making it the body" (*ibid.*).

upon which the corpulent figure of Sudarśana stands. Besides the general complexity of the sculptural style, specific features which provide additional evidence for the relatively late date assigned to the icon include the extremely attenuated form of the cylindrical crown and the completely frontal and vertical position of the *cakra* and *gadā* held in the two rear hands.[364] Several arms are broken, and it is difficult to determine the probable sequence, but the attributes in the left hands appear to follow exactly the prescribed textual order.[365]

The reverse side of the Tirupati icon shows very clearly the *ṣaṭ-koṇa* device that has constituted an important iconographic motif in multi-armed Sudarśana images from their very inception.

Fig. 6. *Ṣaṭ-koṇa* device

Although the precise date of the earliest occurrence of the star hexagram in Tāntric imagery is unknown, its origin must be closely linked to the occult geometrical symbolism of the *yantras*.[366] In the *Śilparatna* and other texts, the image of Sudarśana is explicitly described as standing within

364. The *cakra* and *śankha*, which were once provided with projecting flames, are set somewhat apart from the sweeping array of other attributes, almost as if they were heraldic devices instead of weapons.

365. However, as in the case of the sixteenth-century Tanjore bronze, the attribute in position 13—which according to the *Ahirbudhnya-Saṃhitā* should be a *vajra*—is here shown as a *śakti* blade, or *ṭanka* (see above, Note 326). In the right hands, there seem to be two swords (positions 2 and 7)—perhaps corresponding to the *asi* (a kind of knife or blade) and *khadga* which are listed in the *Śilparatna* description (see above, Note 329). The *śatavaktra* weapon (fire) is shown as a kind of torch (position 6), to the end of which is attached a small stylized flame identical to the large flames projecting from the outer rim of the disk.

366. For detailed accounts of *yantra* see the works cited above, Part One, Note 154. According to Daniélou, "the representation of deities through thought-forms and magic diagrams, *mantras* and *yantras*, being more abstract, is more accurate than an image"

(*Hindu Polytheism*, p. 332). Note that the *śrī-cakra-yantra*, traditionally regarded as the holiest of all the *yantras*, consists of six interlaced triangles, three pointing upward and three inverted (*ibid.*, p. 359). In the Viṣṇu *yantra*, the actual *ṣaṭ-koṇa* device is placed in the center of a lotus *maṇḍala* (*ibid.*, p. 361). The *ṣaṭ-koṇa-cakra* is also employed as a symbol of the *anāhata* (literally, "unbeaten"), or heart center, in the Yogic doctrine of the six meditational centers (*ṣaṭ-cakra*) of the body; see Tucci, *Theory and Practice of the Mandala*, p. 129. It seems likely that the *ṣaṭ-koṇa* had already become an important Tāntric symbol long before the identical Islamic star hexagram became widely known in ancient India. According to Rao, the hexagram, or Star of David, was termed "Agla" by the Freemasons, who regarded it as an apotropaic device with mystic powers similar to those attributed to Sudarśana in Pāñcarātra literature (*Elements of Hindu Iconography*, Vol. 1, p. 331). See also J. S. M. Ward, *Freemasonry and the Ancient Gods* (London, 1926).

a *ṣaṭ-koṇa* device (*ṣaṭkoṇasaṃstham*).[367] The term *ṣaṭ-koṇa* was apparently synonomous with *tāra* ("star"), since in a chapter on *yantras* the *Ahirbudhnya-Saṃhitā* (26.5) says that for purposes of meditation the devotee "should draw a star within a circle and in the star draw the red-colored deity Sudarśana" (*candramaṇḍalamadhye tu tāraṃ kuryāt samāhitaḥ/ tasya madhye likhed devaṃ raktavarṇaṃ sudarśanam//*).[368] The *Parameśvara-Saṃhitā* (23.29) makes a similar prescription:

Draw a star in the middle of that (circle), in the middle of which Sudarśana (should be depicted), surrounded by a fiery radiance, and provided with either eight or sixteen arms.

(*tanmadhye tārakaṃ kuryāt tanmadhyena sudarśanam bhujaiḥ ṣoḍaśabhiryuktamaṣṭabhirvā'nalaprabham*)

In Tāntric symbolism the upright equilateral triangle (*tri-koṇa*) alone △ is associated with the male principle and fire, while the inverted triangle ▽ is associated with the feminine principle and water.[369] The *ṣaṭ-koṇa*, in which the two triangles are conjoined, may symbolically represent the union of the two principles which create and coordinate the universe, that is, the phenomenal world manifested in space and time.[370] The Pāñcarātra doctrine of the six *guṇas* ("qualities"), which in various combinations go to make up the created universe, may also be linked symbolically with the *ṣaṭ-koṇa-cakra*.[371] The possibility also exists that the *ṣaṭ-koṇa* device was not originally employed in Sudarśana images solely on account of its Tāntric symbolism or its occult role in yogic meditational practices. Like the radiating array of the arms of the deity, the arms of the star may also have visually suggested the spokes of the wheel which the deity personified.[372]

The general development of the sixteen-armed Sudarśana images which we have outlined above, with examples from the fifteenth through the eighteenth century, is basically that of a uniform iconographic type. Two exceptional images which deviate from this typology of the sixteen-armed images of Sudarśana should be noted. Both of these are carved on *maṇḍapa* pillars in the Varadarājaperumāl Temple at Kanchipuram, and date probably to the late sixteenth or early seventeenth century.[373] The first image (Figure 58) reverses the usual *pratyālīḍha* posture of

367. *Śilparatna* (Vol. 2) 23.6 (see above, Note 305). See also *Ahirbudhnya-Saṃhitā* 26.16; *Parāśara-Saṃhitā* 16.7 (cited in Smith, *Vaiṣṇava Iconography*, p. 221). The term *ṣaṭ-koṇa* occurs literally hundreds of times in the *yantra* sections of the Pāñcarātra texts.

368. However, a few verses later (23.16), the text mentions that a *ṣaṭ-koṇa* is to be drawn at the circumference, presumably of the *candra-maṇḍala*; thus the *yantra* apparently has a second *ṣaṭ-koṇa-cakra* circumscribed around the one in which Sudarśana stands.

369. Danielou, *Hindu Polytheism*, p. 352; cf. Zimmer, *Myths and Symbols*, p. 147: "The downward-pointing triangle is a female symbol corresponding to the yoni; it is called 'shakti.' The upward-pointing triangle is the male, the lingam, and is called 'the fire' (*vahni*). *Vahni* is synonymous with *tejas*, 'fiery energy, solar heat, kingly splendor, the threatening fervor of the ascetic, the bodily heat of the warm-blooded organism, the life-force condensed in the male seed.' "

370. Cf. Danielou, *op cit.*, p. 354: the star hexagram is "the basis of the wheel symbol of the third-tendency or revolving tendency (*rajas*) from which the universe is manifested. The circle by which the hexagon is surrounded represents the field in which the two triangles unite, that is, the field of time."

371. See above, Part One, Note 87.

372. This is not to imply that the symbolic aspects of the device were secondary; rather the visual form of the *ṣaṭ-koṇa* reinforced its appropriateness as a Tāntric emblem of Sudarśana. In the eighteenth-century wall painting of Sudarśana at Padmanabhapuram, the *ṣaṭ-koṇa* device replaces the spokes of the actual discus held in the deity's upper right hand (Figure 71). In this connection, it is probably significant that the term *ṣaṭ-koṇa* is one of the traditional epithets applied to Indra's *vajra* (see above, Part One, Note 26).

373. At Kanchipuram the *maṇḍapa* containing the carved pillars is located just inside the outer *prākāra* enclosure of the temple, to the left of the entrance *gopura*.

Sudarśana and shows the deity with feet spread apart, striding toward his right side in the *ālīḍha* pose.[374] The *cakra* and *gadā* are held obliquely in order to conform to the curvature of the rim of the disk and thus point inward toward the figure's headdress. The *gadā* held in the left front hand is also unusual in sixteen-armed images.[375] The other sixteen-armed Sudarśana is a far more inexplicable image (Figure 59). It depicts the deity standing on the outstretched hands of a four-armed winged Garuḍa kneeling in adoration (the two front hands being held in *añjali-mudrā*). Sudarśana has five visible conjoined heads, each wearing a separate high cylindrical crown. This bizarre and anomalous form of the deity is extremely perplexing. However, if six faces are to be presumed—as in images of Kārttikeya (who is known as *ṣanmukha*, or "six-faced")—the underlying symbolism may be allied with that of the *ṣaṭ-koṇa-cakra*.[376] Another peculiar feature is the canopy at the top of the flaming disk, formed by the hoods of a nine-headed serpent, the coiled body of which supports the kneeling Garuḍa.[377]

The weapon attributes and the menacing *ugra* aspect of the sixteen-armed Sudarśana make it abundantly clear that the deity was worshipped as a god of military destruction. However, the majority of devotees—who were not in any event charged with the responsibility of defeating enemy armies—seem to have viewed the destructive powers of Sudarśana in an allegorical and not in a literal sense. An allegorical interpretation seems implicit, for example, in Vedāntadeśika's devotional hymn *Ṣoḍaśāyudhastotram*.[378] In fact, the Tāntric worship of Sudarśana consisted largely of yogic meditation, to be performed in a quiet and remote setting.[379] The goal, according to the *Ahirbudhnya-Saṃhitā*, was to attain salvation and free oneself from all sins—the latter presumably to be burned up by the destructive powers of Sudarśana.[380] Even in the ritual of *pūjā* that was performed in the temple, the majority of the devotees must have been primarily concerned with the relevance of Viṣṇu's personified discus in the moral sphere, not in the political.

Both of these aspects of the cult of Sudarśana are reflected in the iconographic motif of Yoga-Narasiṃha found on the reverse side of certain stone and metal icons dating to the seventeenth and eighteenth century.[381] One of the earliest examples of the composite

374. As already noted, however, at least one Pāñcarātra text, the *Vihagendra-Saṃhitā*, interchanges the definitions of *ālīḍha* and *pratyālīḍha* (see above, Note 308).

375. The *gadā* is also held in the same hand by the sixteen-armed Sudarśana at Kumbakonam (Figure 56). The shield (*kheṭa*) is an iconographic innovation, apparently occurring here for the first time (see above, Note 329).

376. The six faces may also be in direct imitation of the multi-headed images of Kārttikeya, whose iconographic function as a god of warfare is analogous to that of Sudarśana.

377. There seems to be no textual explanation of the hooded serpent in conjunction with Sudarśana; the iconographic associate may perhaps be with Garuḍa, who is known as the conqueror of serpents. However, compare the auspicious use of hooded serpents on the rear of the Sudarśana image installed in a special shrine elsewhere in the Varadarājaperumāḷ Temple (Figure 65).

378. See above, Part One, Note 160; thus the *śatavaktrāgni* is said to "consume the sins of men"; the *nistriṃśa* to "cut through Ignorance"; and the *musala* to "obliterate Delusion."

379. See *Ahirbudhnya-Saṃhitā*, Chapters 31 and 32, which "consist of an outline of the Yoga theory and practice" (Schrader, p. 123ff).

380. *Ibid.* 32.69, 70: *padmāsanasthaṃ bhuktānāṃ viśveṣām-abhayapradam// evaṃ dhāyayan vimucyet muktaḥ sakalakilbiṣaiḥ/.*

381. Although the *Ahirbudhnya-Saṃhitā* and other relatively "early" Pāñcarātra texts furnish descriptions of Narasiṃha in conjunction with the Sudarśana *yantra*, they do not specify what is to be placed on the rear of icons fashioned from permanent materials and installed in special Sudarśana shrines. However, see *Vihagendra-Saṃhitā* 4.1 (cited in Smith, *Vaiṣṇava Iconography*, p. 227), where it is explicitly stated that Sudarśana appears on the front and Narasiṃha on the reverse (*pūrvaṃ sudarśanaṃ*

Sudarśana-Narasiṃha icon is, perhaps, the rectangular slab, carved on both sides, found at Tirumogur in Tirunelveli District, which may be dated to the late sixteenth or early seventeenth century (Figures 62, 63).[382] The image of the sixteen-armed Sudarśana on the obverse stands in the middle of a disk, the rim of which is carved in the form of a lotus *maṇḍala*.[383] Outside the rim of the disk are numerous tiny standing figures, including—directly above the head of Sudarśana—an image of Narasiṃha.[384] The slab has an unfinished appearance because of the lack of perceptible ornaments on the figure of Sudarśana. On the reverse and within a wide-rimmed disk is a large image of a four-armed Narasiṃha seated in yogic posture on a lotus pedestal. The two rear hands hold *cakras,* and the now broken front hands would also have had them—as we know from the example of other images and from the description in the *Ahirbudhnya-Saṃhitā* (26.62):[385]

In the middle of that (circle), with his legs tied with a *yogapaṭṭa,* (is seated) the resolute Narasiṃha, with four arms carrying four *cakras.*

(*tanmadhye yogapaṭṭena pinaddhāṅgaṃ sanātanam nārasiṃhaṃ caturbāhuṃ catuścakradharaṃ param*)

It is not surprising that Narasiṃha, the most horrific of the *avatāras,* should be associated symbolically with the *ugra* sixteen-armed Sudarśana. By holding four *cakras* as weapon-attributes, Narasiṃha's horrible powers of destruction are linked speculatively with the destructiveness of the "support of all weapons and powers," [386] the *sudarśana-cakra* itself. Apparently the yogic posture of Narasiṃha also reflects the preoccupation with Tāntric meditational practices in the Sudarśana cult.

On the reverse of the seventeenth-century Sudarśana icon installed in the Rāmacandra Temple at Nedungunam in North Arcot District, the image of Narasiṃha is shown seated on what appears to be a large flame emerging from the center of the *ṣaṭ-koṇa* device (Figure 64).[387] Here all four arms are intact, clearly revealing the array of supernumerary *cakras* held in all of the hands. The disk has four large flames marking the quadrants and is provided with thirty-two lotus-petal

devamaparena nṛsiṃhakam). As previously mentioned, this *Saṃhitā*—which appears to be a late work—is devoted exclusively to the cult of Sudarśana (see above, Note 308).

382. Tirumogur is apparently another important center of Pāñcarātra traditions; Smith (*Vaiṣṇava Iconography,* p. 305) remarks that "the injunctions in (the *Śrīpraśna-Saṃhitā*) regarding worship are followed" at this temple. The rectangular slab is set up in the open; presumably another image is installed in a Sudarśana shrine inside the temple. The image is a problematic one, and the date assigned must be regarded as a tentative assessment.

383. This is probably one of the earliest instances in which the image is treated as if it were an actual *yantra* (cf. the lotus *maṇḍala* behind the image in Figure 70).

384. Narasiṃha is shown in the act of disembowelling Hiraṇyakaśipu (cf. Figure 67). The tiny figures perhaps represent

the twelve forms of Viṣṇu, with consorts, which the *Ahirbudhnya-Saṃhitā* states should be drawn around the Sudarśana *yantra* (26.32–46); similarly, the figures on the reverse are probably the attendants of Narasiṃha prescribed in the same chapter (26.66).

385. Cf. *Vihagendra-Saṃhitā* 4.2 (quoted in Smith, *Vaiṣṇava Iconography,* p. 227), which implies that Sudarśana is also to be shown with a *cakra* in every hand and that the number of hands can be indefinitely multiplied. However, no such images are known.

386. See above, Note 299. The *Vihagendra-Saṃhitā* speculatively equates Sudarśana and Narasiṃha (4.6; cited in Smith, *loc. cit.*): *sudarśananaṇṛsiṃhaṃ ca narasiṃhaṃ sudarśanam/sudarśane nṛsiṃhe vā ekarūpamihocyate//.*

387. Cf. the lotus-pedestal of Narasiṃha in Figure 63, and the architectonic pedestal in Figure 65.

divisions on the rim. Clearly later in date than the Nedungunam image is the magnificent Narasiṃha seated on the reverse of the large Sudarśana icon installed in a special shrine in the Varadarājaperumāl Temple at Kanchipuram (Figure 65).[388] Probably dating to the late seventeenth century, the image depicts Narasiṃha seated on a stepped platform supported by the hood of a five-headed serpent, recalling the similar iconographic function of the serpent in the anomalous image of Sudarśana carved on a *maṇḍapa* pillar in the same temple (Figure 59). Here the rim of the disk has two concentric rings of lotus-petal decoration, the inner with sixteen divisions and the outer with thirty-two.

At some time in the late seventeenth or early eighteenth century, certain innovations occurred in the iconography of the composite Sudarśana-Narasiṃha icon, largely with respect to the conception of Narasiṃha. An interesting but rather mediocre example of these innovations is the eighteenth-century bronze Sudarśana in the Sundararājaperumāl Temple at Dadikkombu (Figures 68, 69).[389] The image is in the form of a solid disk with a flat rim, with thirty-two projecting flames (including four prominent ones) circumscribing the outer edge and seventy-six small spokes decorating the inner ring. The obverse of the disk depicts Sudarśana wearing a flame headdress similar to the one in the large stone image in the Śrī Alagarperumāl Temple, also at Dadikkombu. The attributes are arrayed at the level of the shoulders in a slightly curved arc extending across the upper part of the torso and obscuring most of the arms. On the reverse of the disk the figure of Yoga-Narasiṃha sits within an upward-pointing equilateral triangle (*tri-koṇa*).[390] Flames spring up from behind his cylindrical crown, thus providing the probable inspiration for the name Jvāla-Narasiṃha, or "fiery" Narasiṃha, by which this form of the deity is known in South India.[391] The four *cakra* attributes are held with the edges toward the viewer, with flames projecting from their centers as well as from the rims.[392]

The iconography of the Narasiṃha image is further elaborated on the reverse of a copper

388. Compared to the modest Sudarśana cella at Nedungunam, the Kanchipuram shrine is a very imposing edifice (see above, Note 304, and text illustration). The shrine is attached to a wall surrounding a closed-off garden within the outer enclosure of the temple, and can be entered from both front and rear entrances.

389. See Gopinatha Rao, *Elements of Hindu Iconography*, Vol. 1, Pl. LXXXV-A; and H. Krishna Sastri, *South Indian Gods and Goddesses*, Fig. 45. The bronze is approximately contemporary with the large stone image of Sudarśana at Dadikkombu discussed above (Figure 57).

390. The Yoga form of Narasiṃha was an established type long before it was incorporated into the iconography of the multi-armed Sudarśana. However, the *tri-koṇa* device occurs behind Narasiṃha only when he is represented in conjunction with Sudarśana. The *tri-koṇa* undoubtedly derived from the *ṣaṭ-koṇa* device, and probably shared part of its symbolic meaning (see above, Notes 366ff). However, since the triangular device is apparently not prescribed in the Pāñcarātra texts, it seems likely that its visual function is at least as important as its symbolic

meaning. In fact the motif was probably developed "accidentally," or rather in response to the visual effect produced by the superimposition of the seated Narasiṃha on the *ṣaṭ-koṇa* device behind Sudarśana, as at Kanchipuram (Figure 65), where the *ṣaṭ-koṇa* forms a symbolic backdrop for both deities. However, due to the special posture of Narasiṃha, it was probably felt that the single vertical triangle was more appropriate by itself; in any event, Narasiṃha, who was speculatively regarded as subordinate to Sudarśana, could not actually share his symbolic diagram.

391. Krishna Sastri, *South Indian Gods and Goddesses*, p. 70. The flaming headdress of Narasiṃha represents another assimilative borrowing from the iconographic conception of Sudarśana; the flames reinforce the fiery significance of the *tri-koṇa* symbol itself.

392. The flaming *cakra* in Sudarśana's right rear hand is also held in a similar position; the edge-on view represents an unusual departure from the usual frontal position of the *cakra* almost invariably found in Vaiṣṇava images from the fourteenth century onwards.

image of Sudarśana with sixteen arms dating to the seventeenth or more probably the eighteenth century and now in the Madras Government Museum (Figures 66, 67).[393] Although crude in execution, this small image is one of the most interesting of the series. The decorative treatment of the solid disk, which has thirty-two flames projecting from the rim and an equal number of spokes on an inner concentric band, is similar to that of the Dadikkombu bronze. The thin edges of the *ṣaṭ-koṇa* device are also treated in a similar fashion. The arrangement of arms in the Madras icon is completely different, as is also the decoration of the square pedestal, which here has eight hooded serpents, two on each side.[394] In the angles of the *ṣaṭ-koṇa* device, and elsewhere on the surface of the disk, are inscribed occult syllables known as *bījākṣaras*.[395] On the petals of the circular lotus pedestal is inscribed the sacred *mantra* of eight syllables: *oṃ namo nārāyaṇāya* ("Om. Salutation to Nārāyaṇa").[396] On the reverse of the disk and within a *tri-koṇa* is an unusual image of Narasiṃha with eight arms, shown in the act of disemboweling the demon Hiraṇyakaśipu with his two front hands.[397] A small figure representing the demon's son Prahlāda—who, unlike his father, was an ardent devotee of Viṣṇu—is shown standing at the right with his hands held in *añjali-mudrā,* a silent and reverential witness to the gory scene.[398] The almost lifeless demon holds a shield and a small sword. Narasiṃha stands precariously on one foot, using the other leg to support the demon's body across his knee. The rear right hand of Narasiṃha is upraised as if about to strike his foe. The other two right hands hold *cakra* and a small *khaḍga,* while the left hands hold *śaṅkha, dhanus,* and *gadā.*

The iconographic conception of the Madras image illustrates the latest and conceptually most complex phase of the development of the Sudarśana cult image. The substitution of a violent form of Narasiṃha for the one seated in yogic posture reinforces the notion of the personified Sudarśana as an embodiment of Viṣṇu's implacable wrath toward his foes. Prahlāda's presence is doubly appropriate, by virtue both of his unswerving devotion to the deity and the fact that in a previous birth he had been killed by the discus of Viṣṇu—a warning of quick and sure retribution to enemy and erring devotee alike.[399]

393. See F. H. Gravely and T. N. Ramachandran, *Catalogue of the South Indian Metal Images in the Madras Government Museum* (Madras, 1932), pp. 99, 100. The bronze is less than eight inches in height.

394. Compare the hooded serpent on the pedestal supporting Narasiṃha on the rear of the Kanchipuram Sudarśana image (Figure 65).

395. Gravely and Ramachandran, *Catalogue of South Indian Metal Images*, pp. 99, 100. (cf. Note 400 below).

396. *Ibid.*; the authors point out that *mantra* is inscribed in "modern Grantha characters."

397. This motif also occurs above Sudarśana's head on the rectangular slab at Tirumogur, dating to the seventeenth century (Figure 62). For the iconography of the horrific form of Narasiṃha, see Gopinatha Rao, *Elements of Hindu Iconography,* Vol. 1, pp. 145ff; also Krishna Sastri, *South Indian Gods and Goddesses,* pp. 24ff.

398. See Dowson, *Classical Dictionary of Hindu Mythology,* s.v. "Prahlāda" (pp. 238, 239).

399. *Ibid.* According to Dowson's summary of the account in the *Padma Purāṇa,* Prahlāda in a previous existence "was a Brāhman named Somaśarman, fifth son of Śivaśarman. His four brothers died and obtained union with Vishnu, and he desired to follow them. To accomplish this he engaged in profound meditation, but he allowed himself to be distracted by an alarm of the Daityas, and so was born again as one of them. He took the part of his race in the war between them and the gods, and was killed by the discus of Vishnu, after that he was again born as son of Hiraṇyakaśipu." Note that Prahlāda was the grandfather of Bali, the Daitya *cakravartin,* whose universal kingdom was acquired for the gods by Viṣṇu in the Vāmana *avatāra.*

With respect to the cabalistic *bījākṣaras* inscribed on the surface of the Madras image, it should be noted that the *Ahirbudhnya-Saṃhitā* gives the prescription for these only in connection with the *yantras,* or diagrammatic "instruments" for meditation.[400] The inclusion of the *bījākṣaras* on the cult images of Sudarśana suggests that these later images were regarded as the equivalent of *yantras,* thus demonstrating the increased importance of Tāntric symbolism in the ritual veneration of the deity. One of the most elaborate of the inscribed icons is the sixteen-armed bronze Sudarśana in the Śrī Kālamekaperumāl Temple at Tirumohur, in the Madurai District (Figure 70).[401] This image, which probably dates to about the seventeenth century, depicts Suśarśana standing against a solid disk rimmed with flames, the whole being conceived as a lotus *maṇḍala.* There are four concentric bands surrounding the *ṣaṭ-koṇa-cakra* behind Sudarśana. These are decorated with lotus petals inscribed with characters in *grantha* script. The innermost circular band has eight petals, the next sixteen, the next thirty-two, and the last sixty-four.[402]

Some miscellaneous examples of Sudarśana images of relatively unusual type should be noted. The first of these is a wall painting of the sixteen-armed Sudarśana (Figure 71) in the palace at Padmanabhapuram in Kanyakumari District, dating to the eighteenth century.[403] Aside from being a unique specimen of a painting of Sudarśana surviving from this period, the image has some peculiar iconographic features, the chief of which is the *samapādasthānaka* posture. This is one of the few instances where the sixteen-armed Sudarśana is not shown in the *pratyālīḍha* pose.[404] Other unusual features include the downward-pointing *gadā* held in the left front hand and the greatly elongated front arms themselves, which both hang down almost to the knees.

The second example of a relatively rare iconographic type is the late eighteenth- or early nineteenth-century bronze image of Sudarśana with only six arms, now in the Madras Government Museum (Figure 72). Although the six-armed form is described in the *Puruṣottama-Saṃhitā,* no other example besides this has come to light.[405] The demeanor of

400. See Schrader, *Introduction to the Pāñcarātra,* pp. 122, 123, where he points out that in the chapters on *yantras* (21–27), "the mystical alphabets play an important part"; cf. Chapters 16 and 17, which deal with the symbolism of the letters of the alphabet. Each of the *bījākṣaras* is actually a separate *mantra,* and as such is considered to be just as concrete a manifestation of the deity's potency as the image itself. See the discussion of *yantras* in Gopinatha Rao, *Elements of Hindu Iconography,* Vol. 1, pp. 329ff; Rao points out that "certain letters called *bījākṣaras* or seed-letters are associated with these *chakras* and *yantras,* and are written down invariably in specified parts thereof. The *bījākṣaras* may be imagined to be something like code words, whose significance is known only to the initiates."

401. A similar bronze image, but without the inscribed *bījākṣaras,* is in the Srirangam Museum.

402. Filling out the diagrammatic scheme are two interlaced squares, the eight corners of which are shown as small triangles emerging from behind the circular *maṇḍala.*

403. For an account of the paintings in the Padmanabhapuram

Palace, see Stella Kramrisch, J. H. Cousins, and R. Vasudeva Poduval, *The Arts and Crafts of Kerala* (Cochin, 1970), pp. 165ff; a portion of the painting of Sudarśana is reproduced in C. Sivaramamurti, *South Indian Paintings* (New Delhi, 1968), Fig. 97.

404. See above, Note 338. The positions of several of the attributes deviate from the prescribed order; note that the figure holds a rectangular shield (*kheṭa*), an attribute which was apparently introduced in the second half of the seventeenth century (see above, Note 329).

405. *Puruṣottama-Saṃhitā* 7.40, 41 (cited in Smith, *Vaiṣṇava Iconography,* p. 222):

ṣaṭkoṇacakramadhye ca mūrtiḥ ṣaḍbhuja ucyate
paṅkajam hetirājam ca gadām dakṣiṇabāhubhiḥ
śaṅkham ca musalam śārṅgam dhārayedvāmabāhubhiḥ

Thus the sequence is lotus, discus, and mace in the right hands; conch, pestle, and bow in the left hands. In the present image, the positions of the mace and pestle have been interchanged.

Sudarśana is almost fatuous, an effect to which the exaggerated decorative qualities of the disk contribute substantially—especially the four prominent flames (two of which have been provided with streamers, as if they were not really flames).

The third unusual image of Sudarśana is an eighteenth-century woodcarving from Kerala (Figure 73). Unlike the preceding icon, the present one retains the typical *ugra* expression. However, except for the large head and the feet, Sudarśana has no body—that is, in front of his body he wears, like a protective shield, a large flaming disk covered with floral rosettes, with a *ṣaṭ-koṇa* in the center. Projecting from the interstices formed by the angles of the *ṣaṭ-koṇa* touching the circumference are four tiny hands holding *cakra, padma, śaṅkha,* and *gadā,* the attributes of the four-armed Viṣṇu.

In addition to the personified varieties of Sudarśana already discussed, aniconic forms of the *cakra* are found in almost every Vaiṣṇava temple in South India. The vast majority of these are small metal disks mounted on a stand and placed along with other detached attributes and cult objects in front of the main deity enshrined in the temple, instead of in separate shrines. Three bronze Sudarśana disks of this type, dating to the seventeenth and eighteenth centuries, are now in the Madras Government Museum (Figures 78–80).[406] Occasionally, large aniconic disks of stone were set up in the special Sudarśana shrines, in substitution for the more usual cult images, as in the Śrī Raṅganāthasvāmi Temple at Singavaram in South Arcot District, where the *cakra* has sixteen spokes in the form of lotus petals (Figure 77).

Unexpectedly, other metal disks show two-armed (as opposed to the typical multi-armed) personifications of Sudarśana standing against or in the center of the actual spokes of the flaming wheel, as in the case of the bronzes from Alathur in North Arcot District (Figure 76) and from the Śrī Chennakeśavaperumāl Temple at Mallanginar in Thanjavur District (Figure 74), both dating to the eighteenth century. Although the personifications are shown in devotional attitudes, with hands held in *añjali-mudrā,* the fact that the disks have sixteen spokes suggests that the presence of the sixteen-armed Sudarśana is symbolically implied.[407]

Finally, we should mention a bronze *cakra* with eight spokes in the Śrī Kudalalagar Temple at Madurai, dating to the seventeenth century (Figure 75). This bronze does not depict Sudarśana, but instead shows Garuḍa kneeling on top of a small platform supported by a pillar-like stand. The double role of Garuḍa as the ensign of the deity and the symbolic *vāhana* of the *sudarśana-cakra* takes us back full circle to the Besnagar *garuḍa-dhvaja* and also the heraldic pillar of Viṣṇu at Eran, where Garuḍa and the great discus emblem of Viṣṇu were conjoined.

406. Gravely and Ramachandran, *Catalogue of the South Indian Metal Images,* p. 99 (Nos. 2, 4, and 5); the *cakra* reproduced in Figure 79 is "mounted on a socket for a pole," indicating that it was probably to be held aloft in processions. For a similar aniconic *cakra* in the Museé Guimet, see J. Hackin, *La Sculpture Indienne et Tibétaine au Museé Guimet* (Paris, 1931), p. 12 and Pl. XXVII.

407. For a Jaina parallel to the *cakras* mounted on stands, see the *nava-devatā-cakra* reproduced in Shah, *Studies in Jaina Art,* Fig. 77 (discussed on p. 77).

To briefly conclude, in this study we have traced the iconographic development of the *cakra* from the actual discoid weapons used in ancient India to the incredibly esoteric cult images of Sudarśana developed in the medieval period. Between these two points of origin and termination came the anthropomorphic personifications of the discus serving as faithful attendants of the Supreme Deity Viṣṇu. In contrast to the humanistic guise and implications of the two-armed *cakra-puruṣa,* the medieval multi-armed Sudarśana was depicted and speculatively regarded as an ambivalent, largely impersonal manifestation of the destructive forces inherent in the universe. In its final terrible aspect, the discus of Viṣṇu symbolically combined the conceptions of a fabled flaming weapon and the irrevocably upraised Wheel of Time which destroys this world.

Glossary
and Bibliography

Glossary

Abhaya-mudrā. Gesture signifying reassurance, with the right hand held up, palm exposed.

Abhicārika-mūrti. "Inauspicious form" of a deity.

Agni. Vedic deity of fire, closely associated with the sacrifice and the priestly hierarchy.

Ālīḍha. Striding posture, with the right foot advanced.

Anantaśayin. "Reclining upon Ananta (cosmic serpent)"; special iconographic form of Viṣṇu as primordial creator.

Añjali-mudrā. Gesture of respect or adoration, with the palms of both hands held together in front of the chest.

Aṅkuśa. Elephant goad; weapon-attribute.

Arjuna. One of the five Pāṇḍava heroes of the Mahābhārata war; Kṛṣṇa served as his charioteer.

Asuras. Demons, opponents of the *devas*, or "gods." The Daityas and Dānavas belong to this category.

Avatāra. "Descent," or incarnation of the deity Viṣṇu; the traditional number is ten.

Āyudha. Weapon.

Āyudha-puruṣa. "Weapon-personification," the sex of the personification being determined by the gender of the Sanskrit word for the weapon.

Bali. Demon emperor humiliated by Viṣṇu in his Vāmana *avatāra*.

Bhāgavata. Adjective referring to early cult of Vāsudeva-Kṛṣṇa, called *bhagavat*, the "blessed one"; synonymous with Pāñcarātra.

Bhakti. "Devotion, attachment"; pertains to doctrine of the compassionate nature of the Supreme Deity, who inspires love in his devotees.

Bhāsa. Early Sanskrit playwright, probably flourished in second or third century A.D.

Bījākṣaras. "Seed-letters"; auspicious syllables having a cabalistic significance.

Brahmā. God of creation, first member of so-called Trinity; derived from Vedic deity Prajāpati.

Cakra. Discus or wheel; distinctive weapon-attribute of Viṣṇu.

Cakra-puruṣa. Personification of Viṣṇu's discus; the term is here used as designation of two-armed personification.

Cakravartin. Emperor, ideal Āryan ruler; precise meaning uncertain, sometimes translated as "turner of the wheel"; perhaps "possessor of vast circular territories."

Cālukya. Dynasty ruling portions of South India about 550–750 A.D.

Cāmara. Ceremonial fly whisk.

Catur-vyūha. "Four-formations"; pertains to the Bhāgavata doctrine of the quadripartite divine nature of Vāsudeva-Kṛṣṇa-Viṣṇu.

Cōḷa. Dynasty ruling portions of South India about 850 to 1250 A.D.

Daṇḍa. Rod, staff; weapon-attribute.

Dhanus. Bow; weapon-attribute.

Dharma. Law, morality, obligation, doctrine; in later periods almost equivalent to the term religion.

Dhvaja. Standard, ensign; as in *dhvaja-stambha*, "standard-pillar."

Epic. Refers to *Mahābhārata* and *Rāmāyaṇa*, the two great Indian epics; as used here, Epic Period refers to the period of composition and compilation of these poetical works, that is, about 400 B.C. to 400 A.D.

Gadā. Mace; distinctive weapon-attribute of Viṣṇu.

Gadā-devī. "Goddess of the mace"; epithet applied to personified form of Viṣṇu's *gadā*.

Gaṇa. One of a class of minor divinities, usually dwarfish attendants of Śiva.

Garuḍa. Mythical eaglelike bird serving as Viṣṇu's *vāhana*, or symbolic vehicle; usually represented as human figure with wings and other bird characteristics.

Garuḍa-dhvaja. The standard of Viṣṇu, having Garuḍa as emblem.

Guṇa. "Quality, characteristic"; technical metaphysical term.

Gupta. Dynasty ruling North India about 320 to 500 A.D. and later; the Gupta period is regarded as a classical phase of Indian art and civilization.

Hala. Plough; weapon-attribute, especially of Saṅkarṣaṇa.

Harihara. Composite form of Viṣṇu (Hari) and Śiva (Hara).

Hoysala. Dynasty ruling portions of South India about 1150–1350 A.D.

Indra. Major Vedic deity, warrior-chieftain of the gods, wielder of the heavenly thunderbolt, destroyer of the demon Vṛtra; Indra's position of supremacy was later usurped by Vāsudeva-Kṛṣṇa-Viṣṇu.

Kaiṭabha. Demon killed by Kṛṣṇa-Viṣṇu.

Kāla-cakra. "Wheel of Time," and, by implication, death and destruction.

Kārttikeya. Six-headed God of warfare, son of Śiva.

Kaumodakī. Epithet of the personification of Viṣṇu's *gadā* (same as *gadā-devī*).

Kaustubha. Distinctive jewel emblem on Viṣṇu's chest.

Kāvya. Poetry, refers especially to lyrical works in an ornate style.

Ketu. Banner or flag; distinctive heraldic emblem.

Khaḍga. Sword; weapon-attribute.

Kirīṭa-mukuṭa. Jeweled headdress; type of crown worn by Viṣṇu.

Kīrtimukha. "Face of glory," apotropaic mask and architectural motif; also occurs at top of some medieval steles.

Kṛṣṇa. The "Dark One," personal name of deified Epic hero, later regarded as the eighth *avatāra* of Viṣṇu in the traditional list of ten.

Kṣatriya. Noble warrior; second of four traditional Hindu castes.

Kunta. Lance or spear; weapon-attribute.

Kushān. Dynasty ruling portions of North India about 50 to 225 A.D.; their southern capital was at Mathura.

Lakṣmī (also called *Śrī*). Goddess of good fortune; consort of Viṣṇu.

Madhu. Demon killed by Kṛṣṇa-Viṣṇu.

Maṇḍala. Magical cosmological diagram consisting of superimposed geometrical forms: circle, square, and triangles.

Maṇḍapa. Pillared hall in Hindu temple complex.

Mantra. Formulaic utterance, sometimes functioning as a spell or incantation.

Mukuṭa. Headdress.

Mūrti. Form or image of a deity.

Musala. Pestle; weapon-attribute.

Nandaka. Epithet of Viṣṇu's personified sword (*khaḍga*).

Narasiṃha. "Man-Lion," fourth in traditional list of Viṣṇu's *avatāras.*

Nārāyaṇa. Later Vedic deity associated with the Sacrifice; epithet of Viṣṇu of the historical period.

Nāyak. Period of successive military overlords in South India following downfall of Vijayanagara Empire, about 1565 to 1800 A.D.

Nivartaka. "Defensive"; refers to category of weapons.

Padma. Lotus, one of Viṣṇu's distinctive attributes.

Pāla. Dynasty ruling Eastern India, about 750 to 1150 A.D.

Pallava. Dynasty ruling portions of South India, about 600 to 850 A.D.

Pāñcajanya. Epithet of Viṣṇu's conch (*śaṅkha*).

Pāñcarātra. Adjective referring to early Vaiṣṇava cult; synonymous with Bhāgavata (precise meaning uncertain, perhaps "five nights" of sacrificial ritual).

Pañcavīra. "Five-heroes," deified warriors consisting of Kṛṣṇa, his elder half-brother, his two sons, and his grandson; worshipped as a group around beginning of Christian era (cf. *catur-vyūha*).

Paraśu. Axe; weapon-attribute.

Pārśva-devatā. Subsidiary deity; refers to other images besides main one installed in Hindu temple.

Pāśa. Noose; weapon-attribute.

Prajāpati. Lord of creatures or lord of progeny; Vedic deity associated with creation (cf. Brahmā).

Prākāra. Enclosure; refers to various compounds surrounding the main shrine in South Indian temple complex.

Pratyālīḍha. Striding posture, with left leg advanced.

Pravartaka. "Offensive"; refers to category of weapons.

Pūjā. Ritual worship of images installed in temples.

Purāṇic. From *Purāṇa* ("ancient" tradition), distinctive

type of religious text of classical and early medieval periods, concerned with mythological exploits and antecedents of the gods; Purāṇic Period here refers to period of compilation of eighteen major *Purāṇas*, about 200 to 1000 A.D.

Rāma. Hero of *Rāmāyaṇa*; Seventh *avatāra* of Viṣṇu in traditional list.

Rāmānuja. South Indian Vaiṣṇava theologian (?1017–1137).

Śakti. The "potency" of a deity personified as his wife, cosmic power conceived as of a feminine principle; also, a spear.

Samapādasthānaka. Hieratic, frontal posture, with weight equally distributed on both feet.

Saṅkarṣaṇa (also called Balarāma). Elder half-brother of Kṛṣṇa.

Śaṅkha. Conch shell, used by ancient warriors of India for signaling on battlefield; one of Viṣṇu's distinctive attributes.

Śārṅga. Epithet of Viṣṇu's bow; literally, "made of horn."

Śatavaktra. Term for fire attribute held by Viṣṇu; literally, "hundred-countenanced."

Ṣaṭ-koṇa. Symbolic star hexagram composed of two interlaced triangles; literally, "six-angled."

Sāyaṇa. Medieval South Indian Vedic scholar and exegete (d. 1387).

Sena. Dynasty ruling Eastern India about 1100 to 1225 A.D.

Śiraścakra. Circular aureole attached to back of head-dress, or crown.

Śiva. The "Auspicious One"; major Hindu deity of the historical period; third member of so-called Trinity; chief rival of Viṣṇu.

Śrīvatsa. Auspicious mark or curl of hair on Viṣṇu's chest; figuratively, favored "child of the goddess of fortune."

Stambha. Pillar, especially free-standing votive columns.

Stotra. Hymn of praise.

Sudarśana. "Beauteous-to-behold"; epithet of Viṣṇu's discus.

Sudarśana-puruṣa. Personification of Viṣṇu's discus; here used as designation of multi-armed forms.

Śūla. Pike, weapon-attribute; cf. *Triśūla*, or trident.

Sūrya. Vedic solar deity; the sun.

Tāntric. From *Tantra* ("treatise"), distinctive type of religious text of early and later medieval period, concerned with esoteric doctrines and practices; the main period of the compilation of these texts was about 800 to 1600 A.D. Vaiṣṇava Tāntric texts are usually called *saṃhitā* ("compendium"), Śaiva texts, *āgama* ("approach").

Tvaṣṭṛ. Vedic artificer of the gods.

Ugra. Horrific aspect.

Upavīta. Sacred thread of initiation; worn over left shoulder and under right arm.

Vāhana. "Vehicle" of the gods; usually an animal on whose back the deity rides.

Vaiṣṇava. Adjective referring to cult of Viṣṇu, its doctrines and followers.

Vajra. Pronged thunderbolt; chief weapon of Indra; in compounds, also means "adamantine."

Vāmana. "Dwarf" *avatāra* of Viṣṇu, fifth in traditional list of ten.

Vanamālā. "Forest-garland"; long wreath of flowers worn by Viṣṇu, one of his distinctive attributes.

Varada-mudrā. Gesture signifying boon-bestowing, usually left hand extended downwards with palm open.

Varāha. Cosmic "boar"; third *avatāra* of Viṣṇu in traditional list of ten.

Vāsudeva. Patronymic epithet of Kṛṣṇa, son of Vasudeva.

Vedāntadeśika. South Indian Vaiṣṇava theologian (?1269–1369).

Vedic. From *Veda* (sacred "knowledge"), distinctive type of religious literature of early Indo-Āryans. Primarily refers to four *Vedas* composed about 1200 to 1000 B.C.; however, generic term also includes *Brāhmaṇas* (*ca.* 1000–800 B.C.) and *Upaniṣads* (*ca.* 800–600 B.C.)—hence Vedic refers to entire formative period of Indian civilization, about 1200 to 600 B.C.

Vidyādhara. Class of celestials attendant upon major deities, usually shown carrying garlands.

Vijayanagara. Capital city of dynasty ruling South India about 1336 to 1565; name given to this period.

Viṣṇu. The "Pervader"; Major Hindu deity of the historical period, chief rival of Śiva, second member

of so-called Trinity; also minor Vedic deity.

Viśvakarma. "All-maker," artificer of the gods (identified with Tvaṣṭṛ).

Vṛṣṇi. Ancient Indian *kṣatriya* clan to which Kṛṣṇa belonged.

Vṛtra. Demon slain by the Vedic deity Indra.

Vyūha. "Formation"; refers to doctrine of divine emanations of Kṛṣṇa (cf. *avatāra*).

Yāli. Mythical leonine animal; decorative sculptural motif.

Yantra. "Instrument"; refers literally to mechanical contrivances, figuratively to magical diagrams, icons, etc. which aid in ritual.

Bibliography

(lists only books and articles cited in the notes)

Agni Purāṇa. See: Dutt, Manmatha Nath.

Agrawala, R. C. "Cakra Puruṣa in Early Indian Art." *Bhāratīya Vidyā*, 24 (1964), 41–45.

————. "Unpublished Sculptures and Terra cottas in the National Museum, New Delhi and Some Allied Problems." *East and West*, 17 (1967), 276–286.

Agrawala, V. S. *A Catalogue of the Brahmanical Images in Mathura Art.* Lucknow, 1951.

————. "An Explanation of the Chakravikrama Type of Chandragupta II." *Journal of the Numismatic Society of India*, 16 (1954), 97–101.

————. "Brahmanical Images in Mathura Art." *Journal of the Indian Society of Oriental Art*, 5 (1937), 122–130.

————. *The Wheel Flag of India, Chakra-Dhvaja.* Varanasi, 1964.

————. *Vāmana Purāṇa—A Study.* Varanasi, 1964.

Ahirbudhnya-Saṃhitā. See: Ramanujacharya, M. D.

Allen, John. *Catalogue of the Coins of Ancient India.* London, 1936.

Altekar, A. S. *Catalogue of the Gupta Gold Coins in the Bayana Hoard.* Bombay, 1954.

————. *The Coinage of the Gupta Empire.* Corpus of Indian Coins, Vol. 4. Varanasi, 1957.

————. "Rare and Unique Coins from the Bayana Hoard." *Journal of Numismatic Society of India*, 10 (1948), 103–104.

Annangaracarya, P. B., ed. *Stotrāvalī Vibhāgaḥ, Srīmadvedānta-desikagranthamālāyām.* Kanchipuram, 1958.

Archaeological Survey of India, Annual Report, 1930–1934. Delhi, 1936.

Asher, Frederick M. "The Former Broadley Collection, Bihar Sharif." *Artibus Asiae*, 32 (1970), 105–124.

Auboyer, Jeannine. "Quelques réflexions à propos du cakra, arme offensive." *Arts Asiatiques*, 11 (1965), 119–130.

Balasubrahmanyam, S. R. "The Date of the Lad Khan (Sūrya-Nārāyaṇa) Temple at Aihole." *Lalit Kalā*, No. 10 (1951), 41–44.

Banerjea, J. N. "An Abhicārika Viṣṇu Image." *Journal of the Indian Society of Oriental Art*, 7 (1940), 159–161.

————. "Images of Sāmba." *Journal of the Indian Society of Oriental Art*, 12 (1944), 129–134.

————. *The Development of Hindu Iconography.* 2nd ed. Calcutta, 1956.

Bannerjee, M. N. "Iron and Steel in the Ṛgvedic Age." *Indian Historical Quarterly*, 5 (1929), 432–440.

Banerji, R. D. *Eastern Indian School of Mediaeval Sculpture.* Archaeological Survey of India, New Imperial Series, Vol. 47. Delhi, 1933.

Barrett, Douglas. "Bronzes from Northwest India and Pakistan." *Lalit Kalā*, No. 11, 1962.

Begley, W. E. "The Earliest Sudarsana-cakra Bronze and the Date of the *Ahirbudhnya-Saṃhitā.*" In *Proceedings of the 27th International Congress of Orientalists.* Wiesbaden, 1971 (pp. 315–316).

Bhagavad Gītā. See: Edgerton, Franklin.

Bhandarkar, D. R. "Excavations at Besnagar." *Archaeological Survey of India, Annual Report* 1913–1914, 186–226.

Bhandarkar, R. G. *Vaiṣṇavism, Saivism and Minor Religious Systems.* 2nd ed. Varanasi, 1965.

Bharati, Agehananda. *The Tantric Tradition.* London, 1965.

Bhattacaryya, J. V., ed. *Viṣṇupurāṇam,* 2 vols. Calcutta, 1882.

Bhattacharji, Sukumari. *The Hindu Theogony*. Cambridge, 1970.

Bhattacharya, Ramshankar, ed. *Garuḍa Purāṇam*. Kashi Sanskrit Series, No. 165. Varanasi, 1964.

Bhattasali, N. K. *Iconography of Buddhist and Brahmanical Images in the Dacca Museum*. Dacca, 1929.

Bidyabirod, B. B. *Varieties of the Vishnu Image*. Memoirs of the Archaeological Survey of India, No. 2. Calcutta, 1920.

Brown, Percy. *Indian Architecture, Buddhist and Hindu Periods*. Bombay, 1965.

Burgess, James. *Report on the Elura Cave Temples*. Archaeological Survey of Western India, Vol. 5. London, 1882.

Chakravarti, P. C. "The Art of War in Ancient India." *Dacca University Bulletin*, Vol. 21. Dacca, 1941.

Chanda, Ramaprasad. *Archaeology and Vaishnava Tradition*. Memoirs of the Archaeological Survey of India, No. 5. Calcutta, 1920.

———. "Jaina Images at Rajgir." *Archaeological Survey of India, Annual Report* 1925–26, 125ff.

Chanda, R. G. "A New Chakravikrama of Chandragupta II." *Journal of the Numismatic Society of India*, 22 (1960), 261–263.

Chandra, Pramod. *A Guide to the Elephanta Caves*. The Heritage of Indian Art Series. Bombay, 1958.

Coomaraswamy, A. K. *The Dance of Siva*. London, 1958.

———. "A Statuette of Vishnu from Kashmir." *The Museum Journal* (University of Pennsylvania), 17 (1926), 91–93.

———. *Yakṣas*, Part II. Washington, D. C., 1931.

Cousens, H. *Chālukyan Architecture of the Kanarese Districts*. Archaeological Survey of India, New Imperial Series, Vol. 42. Calcutta, 1926.

Cunningham, A. *Archaeological Survey of India, Reports*, Vol. 10. Calcutta, 1880.

———. *Coins of Ancient India*. London, 1891.

Dahlquist, Allan. *Megasthenes and Indian Religion*. Uppsala, 1962.

Daniélou, Alain. *Hindu Polytheism*. London, 1963.

De, S. K. *Early History of the Vaishnava Faith and Movement in Bengal*. 2nd ed. Calcutta, 1961.

Dikshit, S. K. *A Guide to the Central Archaeological Museum, Gwalior*. Bhopal, 1962.

Dikshitar, V. R. Ramachandra. *The Purāṇa Index*, 3 vols. Madras, 1951–1955.

Dowson, John. *A Classical Dictionary of Hindu Mythology*. 7th ed. London, 1950.

Duraiswami Aiyangar, M. and Venugopalacharya, T., eds. *Srī Pāñcarātrarakṣa of Srī Vedānta Deśika*. Adyar Library Series, Vol. 36. 2nd ed. Madras, 1967.

Durgaprasad and Parab, K. P., eds. *Kāvyamālā*, Part 8. Bombay, 1891.

Dutt, Manmatha Nath, trans. *The Garuḍa Purāṇam*. Chowkhambha Sanskrit Series, Vol. 67. 2nd ed. Varanasi, 1968.

———, trans. *Harivaṃsha*. Calcutta, 1897.

———, trans. *A Prose English Translation of the Agni Purāṇa*, 2 vols. Calcutta, 1902–1904.

Edgerton, Franklin. *The Bhagavad Gītā*. Harvard Oriental Series, Vols. 38–39. Cambridge, 1944.

Eggeling, Julius, trans. *Satapatha Brāhmana*, 5 vols. Sacred Books of the East, Vols. 12, 26, 41, 42, 44. London, 1879–1910.

Fergusson, James. *History of Indian and Eastern Architecture*, 2 vols. Revised by James Burgess and R. Phene Spiers. London, 1910.

Fleet, J. F. *Inscriptions of the Early Gupta Kings and Their Successors*. Corpus Inscriptionum Indicarum, Vol. 3. Calcutta, 1888.

Gaidoz, Henri. *Le dieu gaulois du soleil et le symbolisme de la roue*. Étude de mythologie gauloise, Vol. 1. Paris, 1886.

Garuḍa Purāṇa. See: Bhattacharya, Ramshankar; also Dutt, Manmatha Nath.

Ghose, Ajit. "An Image of Ārya-Avalokiteśvara of the Time of Vainyagupta." *Journal of the Indian Society of Oriental Art*, 13 (1945), 49–54.

Gonda, J. *Aspects of Early Viṣṇuism*. Utrecht, 1954.

Govindacarya, U. V., ed. *Srī Parameśvara Saṃhitā*. Srirangam, 1953.

Gravely, F. H. and Ramachandran, T. N. *Catalogue of the South Indian Metal Images in the Madras Government Museum*. Bulletin of the Madras Government Museum, Madras, 1932.

Griffith, R. T. H. *Hymns of the Ṛgveda*, 2 vols. Chowkhamba Sanskrit Studies, Vol. 25. Varanasi, 1963.

Gupta, Anand Swarup, ed. and Mukhopadhyay, S. M. *et al.,* trans. *The Vāmana Purāṇa*. Varanasi, 1968.

Hackin, J. *La Sculpture Indienne et Tibétaine au Museé Guimet*. Paris, 1931.

Harivaṃśa. See: Dutt, Manmatha Nath; Langlois, M. A.; also Vaidya, P. L.

Härtel, H. *Indische Skulpturen*, Vol. 1. Berlin, 1960.

———. "Zur Datierung einer alten Viṣṇu-Bronze." *Indologen-Tagung 1959*. Edited by E. Waldschmidt. Göttingen, 1960, 165–168.

Havell, E. B. *The Ideals of Indian Art*. London, 1911.

Hollis, H. "The Angel of the Discus." *Bulletin of the Cleveland Museum of Art*, 33 (1946), 164, 165.

Hopkins, E. Washburn, *Epic Mythology*. 2nd ed. Varanasi, 1968.

Jaiswal, Suvira. *The Origin and Development of Vaiṣṇavism*. Delhi, 1967.

Jouveau-Debreuil, G. *Iconography of Southern India*. Paris, 1937.

Kennedy, Vans. *Researches into the Nature and Affinity of Ancient and Hindu Mythology*. London, 1831.

Khan, Abdul Waheed. *An Early Sculpture of Narasimha*. Andhra Pradesh Government Archaeological Series, No. 16. Hyderabad, 1964.

Khare, M. D. "Discovery of a Vishṇu Temple near the Heliodoros Pillar, Besnagar, Dist. Vidisha (M. P.)." *Lalit Kalā*, No. 13 (1967), 21–27.

Kramrisch, Stella, trans. *The Vishṇudharmottara*, Part III. Calcutta, 1928.

———. *Indian Sculpture*. Calcutta, 1933.

———. "Pāla and Sena Sculpture." *Rūpam*, No. 40 (1929), 107–26.

Kramrisch, Stella, Cousins, J. H., and Poduval, R. Vasudeva. *The Arts and Crafts of Kerala*. Cochin, 1970.

Krishnamachariar, M. *History of Classical Sanskrit Literature*. Madras, 1937.

Krishna Sastri, H. *South Indian Images of Gods and Goddesses*. Madras, 1916.

Kuraishi, M. H. and Ghosh, A. *Rajgir*. Delhi, 1944.

Langlois, M. A., trans. *Harivaṃśa*. Paris, 1834.

Laufer, Berthold. *Archaic Chinese Jades*. New York, 1927.

Lee, Sherman. "A Bronze Yaksha Image and its Significance." *Bulletin of the Royal Ontario Museum*, No. 24 (1956), 23–25.

Macdonell, A. A. *Vedic Mythology*. 2nd ed. Varanasi, 1963.

Macdonell, A. A. and Keith, A. B. *Vedic Index*, 2 vols. London, 1912.

Mahābhārata. See: Roy, P. C.; also Sukthankar, V. S.

Majumdar, R. C., ed. *The Classical Age*. The History and Culture of the Indian People, Vol. 3. Bombay, 1954.

———, ed. *The History of Bengal*, Vol. 1. Dacca, 1943.

de Mallmann, M.-T. *Les enseignements iconographiques de l'Agni-Purāṇa*. Paris, 1963.

Mārkaṇḍeya Purāṇa. See: Pargiter, F. E.

Masson, J. L. and Patwardhan, V. *Śāntarasa and Abhinavagupta's Philosophy of Aesthetics*. Poona, 1969.

Matsya Purāṇam. Sacred Books of the Hindus, Vol. 17. Allahabad, 1916.

Mitra, Haridas. *Contribution to a Bibliography of Indian Art and Aesthetics*. Santiniketan, 1951.

Mittal, Jagdish. "The Temple of Basheshar Mahadev in Kulu." *Roopa-Lekha*, 32 (1961), 66–68.

Nilakantha, Sastri, K. A. *The Cōḷas*. 2nd ed. Madras, 1955.

———. *A History of South India*. 3rd ed. Madras, 1966.

O'Neill, John. *The Night of the Gods, An Enquiry into Cosmic and Cosmogonic Mythology and Symbolism*, 2 vols. London, 1893–1897.

Padma-Saṃhitā. *See:* Smith, H. Daniel.

Pañcarātrarakṣa. *See:* Duraiswami Aiyangar, M.

Parameśvara-Saṃhitā. *See:* Govindacarya, U. V.

Pargiter, F. E., trans. *The Mārkaṇḍeya Purāṇa*. Calcutta, 1904.

Patil, D. R. *Cultural History from the Vāyu Purāṇa*. Poona, 1946.

———. *The Monuments of The Udayagiri Hill*. Gwalior, 1948.

Ramanujacharya, M. D., ed. *Ahirbudhnya-Saṃhitā of the Pāñcarātrāgama*, 2 vols. Madras, 1916 (2nd ed. 1966).

Rangachari, K. *The Sri Vaishnava Brahmans*. Madras, 1931.

Rao, T. A. Gopinatha. *Elements of Hindu Iconography*, 4 vols. Madras, 1914–1916.

Raychaudhari, Hemachandra. *Materials for the Study of the Early History of the Vaishnava Sect*. Calcutta, 1920 (2nd ed. 1936).

Ṛg Veda. *See:* Griffith, R. T. H.

Rosenfield, John *et al*. *The Arts of India and Nepal: The Nasli and Alice Heeramaneck Collection*. Boston, 1966.

Roy, P. C., trans. *The Mahābhārata of Krishna-Dwaipāyana Vyāsa*. Calcutta, 1884–1896.

Sambasiva, Sastri, K., ed. *The Śilparatna of Śrī Kumāra*. Trivandrum Sanskrit Series, Nos. 75, 93. Trivandrum, 1922, 1929.

Saraswati, S. K. *A Survey of Indian Sculpture*. Calcutta, 1957.

Śatapatha Brāhmaṇa. *See:* Eggeling, Julius.

Sathyanatha, Aiyar, R. *History of the Nayaks of Madura*. Madras, 1924.

Schrader, F. Otto. *Introduction to the Pāñcarātra and the Ahirbudhnya-Saṃhitā*. Madras, 1916.

Shah, Priyabala, ed. *Viṣṇudharmottara-Purāṇa, Third Khaṇḍa*, 2 vols. Gaekwad's Oriental Series, Vols. 130, 137. Baroda, 1958, 1961.

Shah, U. P. *Studies in Jaina Art*. Banaras, 1955.

Śilparatna. *See:* Sambasiva Sastri, K.

Simpson, William. *The Buddhist Praying Wheel: A Collection of Material Bearing on the Symbolism of the Wheel and Circular Movements in Custom and Religious Ritual*. London, 1886.

Singh, Satyavrata. *Vedānta Deśika*. Chowkhamba Sanskrit Studies, Vol. 5. Varanasi, 1958.

Sircar, D. C. "Burhikhar Inscription." *Quarterly Journal of the Mythic Society*, 46 (1956), 221–224.

Sivaramamurti, C. "Chakravikrama Type." *Journal of the Numismatic Society of India*, 13 (1951), 180–182.

———. "Geographical and Chronological Factors in Indian Iconography." *Ancient India*, No. 6 (1950), 21–63.

———. *Indian Bronzes*. Bombay, 1962.

———. *Indian Sculpture*. New Delhi, 1961.

———. *South Indian Bronzes*. Delhi, 1963.

———. *South Indian Paintings*. New Delhi, 1968.

———. "The Weapons of Vishnu." *Artibus Asiae*, 18 (1955), 128–137.

Smith, H. Daniel, ed. *Pāñcarātraprāsādaprasādhanam, Chapters 1–10 of the "Kriyāpāda," Padmasaṃhitā*. Madras, 1963.

———. *A Source Book of Vaiṣṇava Iconography*. Madras, 1969.

Sørenson, S. *An Index to the Names in the Mahābhārata*, 2 vols. London, 1904.

Soundararajan, K. V. "The Typology of the Anantaśayī Icon." *Artibus Asiae*, 29 (1967), 67–84.

Srinivasa Ayyangar, T. R., trans. *The Vaiṣṇavopaniṣads*. Adyar Library Series, No. 52. Madras, 1945.

Srinivasan, K. R. *Cave Temples of the Pallavas*. New Delhi, 1964.

Srinivasan, P. R. *Bronzes of South India*. Bulletin of the Madras Government Museum, Madras, 1963.

———. "Inscriptional Evidence on Early Hindu Temples." *The Adyar Library Bulletin*, 25 (1961), 511–523.

Subrahmanya Sastry, S., ed. *Śrī Tirumala Tirupati Devasthānam Epigraphical Series*. Madras, 1930ff.

Sukthankar, V. S. *et al.*, eds. *The Mahābhārata* (critical edition). Poona, 1927–1966.

Tucci, Giuseppi. *The Theory and Practice of the Maṇḍala*. London, 1969.

Vaidya, P. L., ed. *The Harivaṃśa* (critical edition). Poona, 1969.

Vaiṣṇavopaniṣads. See: Srinivasa Ayyangar, T. R.

Vāmana Purāṇa. See: Gupta, Anand Swarup.

Vats, M. S. *The Gupta Temple at Deogarh*. Memoirs of the Archaeological Survey of India, No. 70. Delhi, 1952.

Viṣṇudharmottara Purāṇa. See: Kramrisch, Stella; also Shah, Priyabala.

Viṣṇu Purāṇa. See: Bhattacaryya, J. V.; also Wilson, H. H.

Vriddhagirisan, V. *The Nayaks of Tanjore*. Annamalainagar, 1941.

Ward, J. S. M. *Freemasonry and the Ancient Gods*. London, 1926.

Weiner, Sheila. "From Gupta to Pāla Sculpture." *Artibus Asiae*, 25 (1962), 167–182.

Wijesekera, O. H. de A. "Discoid Weapons in Ancient India, A Study of Vedic Cakra, Pavi and Kṣurapavi." *Adyar Library Bulletin*, 25 (1961), 250–261.

———. "The Symbolism of the Wheel in the Cakravartin Concept." In A. S. Altekar, ed., *Felicitation Volume Presented to Professor Sripad Krishna Belvalkar*. Benares, 1957, 262–267.

Winternitz, M. *History of Indian Literature*, Vol. 1. Calcutta, 1927.

Woolner, A. G. and Sarup, L., trans. *Thirteen Trivandrum Plays Attributed to Bhāsa*, 2 vols. Panjab University Oriental Publications, No. 13. London, 1931.

Wilson, H. H., trans. *The Vishnu Purāṇa*. 3rd ed. Calcutta, 1961.

Zimmer, H. *Myths and Symbols in Indian Art and Civilization*. New York, 1962.

Plates

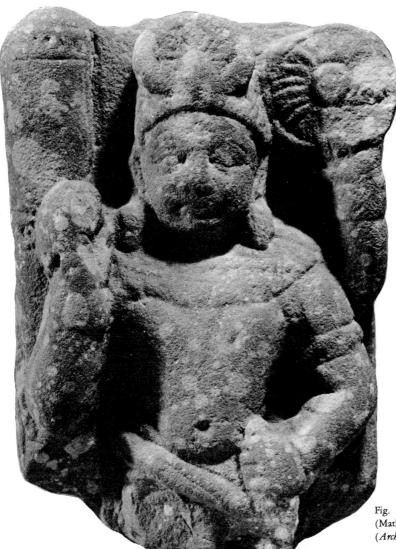

Fig. 1. Viṣṇu holding *gadā* and *cakra*. Mathura (Mathura District), Uttar Pradesh, first century A.D. (*Archaeological Museum, Mathura*)

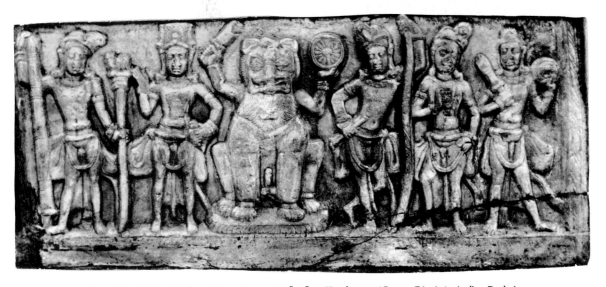

Fig. 2. Narasimha with five Vaiṣṇava heroes (*pañcavīra*). Kondamotu (Guntur District), Andhra Pradesh, late third to fourth century A.D. (*State Department of Archaeology, Hyderabad*)

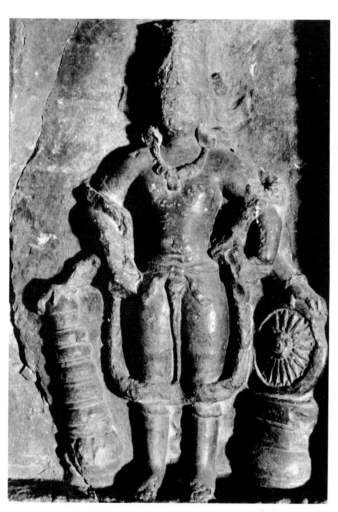 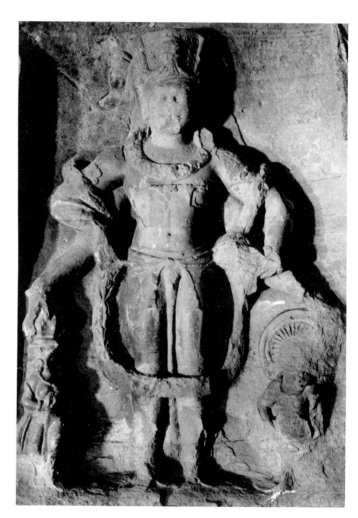

Fig. 3. Viṣṇu holding *gadā* and *cakra*. Façade of Cave 6. Udayagiri (Vidisha District), Madhya Pradesh, ca. 401–402 A.D.

Fig. 4. Viṣṇu with personified *gadā* and *cakra*. Façade of Cave 6. Udayagiri (Vidisha District), Madhya Pradesh, ca. 401–402 A.D.

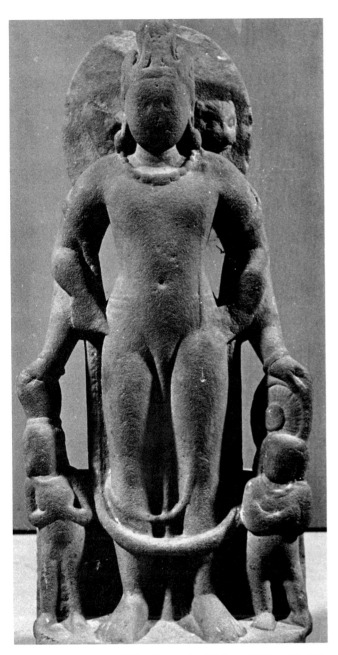

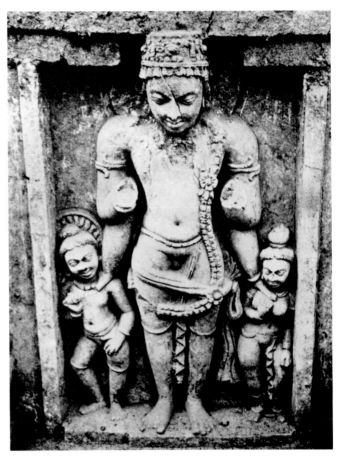

Fig. 5. Viṣṇu with personified *gadā* and *cakra*. Mathura (Mathura District), Uttar Pradesh, fifth century (*Archaeological Museum, Mathura*)

Fig. 6. Stucco Viṣṇu with personified *gadā* and *cakra*. Maṇiyār Maṭha. Rajgir (Patna District), Bihar, fifth century

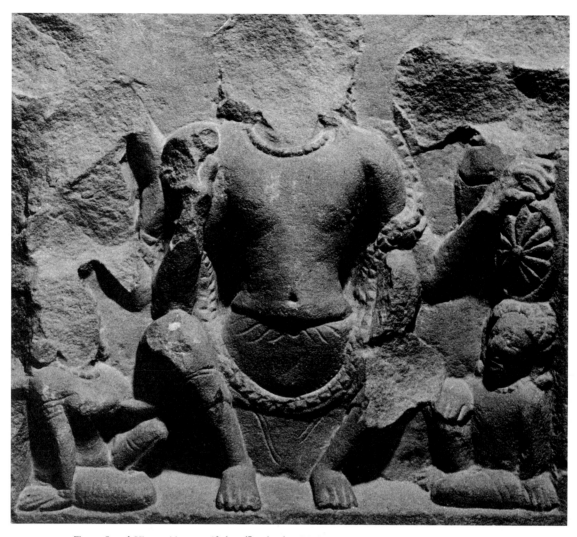

Fig. 7. Seated Viṣṇu with personified *gadā* and *cakra*. Mathura (Mathura District), Uttar Pradesh, fifth century (*Archaeological Museum, Mathura*)

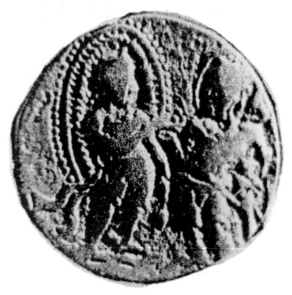

Fig. 8. Personified *cakra* on *cakravikrama* gold coin of Candragupta II. Bayana Hoard (Bharatpur District), Rajasthan, early fifth century (*Collection, Maharaja of Bharatpur*)

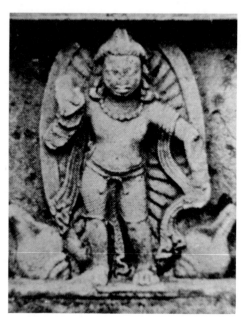

Fig. 9. Personified *cakra* from pedestal of image of Nemīnātha. Vaibhāragiri. Rajgir (Patna District), Bihar, fifth century

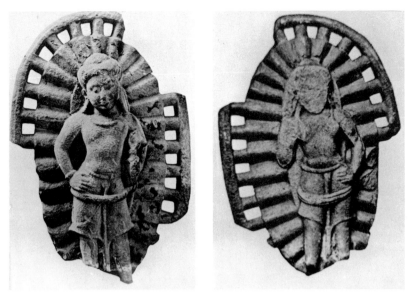

Fig. 10. Double-sided disk with *cakra* personifications (pillar capital). Salar (Murshidabad District), West Bengal, early sixth century (*Vangiya Sahitya Parishad Museum, Calcutta*)

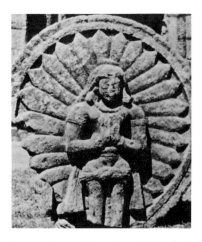

Fig. 11. Personified *cakra* with hands in *añjali-mudrā* (pillar capital). Basheshar Mahādev Temple. Bajaura (Kangra District), Himachal Pradesh, seventh to eighth century

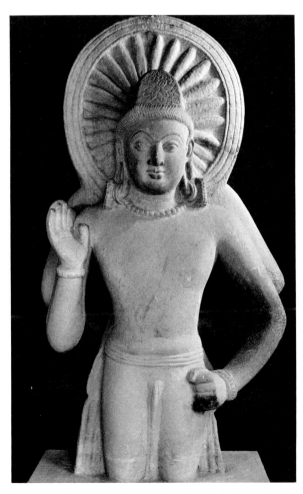

Fig. 12. Standing figure with *cakra* behind head (double-sided pillar capital). Pawaya (Gwalior District), Madhya Pradesh, fifth century (*Gwalior Museum*)

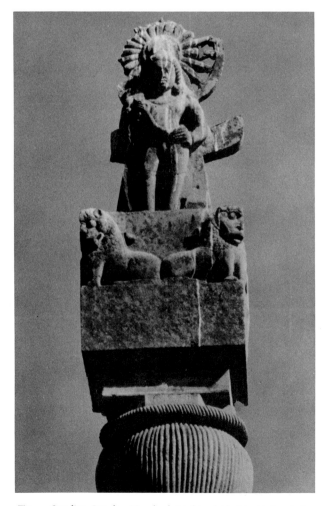

Fig. 13. Standing Garuḍa with *cakra* behind head (double-sided capital). Budhagupta pillar. Eran (Sagar District), Madhya Pradesh, ca. 484–485 A.D.

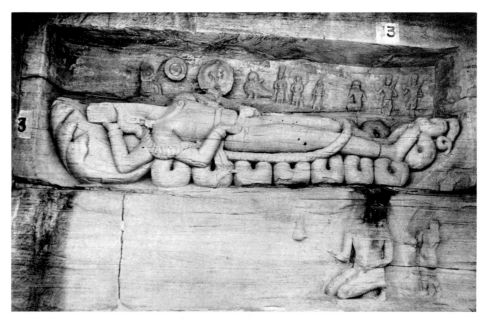

Fig. 14. Reclining Viṣṇu (*anantaśayin*). Cave 13. Udayagiri (Vidisha District), Madhya Pradesh, early fifth century

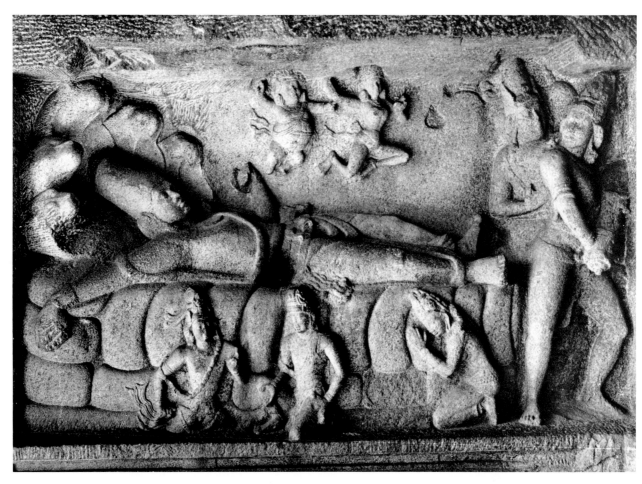

Fig. 15. Reclining Viṣṇu (*anantaśayin*), with personified *cakra* and *gadā* (on back wall of niche). Mahiṣāsuramardini Cave. Mamallapuram (Chingleput District), Tamil Nadu, late seventh century

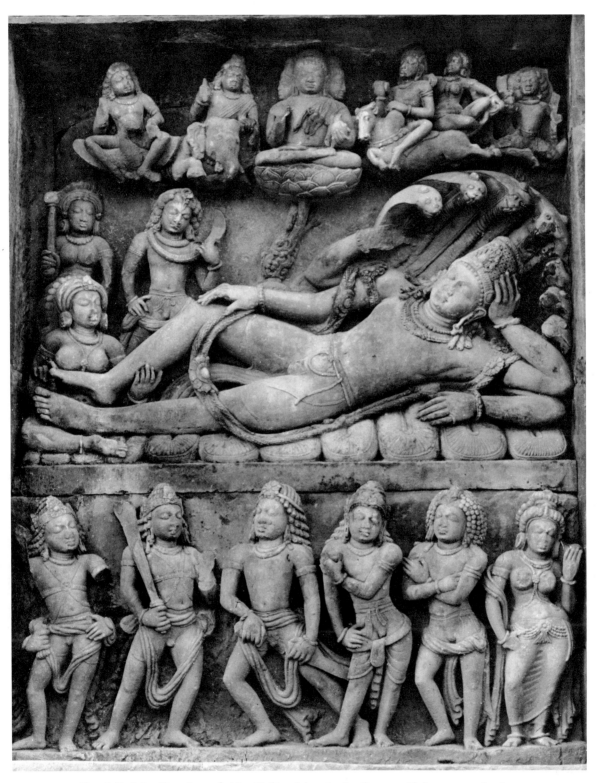

Fig. 16. Reclining Viṣṇu (*anantaśayin*), with frieze below showing four personified weapons confronting the demons Madhu and Kaiṭabha. Daśavatāra Temple. Deogarh (Jhansi District), Uttar Pradesh, middle sixth century.

Fig. 17. Personified *gadā* and *cakra* (detail of Figure 14, back wall of niche)

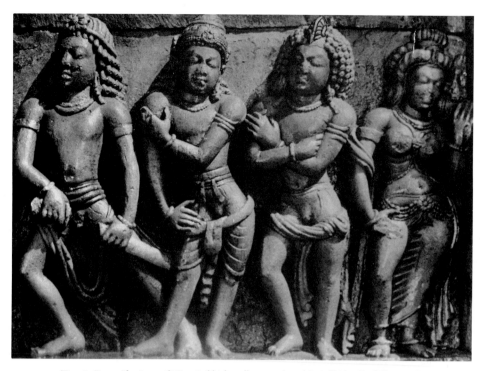

Fig. 18. Personifications of Viṣṇu's *khadga, dhanus, cakra* and *gadā* (detail of Figure 16)

Fig. 19. Standing Narasiṃha, holding personified weapons. Cave 3. Badami (Bijapur District), Mysore, ca. 578 A.D.

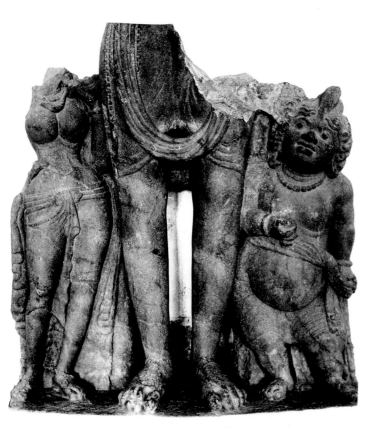

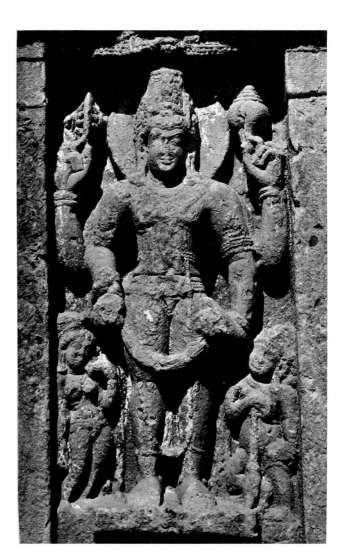

Fig. 20. Damaged Viṣṇu image, with personified *gadā* and *cakra*. Elephanta (Bombay District), Maharashtra, late sixth to early seventh century (*Prince of Wales Museum, Bombay*)

Fig. 21. Viṣṇu with personified *gada* and *cakra*. Lāḍ Khan Temple. Aihole (Bijapur District), Mysore, early seventh century

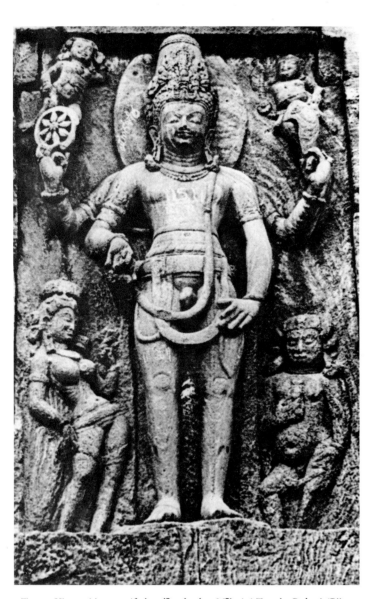

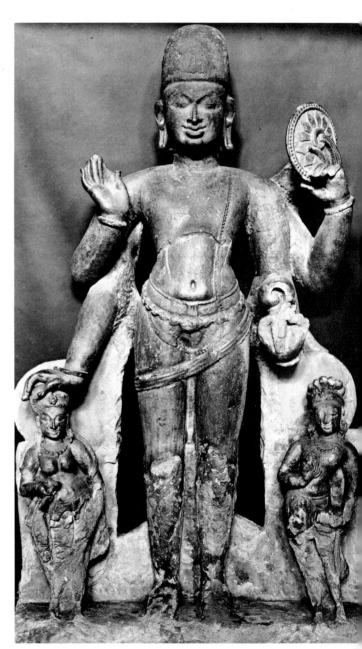

Fig. 22. Viṣṇu with personified *gadā* and *cakra*. Mālegitti Temple. Badami (Bijapur District), Mysore, late seventh century

Fig. 23. Viṣṇu with personified *gadā* and *cakra*. Kanauj (Farrukhabad District) Uttar Pradesh, seventh century (*Baroda Museum and Picture Gallery*)

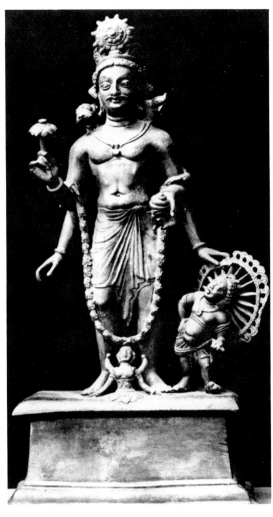

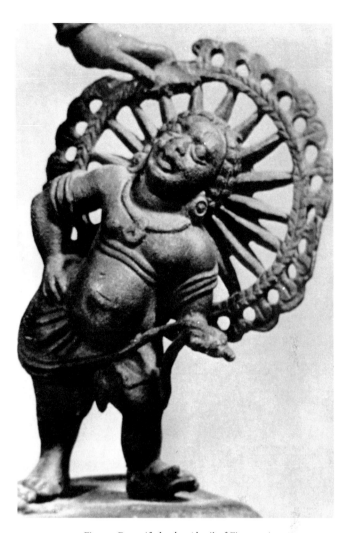

Fig. 24. Bronze Viṣṇu with personified *cakra*. Kashmir, seventh century (*Museum für Indische Kunst, Berlin*)

Fig. 25. Personified *cakra* (detail of Figure 24)

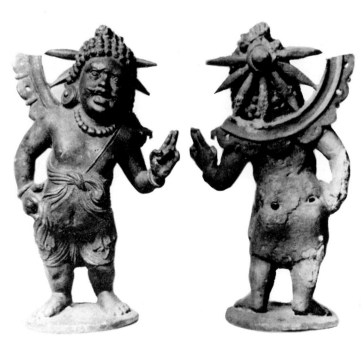

Fig. 26. Bronze personified *cakra* (front and rear views). Kashmir, seventh century (*Royal Ontario Museum, Toronto*)

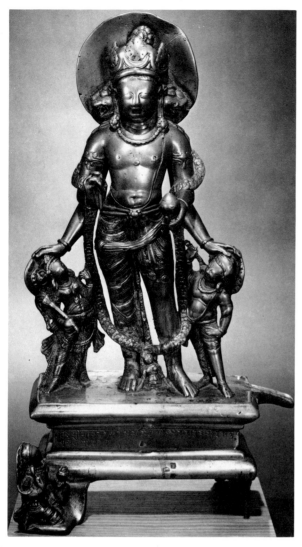

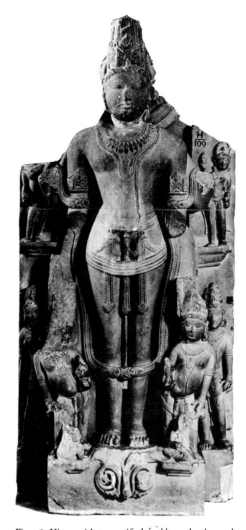

Fig. 28. Viṣṇu with personified śaṅkha and cakra and other attendants. Uttar Pradesh, tenth to eleventh century (*Lucknow Museum*)

Fig. 27. Bronze Viṣṇu with personified *gadā* and *cakra*. Kashmir, ninth century (*Los Angeles County Museum*)

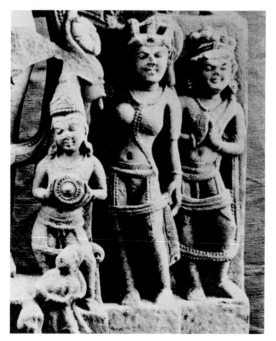

Fig. 29. Personified *cakra* and other attendants (detail of Harihara icon). Rajasthan, ninth century (*Museum of Fine Arts, Boston*)

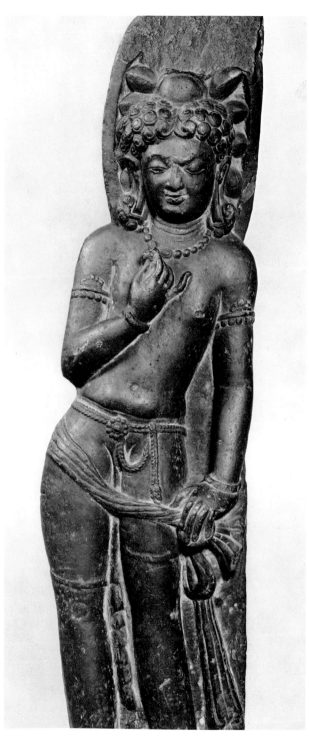

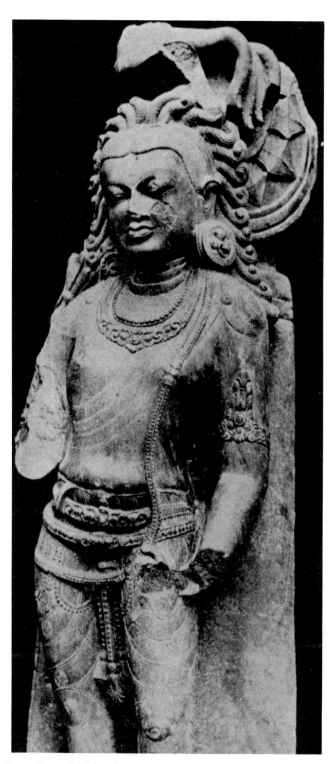

Fig. 30. Personified *cakra* (fragment of Viṣṇu icon). Aphsad (Gaya District), Bihar, late seventh century (*Cleveland Museum of Art; purchase from the J. H. Wade Fund*)

Fig. 31. Personified *cakra* (fragment of Viṣṇu icon). Kasiabari (Bogra District), Bangla Desh, eleventh century (*Varendra Research Society Museum, Rajshahi*)

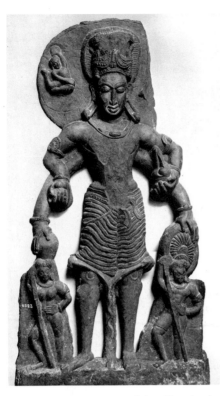

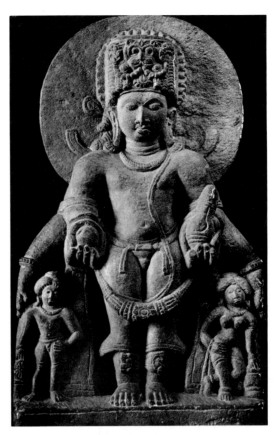

Fig. 32. Viṣṇu with personified *gadā* and *cakra*. Chaitanpur (Burdwan District), West Bengal, seventh century (*Indian Museum, Calcutta*)

Fig. 33. Viṣṇu with personified *cakra* and *gadā*. Benisagar (Singhbhum District), Bihar, seventh century (*Patna Museum*)

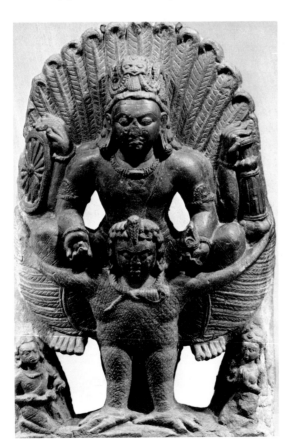

Fig. 34. Viṣṇu seated on garuḍa, holding *cakra* and *gadā*. Bihar, seventh century (*Cleveland Museum of Art; purchase from the J. H. Wade Fund*)

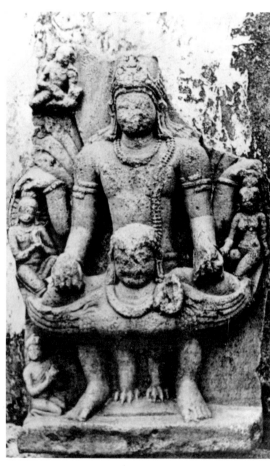

Fig. 35. Viṣṇu seated on Garuḍa, with personified *cakra* and *gadā*.
Bihar, eighth to ninth century (*Indian Museum, Calcutta*)

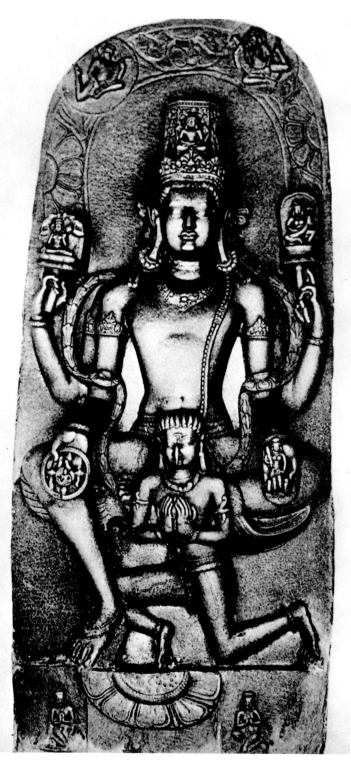

Fig. 36. Viṣṇu seated on Garuḍa, holding personified *cakra* and *gadā*. Lakshmankati
(Bakerganj District), Bangla Desh, ninth to tenth century

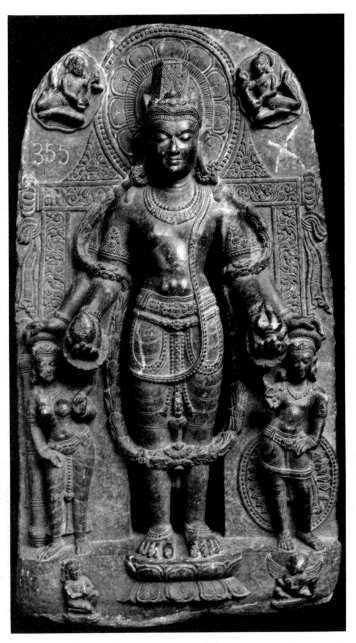

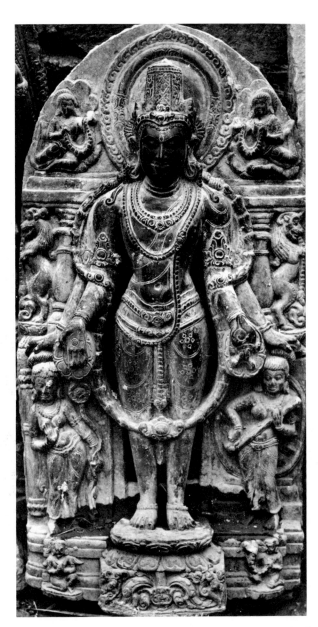

Fig. 37. Viṣṇu with personified *gadā* and *cakra*. Bihar, early tenth century (*Indian Museum, Calcutta*)

Fig. 38. Viṣṇu with personified *gadā* and *cakra* in the guise of Lakṣmī and Sarasvatī. Deo Barnarak (Shahabad District), Bihar, late tenth century

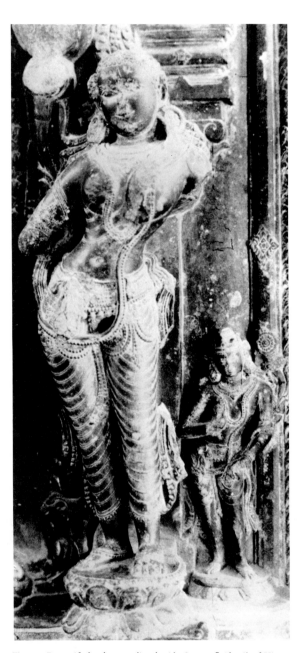

Fig. 39. Personified *cakra* standing beside Sarasvatī (detail of Viṣṇu icon). Bengal, twelfth century (*Indian Museum, Calcutta*)

Fig. 40. Personified *cakra* standing beside Sarasvatī (detail of Viṣṇu icon). Bengal, twelfth century (*Indian Museum, Calcutta*)

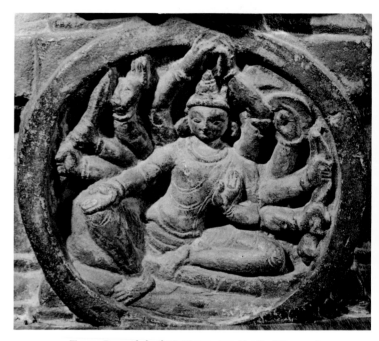

Fig. 42. Personified *cakra* with ten arms (detail of Figure 41)

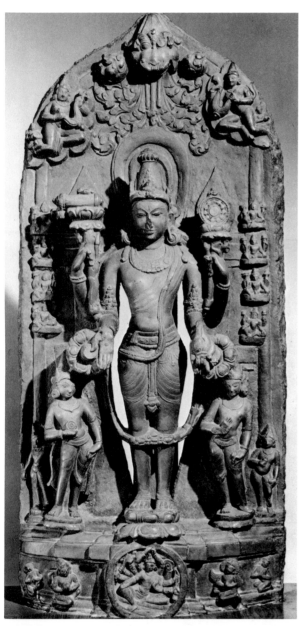

Fig. 41. Viṣṇu with personified *cakra* and *śankha* and other attendants. Bengal, eleventh century (*National Museum, New Delhi*)

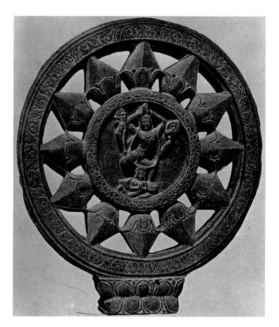

Fig. 43. Double-sided disk with personified *cakra* with four arms, riding on Garuḍa. Sharishadaha (Parganas District), West Bengal, eleventh to twelfth century (*Asutosh Museum, Calcutta*)

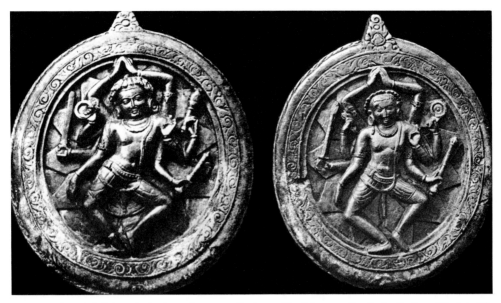

Fig. 44. Double-sided disk with dancing *cakra* personifications with eight arms. Deulberia (Bankura District), West Bengal, eleventh to twelfth century

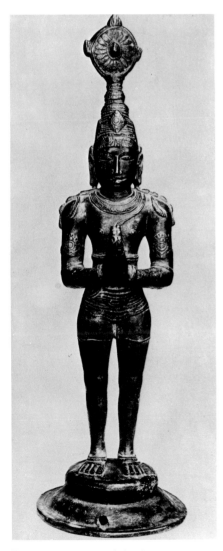

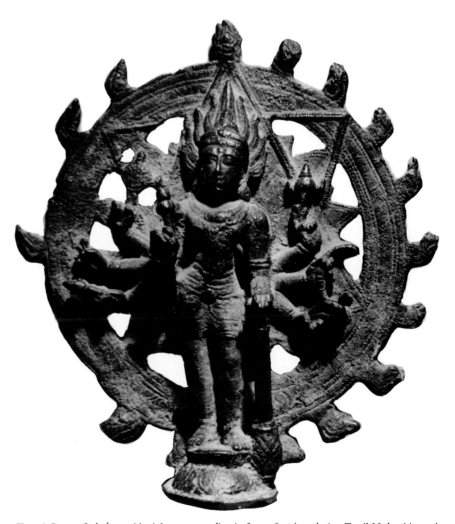

Fig. 46. Bronze Sudarśana with eight arms, standing in front of *saṭ-koṇa* device. Tamil Nadu, thirteenth century (*Private Collection, Bombay*)

Fig. 45. Bronze personified *cakra* with hands in *añjali-mudrā*. Tamil Nadu, thirteenth century (*Madras Museum*)

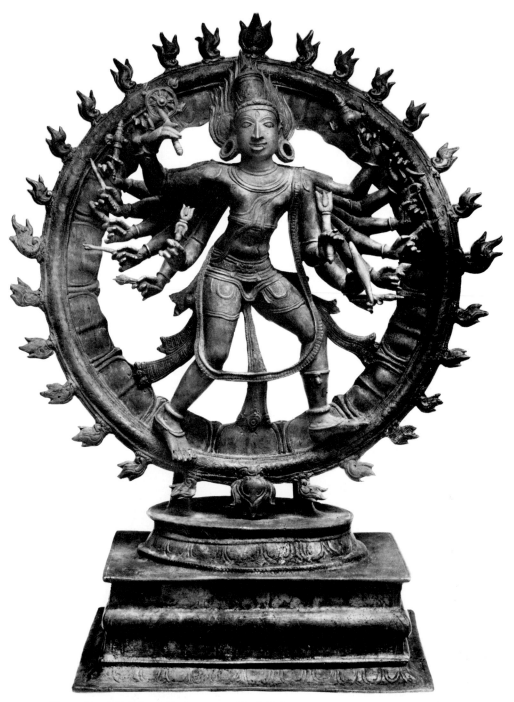

Fig. 47. Bronze Sudarśana with sixteen arms. Tamil Nadu, sixteenth century (*Tanjore Art Gallery*)

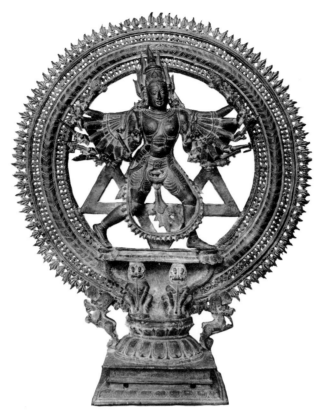

Fig. 48. Bronze Sudarśana with sixteen arms. Tamil Nadu, seventeenth century (*formerly Tanjore Art Gallery*)

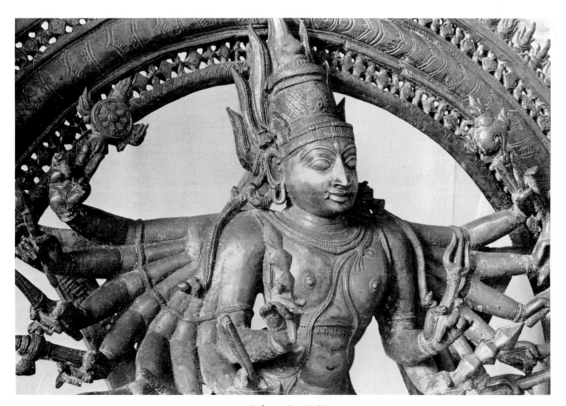

Fig. 49. Sudarśana (detail of Figure 48)

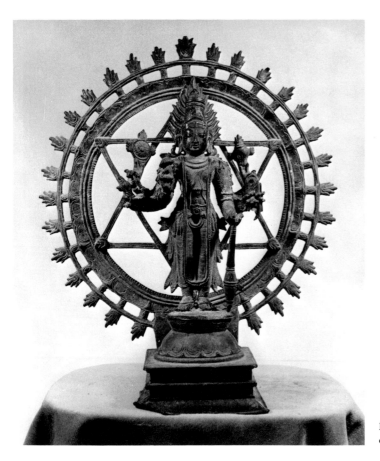

Fig. 50. Bronze Sudarśana with eight arms. Tamil Nadu, seventeenth century (*William H. Wolff, New York*)

Fig. 51. Sudarśana with sixteen arms. Sūryanārāyaṇa Temple. Hampi (Bellary District), Mysore, fifteenth to sixteenth century (?)

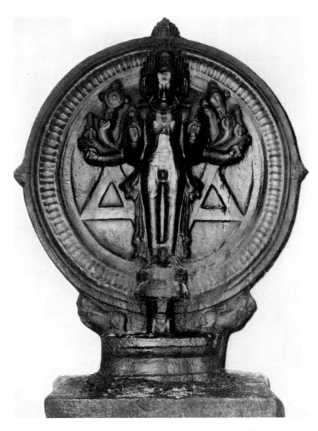

Fig. 52. Sudarśana with eight arms. Śrī Kannam Temple. Kabistalam (Thanjavur District), Tamil Nadu, sixteenth to seventeenth century

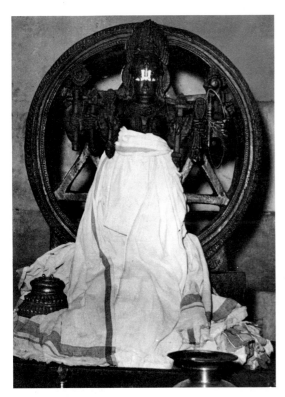

Fig. 53. Sudarśana with eight arms. Nārāyaṇasvāmi Temple. Melukote (Mandya District), Mysore, sixteenth to seventeenth century

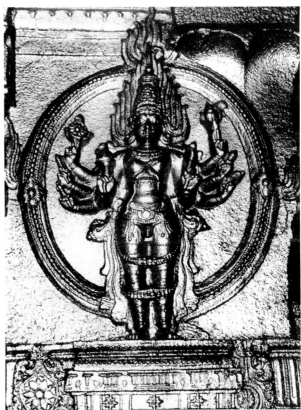

Fig. 54. Sudarśana with eight arms. Rāmasvāmi Temple. Kumbakonam (Thanjavur District), Tamil Nadu, seventeenth to eighteenth century

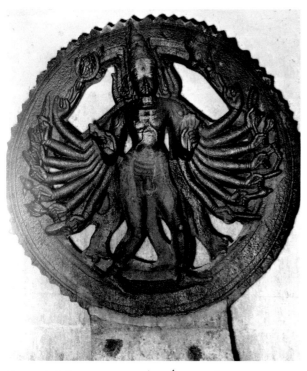

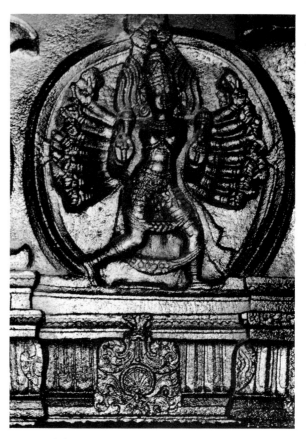

Fig. 55. Sudarśana with sixteen arms. Śri Satyamūrtiperumāl Temple. Tirumayam (Tiruchirapalli District), Tamil Nadu, sixteenth to seventeenth century

Fig. 56. Sudarśana with sixteen arms. Rāmasvāmi Temple. Kumbakonam (Thanjavur District), Tamil Nadu, seventeenth to eighteenth century

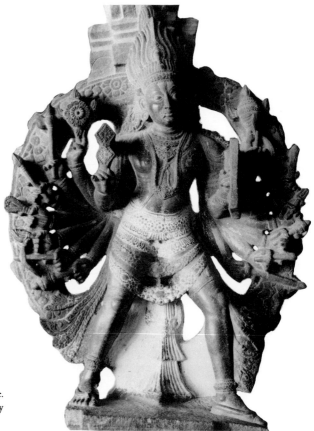

Fig. 57. Sudarśana with sixteen arms. Śrī Alagarperumāl Temple. Dadikkombu (Madurai District), Tamil Nadu, eighteenth century

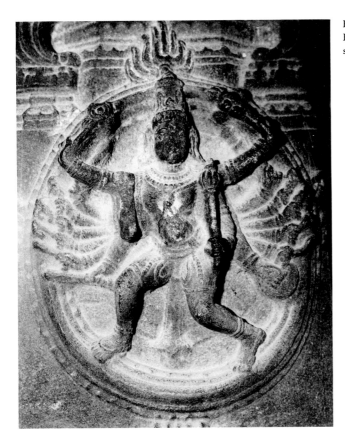

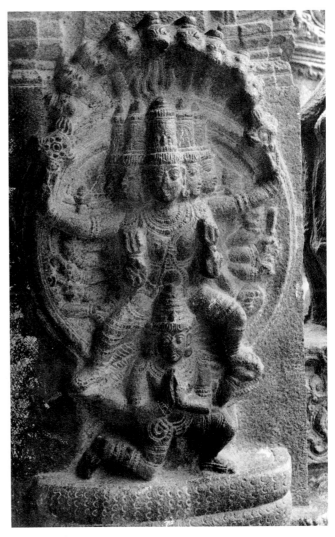

Fig. 58. Sudarśana with sixteen arms. Śrī Varadarājaperumāl Temple. Kanchipuram (Chingleput District), Tamil Nadu, sixteenth to seventeenth century

Fig. 59. Sudarśana with five heads and sixteen arms (?), riding on Garuḍa. Śrī Varadarājaperumāl Temple. Kanchipuram (Chingleput District), Tamil Nadu, sixteenth to seventeenth century

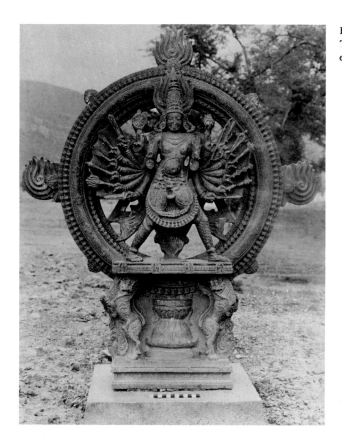

Fig. 60. Sudarśana with sixteen arms. Near Narasimhaguṇṭa Tank. Tirupati (Chittoor District), Andhra Pradesh, seventeenth to eighteenth century

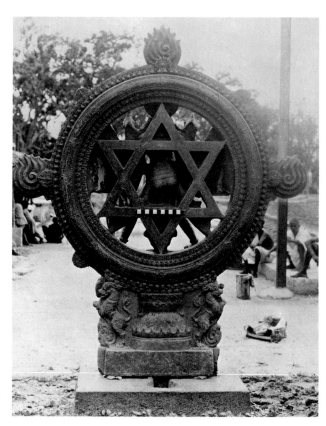

Fig. 61. *Ṣaṭ-koṇa* device behind Sudarśana (rear view of image in Figure 60)

Fig. 63. Yoga-Narasiṃha (reverse of slab in Figure 62)

Fig. 62. Sudarśana with sixteen arms (rectangular slab). Tirumogur (Tirunelveli District), Tamil Nadu, sixteenth to seventeenth century

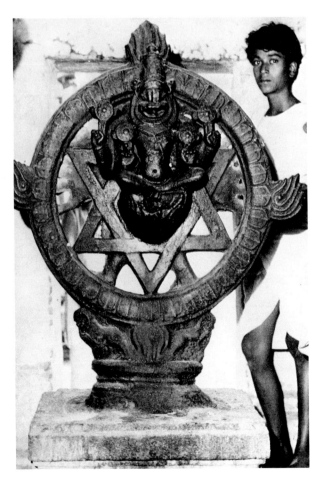

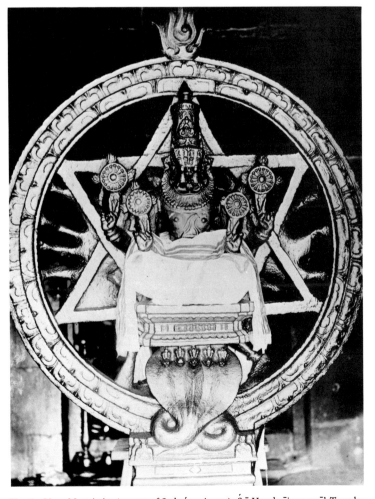

Fig. 64. Yoga-Narasiṃha (reverse of Sudarśana image). Rāmacandra Temple. Nedungunam (North Arcot District), Tamil Nadu, seventeenth century

Fig. 65. Yoga-Narasiṃha (reverse of Sudarśana image). Śrī Varadarājaperumāl Temple. Kanchipuram (Chingleput District), Tamil Nadu, seventeenth century

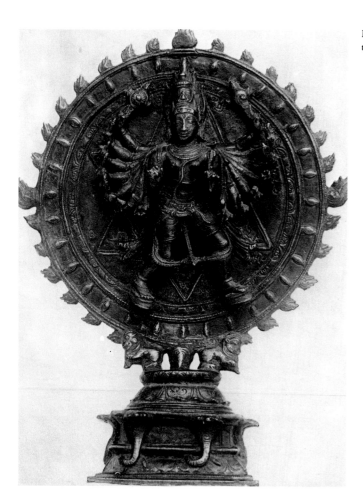

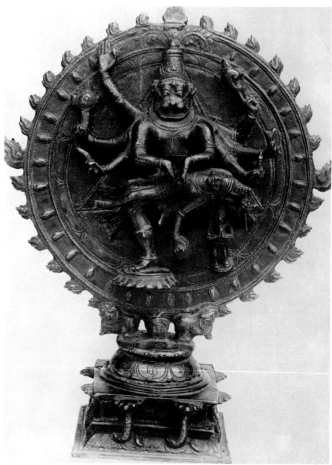

Fig. 66. Bronze Sudarśana with sixteen arms. Tamil Nadu, seventeenth to eighteenth century (*Madras Government Museum*)

Fig. 67. Eight-armed Narasimha destroying the demon Hiranyakaśipu (reverse of image in Figure 66)

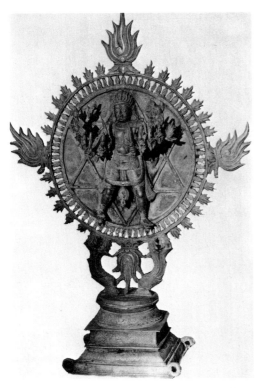

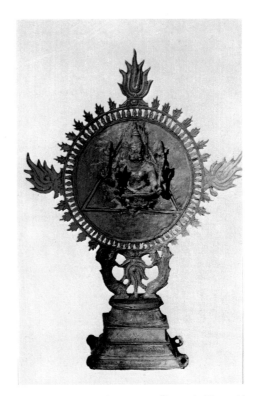

Fig. 68. Bronze Sudarśana with sixteen arms. Sundararājaper-
umāl Temple. Dadikkombu (Madurai District), Tamil
Nadu, eighteenth century

Fig. 69. Yoga-Narasiṃha (reverse of image in Figure 68)

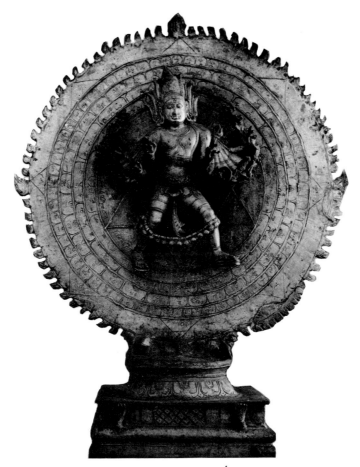

Fig. 70. Bronze Sudarśana with sixteen arms. Śrī Kālamekaperumāl Temple.
Tirumohur (Madurai District), Tamil Nadu, seventeenth century

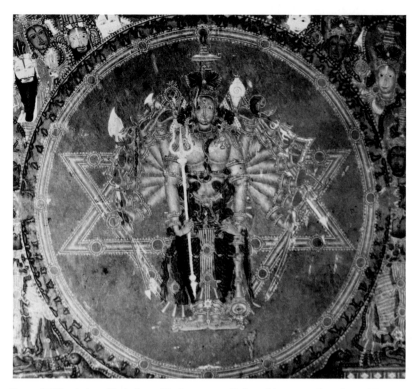

Fig. 71. Wall-painting of Sudarśana with sixteen arms. Padmanabhapuram (Kanyakumari District), Tamil Nadu, eighteenth century

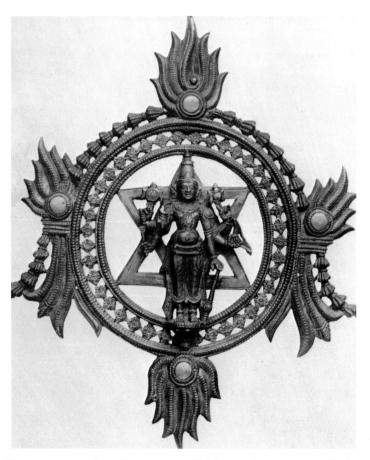

Fig. 72. Bronze Sudarśana with six arms. Tamil Nadu, early nineteenth century (*Madras Government Museum*)

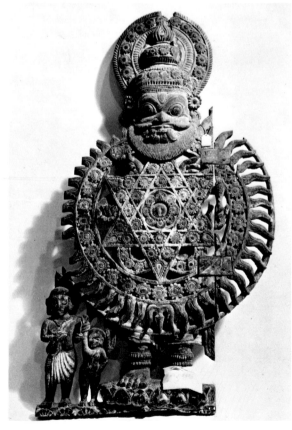

Fig. 73. Woodcarving of Sudarśana with four arms. Kerala, eighteenth century

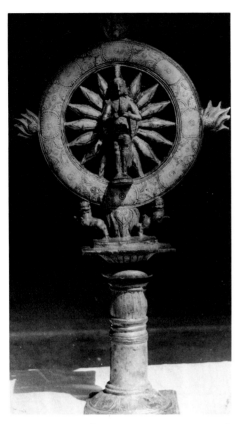

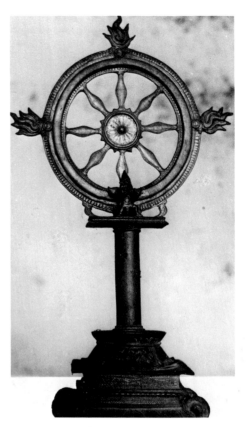

Fig. 74. Bronze Sudarśana with two arms in front of *cakra* with sixteen spokes. Chennakeśavaperumāl Temple. Mallanginar (Thanjavur District), Tamil Nadu, eighteenth century

Fig. 75. Bronze *cakra* with eight spokes, supported by Garuda. Śrī Kudalalagar Temple. Madurai (Madurai District), Tamil Nadu, seventeenth century

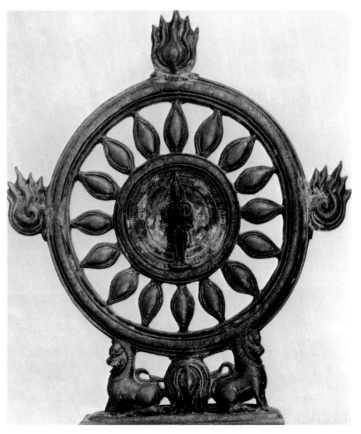

Fig. 76. Bronze Sudarśana with two arms, in front of *cakra* with sixteen spokes. Alathur (North Arcot District), Tamil Nadu, eighteenth century (*Madras Government Museum*)

Fig. 77. *Cakra* with sixteen spokes. Śrī Ranganāthasvāmi Temple. Singavaram (South Arcot District), Tamil Nadu, seventeenth century

Fig. 78. Bronze *cakra* with twelve spokes. Vellore (North Arcot District), Tamil Nadu, seventeenth century (*Madras Government Museum*)

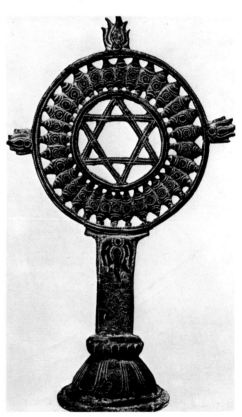

Fig. 79. Bronze *cakra* with sixteen spokes. Tamil Nadu, eighteenth century (*Madras Government Museum*)

Fig. 80. Bronze *cakra* with *ṣaṭ-koṇa* and thirty-two spokes. Chimakurti (Guntur District), Andhra Pradesh, eighteenth century (*Madras Government Museum*)